South Carolina
GOLF

BOB GILLESPIE AND TOMMY BRASWELL

Forewords by Jay Haas and Beth Daniel

THE
History
PRESS

Published by The History Press
Charleston, SC
www.historypress.com

Front cover, top, left to right: Frank Ford Sr. admires some of his golf trophies. *Courtesy of the Ford family*; The 1991 U.S. Ryder Cup team celebrates its win at the Ocean Course, a competition known as the "War by the Shore." *Courtesy of Kiawah Island Golf Resort*; Betsy King, along with her Furman teammates, captured the 1976 AIAW championship, the forerunner of the women's NCAA title. *Courtesy of Furman University*; *bottom*: Harbour Town Golf Links seventeenth green. *Courtesy of Sea Pines Resort*.
Back cover: Seabrook Island's Crooked Oaks course features the trees that give it its name. *Courtesy of Seabrook Island*; *inset*: Five-time RBC Heritage winner Davis Love III. *Courtesy of Heritage Classic Foundation*.

First published 2021

ISBN 9781540246554

Library of Congress Control Number: 2020948448

Our thanks to the many great golf courses in South Carolina, the professionals who operate them and our former newspaper employers, The State *and the* Post and Courier, *which afforded us opportunities to write about the game and the people who play it, teach it and love it. Thanks especially to our wives and families, who allowed us to enjoy the game of a lifetime.*

CONTENTS

FOREWORDS

My first memory that had anything to do with golf was the backyard of my grandparents' house in Belleville, Illinois. George and Helen Goalby had two children: Shirley, my mom, and her brother, Bob. Uncle Bob had handed me a cut-down Chick Harbert 4-wood, showed me a basic interlocking grip and told me to swing so at the finish, my belt buckle faced my target. That was my first lesson and I loved it immediately. I chased plastic golf balls in that yard and my own yard for many years after, back and forth, over trees, bushes and rooftops. In those first few years I had many head-to-head matches against the best players of that time—Arnold Palmer, Jack Nicklaus, Gary Player—and of course, I beat them every time!

Golf is such a wonderful game that can last a lifetime, and in my case, I had a professional giving me guidance to get me started down the right path. My parents were there as well to take me to play and give me the opportunity to continue doing what I loved. I've come to believe that the game of golf has a way of "handing down," whether that be good genes, basic golf knowledge or simply and most importantly, a greater understanding of the proper etiquette of the game and of life, quite frankly. I say these things because the names that you read in this book will most assuredly have had someone show them the proper path to follow, and they in turn will have handed down those same lessons to the next generation. As many have said, you can learn a great deal about someone just by spending the day with them on a golf course. And what an opportunity we have here in the state of South Carolina to enjoy the game.

South Carolina and golf seem synonymous. Not many states can boast of the diversity of courses that we have from our coast to our mountains, from world-class Harbour Town at Hilton Head Island to the beautiful array of the Cliffs courses in the Upstate. Although I haven't played as many courses in our state as some, I've heard so many great stories from friends and acquaintances that have played them.

Being such a great stage to work from, South Carolina has always been a wonderful place to develop champion golfers. Our great South Carolina Golf Association has helped nurture countless junior players and continues to host great events for players of all ages. But whether you are a scratch golfer, someone who is just starting out or someone who has played golf for years simply for the enjoyment of the game, South Carolina has something for all.

Golf is a game for a lifetime, for men and women, young and old, from all walks of life. To me, it's an easy choice to decide to give it a try. So many unforgettable experiences await players. I hope you will enjoy this wonderful book by two of my favorites, Bob Gillespie and Tommy Braswell, who have been covering golf for as long as I can recall and doing it as well as anyone.

—Jay Haas, PGA Tour, PGA Tour Champions

As a native of Charleston, South Carolina, I was fortunate to have had access to golf at an early age. I am the youngest of a family of five, and my parents, brother and sister all played the game along with other sports when we were growing up. I am proud to say we continue to enjoy golf to this day.

South Carolina enjoys a rich history of golf. It is believed that the first golf clubs arrived in the South Carolina Lowcountry from Scotland. The state has so many great courses, it is no wonder it is always deemed one of the best in the nation for golf.

My entire developmental years were spent here. My parents were members at the Country Club of Charleston, where I learned to play in the junior golf program. The club's head professional, Al Esposito, and the SC Women's Golf Association took care of the junior players. We had a large group of boys and girls in the program, so there was always a friend around to play and practice with every day. The women in the association shuttled us to local and state junior tournaments and also helped teach us chipping and

putting. I believe the state juniors program is the reason there are so many PGA and LPGA Tour professionals from the state of South Carolina.

Growing up, I had many South Carolinians in golf to look up to as role models. Henry Picard retired in Charleston and spent much of his time practicing, playing and teaching at the Country Club of Charleston. As a professional, he won twenty-six times, notably the 1938 Masters and 1939 PGA Championship. Picard's record of success earned him induction into the World Golf Hall of Fame, where I had the distinct honor of presenting him. Even though I never officially took lessons from him, he had a huge impact on me and my career, whether it was asking me questions about my strategy and approach to playing or taking the time to show me how to hit different shots.

Frank Ford Sr., another member at the Country Club of Charleston, is widely considered one of the best amateur players from the state. He took an interest in my game and was always open to playing golf with me and answering my questions. He and Mr. Picard were great role models, especially the way they handled themselves on and off the course.

At a young age, I had the good fortune to play Spartanburg Country Club, home to Betsy Rawls, an LPGA and World Golf Hall of Fame member. She was one of the best to ever play professionally, winning fifty-five LPGA tournaments, including eight major championships. Although her family moved from South Carolina to Texas when she was twelve, we formed a friendship after her great playing career. As the head rules official on the LPGA Tour and later as the tournament director of the McDonald's LPGA Championship, Betsy had an enormous impact on my career and always exemplified the attributes of a champion and a great woman.

I stayed in South Carolina for my college career, choosing Furman University over two Florida colleges. Toward the end of my high school years and during my Furman golf tenure, my game blossomed and I began to branch out of state to compete in national tournaments. This is when the authors, Tommy Braswell and Bob Gillespie, had the pleasure (or sometimes displeasure) of covering me for the *Post and Courier* and *The State* newspapers, respectively. It was a difficult job at times since my mood afterward often mirrored how I played that day. I have tremendous respect for both Tommy and Bob and consider them friends. I am thrilled they have collaborated to use their vast knowledge of golf in South Carolina to write this history.

—Beth Daniel, LPGA Tour, World Golf Hall of Fame member

GOLF COMES TO
SOUTH CAROLINA

C hances are pretty good most golfers have never heard of William Wallace. But it's very likely the prosperous Charleston merchant was one of the first people to play golf in America.

The arrival of ships crossing the Atlantic was cause for celebration in the 1700s. The cargo included textiles, manufactured goods and other luxuries not readily available in the New World. But the 1739 arrival of one particular merchant ship from Scotland's Port of Leith brought something else.

It brought golf to the New World.

A document discovered in 2014 in the archives of the University of Edinburgh (Scotland), dated June 29, 1739, shows that golf clubs were sent from Andrew Wallace of Edinburgh to his brother William Wallace of Charleston at a cost of one pound, eighteen shillings.

A few years later, more golf clubs arrived. "Two boxes of eight dozen golf clubs and three gross of balls"—96 clubs and 432 balls—were shipped aboard the *Magdalen* on May 12, 1743, to Scottish immigrant David Deas, arriving in Charleston in August 1743. Atlantic voyages during that time usually took anywhere from six weeks to three months.

An illustration of what the arrival of golf clubs in Charleston might have looked like appeared in a painting by Charleston artist Carol Ezell-Gilson, which was done as an homage to golf in America for the Charleston Golf Expo, an event held in 1990 as the area prepared for the 1991 Ryder Cup Matches that would be held the next year at Kiawah Island. Ezell-Gilson's stunning painting shows wooden-shafted golf clubs in an open crate on a ship in Charleston Harbor. The bill of lading is attached to the crate.

Charleston artist Carol Ezell-Gilson was commissioned to do a painting of golf clubs being shipped from Scotland to Charleston in 1743 for the 1990 Charleston Golf Expo. *Courtesy of Carol Ezell-Gilson.*

Golf would have been a luxury in the 1700s. Clubs were handmade and very expensive, and the ball—a "feathery," so named because it consisted of a stitched leather sphere stuffed with goose feathers—was almost as expensive as a club. Featheries were painted white, making them easier to find on the green.

Other documentation of golf being played in Charleston in the 1700s has been uncovered by researchers. In the book *The Carolina Lowcountry: Birthplace of American Golf 1786*, published in 1980, authors Charles Price and George C. Rogers Jr. wrote that Charleston merchant Andrew Johnston brought golf clubs and balls back from a 1759 trip to Scotland.

The modern game of golf, it is generally accepted, originated in Scotland and dates to the 1400s when King James II banned "ye golf" in an attempt to encourage archery practice. Musselburgh Links in Scotland bills itself as

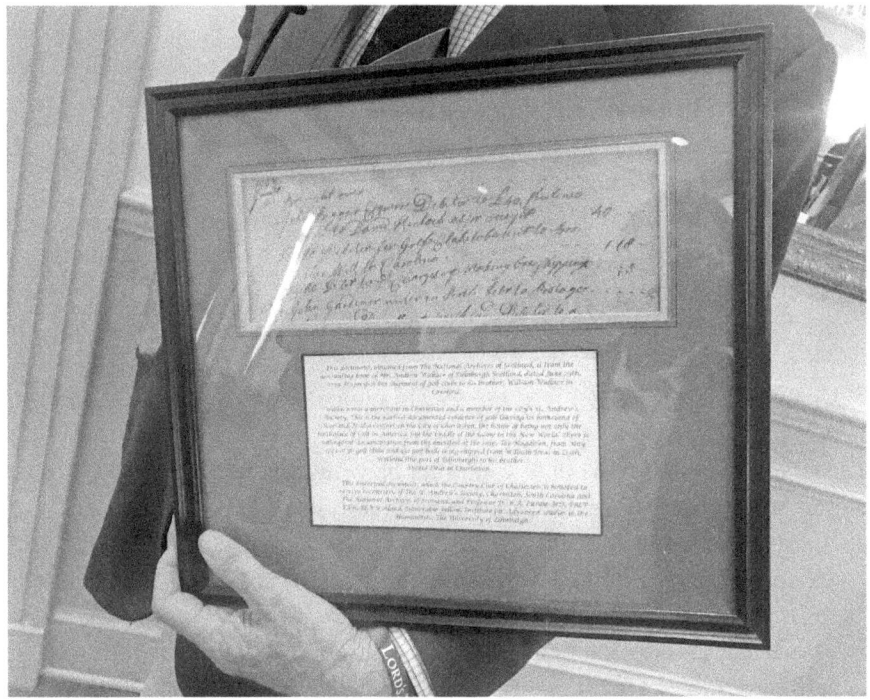

A close-up view of a copy of a 1739 bill of lading and translation showing golf clubs being shipped from Scotland to Charleston. *Photo by Tommy Braswell.*

the world's oldest golf course, dating at least to 1672, and was located in the middle of a horse racing track. It is perhaps a mile from Port of Leith, where both shipments would have made their departure to bring golf to Charleston and to America.

There was a five-hole course in Leith, the historical home of the Honourable Company of Edinburgh Golfers, which dates to the 1500s. A plaque at the course notes that each of the five holes measured over four hundred yards long, and that in 1744 the first official rules were drawn up for a tournament on Leith Links.

RULES OF GOLF

These thirteen rules formed the basis for the rules of golf adopted by the Royal and Ancient Golf Club of St. Andrews:

1. You must Tee your Ball, within a Club's length of the Hole.
2. Your Tee must be upon the Ground.
3. You are not to change the Ball which you Strike off the Tee.
4. You are not to remove Stones, Bones or any Break Club, for the sake of playing your Ball, Except upon the fair Green, & that only within a Club's length of your Ball.
5. If your Ball come among Water, or any wattery filth, you are at liberty to take out your Ball & bringing it behind the hazard and Teeing it, you may play it with any Club and allow your Adversary a Stroke for so getting out your Ball.
6. If your Balls be found anywhere touching one another, You are to lift the first Ball, till you play the last.
7. At Holling, you are to play your Ball honestly for the Hole, and, not to play upon your Adversary's Ball, not lying in your way to the Hole.
8. If you should lose your Ball, by its being taken up, or any other way, you are to go back to the Spot, where you struck last, & drop another Ball, And allow your adversary a Stroke for the misfortune.
9. No man at Holling his Ball, is to be allowed, to mark his way to the Hole with his Club or any thing else.
10. If a Ball be stopp'd by any person, Horse, Dog, or any thing else, The Ball so stop'd must be play'd where it lyes.
11. If you draw your Club in order to Strike & proceed so far in the Stroke, as to be bringing down your Club; If then, your Club shall break, in any way, it is to be Accounted a Stroke.
12. He whose Ball lyes farthest from the Hole is obliged to play first.
13. Neither Trench, Ditch or Dyke, made for the preservation of the Links, nor the Scholar's Holes or the Soldier's Lines, shall be accounted a Hazard; But the Ball is to be taken out Teed and played with any Iron Club.

Scottish historian and author Dr. David Purdie said he learned of the 1739 document through a phone call. "Because I was involved in checking out the 1743 shipment, the researcher at the National Archives of Scotland called and said, 'You have to come down here. We have seen something you will be interested in,'" said Purdie, a Fellow of the Institute for Advanced Studies in the Humanities at the University of Edinburgh.

"The cradle of golf in America is (Charleston)," Purdie said. "The oldest continuous golf club in America is the Saint Andrew's Golf Club in Yonkers, N.Y. They were founded in 1888. But 150 years earlier, this was going on in Charleston."

Dr. David Purdie of Scotland with a copy and translation of a 1739 bill of lading showing golf clubs being shipped from Scotland to Charleston. *Photo by Tommy Braswell.*

The Scottish immigrants played at Harleston Green on the Charleston peninsula, a public park that was located in an area just south of the College of Charleston's present-day Addlestone Library, at the corner of present-day Pitt and Bull Streets.

"Green, in those days, was the original word for a course," Purdie said. "They would meet in the coffee house and then go play golf. I imagine a

Scottish businessman writes home to his brother and says there is land here for golf, send clubs, send balls. There's a business opportunity here, perhaps the formation of a club."

THE EARLY GAME

During those early days of golf in America, there were no formal tees or greens. A finder, an early version of what today is known as a forecaddie, would go ahead and find the hole, then marked it "with a gull's feather or simply by pointing to it," according to Price and Rogers. There was no set number of holes. Once you completed a hole you would tee off at a distance of two club lengths from the just completed hole. The finders also had another important task: going ahead and warning others enjoying the park in other ways—horse races, cattle shows or folks simply enjoying the sunshine—that golfers were approaching.

Caddies would carry an assortment of clubs for the golfer. Golf clubs were made of wood, hickory shafts with hazel heads. Golfers started with what was known as a play club, then continued using spoons, clubs with various lofts. Metal club heads were used only to extricate balls from ruts ("play it as it lies") because the golf balls were easily damaged.

In 1786, it was at Harleston Green that the South Carolina Golf Club, the first golf club in America, was founded. Charleston's *City Gazette* published an advertisement in 1788 calling on club members to meet at Harleston Green and then adjourn to William's Coffee House. In 1795, a clubhouse was mentioned at Harleston Green. Notices continued to appear in the *City Gazette*. But evidence of the South Carolina Golf Club disappeared from historical records after 1799. And Harleston Green, once an open space like a park, was being squeezed out by large mansions being built.

Golf pretty much disappeared from South Carolina history books until the 1890s. There is evidence that a golf course existed at Pine Forest Inn, a premier resort in Summerville that opened in 1889. Golf was played upstate in Aiken, Columbia and Greenville and Asheville, Linville and Pinehurst, North Carolina.

But there apparently was not a golf course in Charleston until Mildred R. Marshall, whose husband was an editor of the *Evening Post*, wrote an editorial in 1895 supporting the idea.

GOLF CLUB.

THE Anniverſary of the South Carolina Golf Club, will be held on Wedneſday the 29th inſtant, at Williams's coffee houſe, where the members are requeſted to attend at two o'clock, to tranſact the buſineſs of club before dinner, which will be on table at three.

September 24. 3t fmw

The Anniversary of South Carolina Golf Club
September 29, 1790

The South Carolina Golf Club posted a notice of an anniversary meeting in the Charleston newspaper in 1790. *Courtesy of the Country Club of Charleston.*

A gift to the City of Charleston helped finance the purchase of property in the country in what is present-day North Charleston. The Olmsted Brothers, the country's preeminent landscape architecture firm (think New York's Central Park and Biltmore Estate in Asheville), were hired to do the planning. A golf course was suggested, and on October 1, 1900, the Chicora Golf Club was formed in a meeting at Carolina Yacht Club.

Less than a year later, the U.S. Navy made the city an offer it couldn't turn down for the Chicora property. Chicora Golf Club had to look for a new site, although navy personnel continued to play on the nine-hole layout until the base was closed in 1996.

The membership of what would become the Country Club of Charleston found land just south of Chicora Park, purchased Belvidere Plantation and leased additional land so they could build an eighteen-hole course. In the 1920s, their lease expired and they were once again forced to move, ending up at their present-day site on James Island.

Saint Andrew's Golf Club in Yonkers, New York—home of the Apple Tree Gang—may be the oldest continuously operating golf club in the United States, dating to 1888. But the truth is that golf in America had its beginnings in Charleston nearly 150 years earlier.

HISTORIC AIKEN
AND PALMETTO GOLF CLUB

As Tom Moore is head professional emeritus at Palmetto Golf Club in Aiken, one of his greatest delights is showing visitors the club's memorabilia-filled room adjacent to Palmetto's small pro shop. Moore, the historic club's head pro for thirty years before "retiring" in 2012, knows everything about everything there, which makes him a historical treasure in his own right.

Most importantly, he serves as caretaker of Palmetto's treasure trove of old photos, paintings, golf clubs and balls, some dating back more than a century. He also tells stories about the course's history—and Moore has a lot of stories.

Take the ties between Palmetto and nearby Augusta National. In 1932, when Dr. Alister Mackenzie was building Bobby Jones's future home of the Masters, several members asked Mackenzie to travel twenty miles east to visit Palmetto, part of the Aiken-Augusta golf scene since 1892.

"They brought Mackenzie over to install grass greens," Moore said. The Scottish-born architect replaced the old sand greens, bringing Palmetto into the twentieth century. Earlier, another Golden Age architect, Donald Ross, helped install the first irrigation system in 1928, according to club records.

Moore can point out sketches of the course's original 1892 footprint, beginning with four holes laid out by founder Thomas Hitchcock, a wealthy Long Island, New York sportsman. The course was expanded to eighteen holes in 1895 by Herbert Leeds, who also built Boston's Myopia Hunt Club. Stanford White, architect of the famed Shinnecock Hills clubhouse

Palmetto Golf Club's Tom Moore, now pro emeritus, stands before a portrait of himself in the Palmetto pro shop. *Photo by Bob Gillespie.*

on Long Island, designed Palmetto's smaller and simpler clubhouse, completed in 1902.

A glass case and other displays hold vintage golf clubs and balls, including gutta-percha balls found on the course. One ancient ball, Moore said, was displayed at the club until he discovered that it was old enough to be "probably priceless." It now resides "in a vault."

At Palmetto, history is around every corner. Aiken's golf roots date to the late 1800s, when wealthy New Yorkers and others wintered in the area, arriving by train to enjoy horse racing, warm temperatures, southern hospitality—and golf.

Palmetto is South Carolina's oldest course, but not two miles away is Aiken Golf Club, founded in 1912 as Highland Park Golf Club, an amenity to the Highland Park Hotel. If Palmetto's history is of the rich and famous, Aiken Golf Club is, and was, an everyman's course: a short but strategic design where many locals learned the game.

Aiken Golf Club also has links to Donald Ross (a Ross protégé, John Inglis, laid out the course) and has its own claims to historic significance. An early bastion of the women's game, Aiken was the first course in America to establish women's tees.

In all, more than a dozen golf courses dot the Aiken landscape. At the opposite end of the historic spectrum from Palmetto and Aiken is a modern monument to one man's love of the game: Sage Valley Golf Club, which opened on September 11, 2001, as terrorists were flying jetliners into the World Trade Center.

The realization of a dream by real estate mogul Weldon Wyatt, Sage Valley has been called "Augusta National on steroids." With its gated access, expansive "cottages," white jumpsuit–clad caddies and a lighted, nine-hole par-3 course, Sage Valley bills itself, in Wyatt's words, as "golf as it should be."

Aiken golf started more than a century ago and continues today. Palmetto, Aiken and Sage Valley together best represent the area's history and its future.

SOUTH CAROLINA'S OLDEST CLUB

At Palmetto Golf Club, Tom Moore's stories are stimulated by a collection of watercolor portraits of famous Palmetto visitors: Presidents William Howard Taft and Dwight D. Eisenhower, entertainers Fred Astaire and

Bing Crosby and some of golf's greatest names: Harry Vardon, Ben Hogan, Byron Nelson, Sam Snead and two-time Masters champion Ben Crenshaw.

"Ike [Eisenhower, a 1960s regular at Augusta National] played Palmetto because his chief of staff had a house near the course," Moore said. "[William Howard] Taft once called to see about playing here. The caddie master told him, 'Sorry, we have no member here named Taft,' and hung up on the president of the United States."

Two other presidents can trace links to Palmetto. George Herbert Walker, a past club president, was grandfather and great-grandfather to Bush 41 and Bush 43 and was "father" of the Walker Cup amateur competition.

Vardon, the legendary British Open champion, played Palmetto in 1900 and, according to Moore, "wanted to go inside the clubhouse, but he wasn't allowed because, as a professional, he wasn't considered a 'gentleman.'" Vardon, a chain smoker, even had to get a club dispensation to smoke while playing.

Hogan, Snead and Nelson played in the club's annual Devereux Milburn Pro-Am (1945–53; Nelson won the inaugural) to prep for the Masters but

The par-4 fourth tee at Palmetto, one of three consecutive holes called "the best series of par-4s anywhere" by Ben Hogan. *Photo by Bob Gillespie.*

also because its first-place prize of $10,000 was then more than the winner of the Masters earned. Crenshaw, who first visited Palmetto in 1984, called it the perfect tune-up for the Masters—and then won the first of his two green jackets that year.

Obviously, Palmetto Golf Club, the nation's second-oldest club on its original site (after Chicago Golf Club), has generated a lot of lore. Short by modern standards at 6,700 yards and par-71, the course's small, subtly undulating greens, dramatic elevation changes and "diabolical" bunkers make it a challenge to modern players. Hogan once dubbed the course's third, fourth and fifth holes "the best back-to-back par-4s I ever played."

Palmetto has what is believed to be the oldest U.S. Golf Association membership certificate in existence (dated January 22, 1896). But that doesn't mean time has stood still at the club. In 1984, Moore oversaw an irrigation upgrade, and renovations took place in 1996 and in 2005, the latter by architect Tom Doak, who specializes in updating Mackenzie courses. In 2007, architect Gil Hanse used aerial photos from the 1930s to restore the original dimensions of the greens, bunkers and sandy scrub border areas.

"[Palmetto] is such a special design with great details in the green complexes, holes that fit the topography perfectly, wonderful vegetation, and it is such a great walking course," Hanse told *Links* magazine. "It's one of the unquestioned hidden gems in American golf, and I always try to get friends and fans of golf course architecture to go and see the course."

Besides Doak and Hanse, South Carolina native and architect Bobby Weed and his mentor, Pete Dye (with his late wife, Alice, also an architect), made the trek to see the course. "Every major architectural firm sends their young guys here to play and look at it," Moore said. "Classic designs never go out of style, and most modern architects copy the old styles."

Palmetto is private, but each year during the Masters, outsiders play at a cost comparable to what many Masters visitors pay for a couple of hotel nights. The club's income from that week means Palmetto members rarely face assessments.

In 2017, the course celebrated its 125th anniversary, and the land on which it is located is owned by the nonprofit Whitney Trust, from which the club leases it for a minimal annual fee. The lease's expiration date is 2080; the next time it comes up for renewal, Palmetto will be planning its 200th birthday celebration. Now that's history.

HIGHLAND PARK, AIKEN GOLF CLUB AND THE MCNAIRS

A couple of blocks from Aiken's downtown, Jim McNair Jr. also owns golf history. Just twenty years younger than storied Palmetto, Aiken Golf Club is where one can find the James McNair Sr. Memorial Putting Course, a nine-hole layout covering roughly a quarter acre just beneath the course's modest clubhouse. McNair Jr. built it around 2011 as a tribute to his father, whose willingness to battle city hall preserved one of South Carolina's golf gems.

"Dad was a great putter," he said, "and after we demolished and removed the swimming pool in 2006, I researched the putting course at St. Andrews" in Scotland. "I realized, 'Wow, I could design a nine-hole putting course right here.'"

The project took McNair four years and cost $50,000 to $60,000, but it was a labor of love. "It was fun to design, and I made sure it had every kind of putt—uphill, downhill," and even a sand trap. "It was something to complement the golf course."

The elder McNair lived long enough to see his son restore the Golden Age course that offers players a vivid step back into golf's—and Aiken's—past.

Aiken Golf Club was born in 1912 as Highland Park Golf Club, part of the nearby luxury Highland Park Hotel. A group of Aiken businessmen, working with the Richard Tufts family of Pinehurst, North Carolina fame,

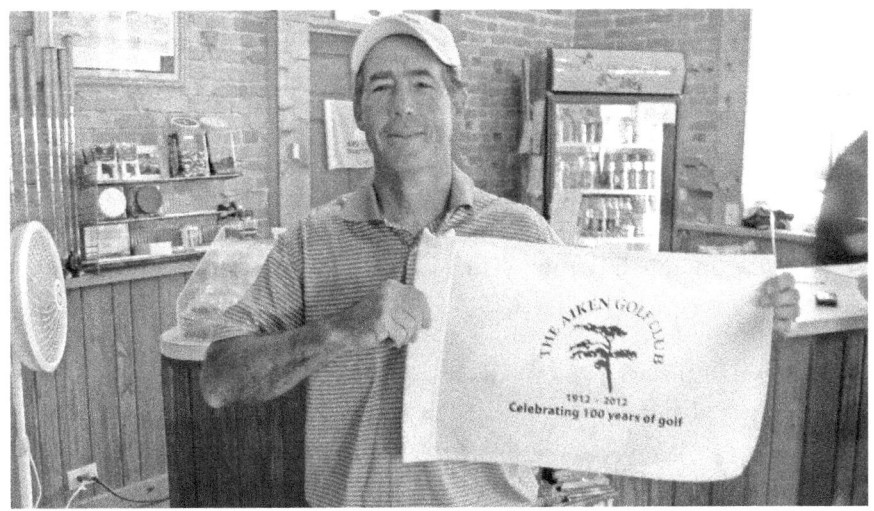

Aiken Golf Club's second-generation owner Jim McNair Jr. holds the club's centennial-celebrating flag. *Photo by Bob Gillespie.*

wanted to create a chain of resort properties stretching from Augusta into North Carolina and beyond.

Aiken Golf Club's 110-acre site, situated between railroad tracks and several neighborhoods, resembles the famed Pinehurst No. 2 course, probably because Pinehurst architect Donald Ross reputedly laid out Aiken's first eleven holes in 1902. (The authoritative Donald Ross Society denies any ties.) A Ross protégé, John R. Inglis—a founding member of the PGA of America—is credited with completing the course and becoming its head professional in 1915.

While Palmetto was a destination for golf's legends circa 1930–1955, Highland Park was visited by U.S. Open champions Julius Boros (who won his first professional paycheck there), Chick Evans, the Turnesa brothers and P.J. Boatwright. But women's players gave Aiken its historic prominence. In 1916, May "Queenie" Dunn, America's first woman professional, recommended to Inglis that Highland Park create "special tees for ladies," making the course the first in the United States to have women's tees.

Later, from 1937 to 1939, Highland Park hosted the Women's Invitational Tournament, drawing such stars as Babe Zaharias, Patty Berg and Helen Detwiler—an event that presaged the start of the current LPGA Tour. McNair displays a 1984 *Golf Journal* article about the role of Aiken's own Mrs. A.J. Sweeney, an avid golfer and wife of the Highland Park Hotel's manager, who turned Dunn's suggestion of women's tees into action.

The Great Depression hit Aiken hard; the Highland Park Hotel was torn down in 1941 after the city took over the struggling club in 1939, changing its name to Aiken Municipal Golf Club. In 1959, Jim McNair Sr. bought the barebones club (and renamed it Highland Park Golf Club), but the city retained rights to buy it back at any time for $40,000.

"Dad didn't mind at first," Jim Jr. said, "because the taxes were based on that $40,000." But in the 1980s, tax bills claiming a $500,000 property forced the family to sue the county and state. In 1986, the city rescinded its buy-back option, and improvements began. For roughly a decade, most work was done by McNair Jr., fellow Clemson alum Brent McGee and a few volunteers.

Finally, a frustrated Jim Jr. (who'd taken over the club in 1987) told his father, "We either have to renovate or the club is not going to survive." Starting in 1997, the family sank roughly $1 million into improvements, completing the job in the fall of 1999.

Today, Aiken Golf Club is like a time machine journey to golf's Golden Age. Surrounded by tall pines and little rough, the course—just 5,734 yards

The view from the tee of the par-5, downhill second hole at Aiken Golf Club. *Photo by Bob Gillespie.*

at its longest—still challenges players. The 185-yard, uphill par-3 ninth hole requires a long, accurate tee shot to a severe back-to-front green fronted by a tree on the left and a bunker on the right. The 183-yard sixteenth hole drops about 80 feet to its deep but narrow green, with bunkers guarding either side.

In 2019, the South Carolina Golf Course Ratings Panel named Aiken Golf Club "South Carolina's Best Kept Secret." In 2011, *Sports Illustrated* writer Michael Bamberger praised the course's old-school charms, writing that "the overall experience was pure joy."

Jim McNair Jr. still remembers telling his late father in the mid-1990s, "I'm not going to let this golf course die under my watch." In 2001, one renovation was completed just two months before McNair Sr. passed away, and the two men rode the golf course together, silently admiring their reclamation.

For the McNairs and hundreds of locals who learned the game there, Aiken Golf Club is more than a piece of golf history. It's a family affair.

BORN ON 9/11: SAGE VALLEY GOLF CLUB

Sage Valley, six miles west of Aiken near Graniteville, is about a century younger than either Palmetto or Aiken Golf Club, but its official opening date is also historic: September 11, 2001, the day terrorists attacked the World Trade Center in New York.

Tom Wyatt, son of club founder Weldon Wyatt and now Sage Valley's president, was a college student at Furman University in 2001. He'd planned to drive down for the ceremonial first round but wondered if he should after the attacks. "I'd rather have you here today," the elder Wyatt told his son. "I wasn't going to let them [terrorists] spoil my day."

"Dad and I hit the first tee shots at the same time," Tom Wyatt said, "and I shot 68, a round I'll never forget."

Today, *Golf Digest* ranks the Tom Fazio–designed Sage Valley course, measuring 7,245 yards at its longest, fourth among South Carolina courses. In 2019, Golfweek rated Sage Valley 100th in its Top 200 Modern Designs.

With an opulent clubhouse, plush "cottages," white jumpsuit–clad caddies and pristine fairways and greens, Sage Valley is often compared to nearby

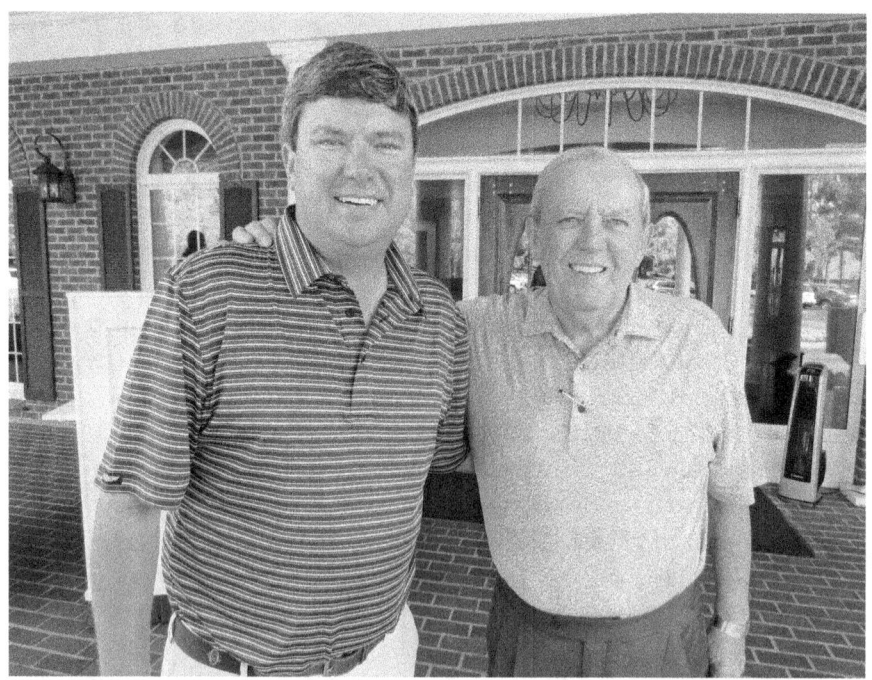

Sage Valley founder Weldon Wyatt (*right*) with son Tom Wyatt. *Photo by Bob Gillespie.*

Augusta National, leading to speculation that Weldon Wyatt built his course to be his personal Augusta National, of which he is not a member.

"That's not an unfair statement," he said. He admits many of Sage Valley's amenities were "stolen from somewhere else." Among Wyatt's inspirations were such famed courses as Pine Valley, Shinnecock Hills, Seminole—and yes, Augusta National.

"We didn't try to recreate Augusta National; you can't do that, it's impossible," the elder Wyatt said. "But everyone can't be a member of Augusta National. I'm fortunate enough to have a place like Sage Valley."

Since its opening, said club general manager Dave Christensen, Sage Valley has doubled its number of cottages (to twenty-one from ten); redone its locker room, grille and golf shop; and had Fazio perform upgrades on the seventeenth and eighteenth holes. The seventeenth became the course's No. 1 handicap hole by bringing a pond into play and adding length, while the eighteenth had a new tee added and new flag locations specifically for the club's annual Junior Invitational, rated in 2009 as the No. 1 junior event in the world by *Golf Digest*.

When the course opened, three extra "dormie" (playoff) holes, two par-4s and a par-3, were available for finishing tied matches after eighteen holes—a concept Weldon Wyatt copied from Double Eagle, an exclusive Ohio course. Replacing those holes on the same tract of land is a nine-hole, fully lighted par-3 course.

Augusta National, of course, also has its own (unlighted) nine-hole par-3 course. In Sage Valley's case, though, players can enjoy pre- and post-dinner competitions or just relax after a day of golf. The adjacent Retreat is a smaller dining and lounging facility away from the main clubhouse.

How did such opulence arrive in the Aiken area? Wyatt, who went into commercial real estate in 1973, later pitched an up-and-coming company—Walmart—and began developing properties for the chain's stores nationwide. Wyatt Development Co. Inc. created more than eighty retail projects encompassing some fourteen million square feet and made Wyatt and his brother, Joe, wealthy.

Savings and loan crashes took a toll in 1990, and Wyatt said he "woke up and was about $30-something million in the hole." But by 2000, he emerged perhaps even wealthier and decided to create his dream golf course.

He and his family brought large tracts of land—480 acres for the course alone—and hired Fazio, one of golf's renowned modern architects, to build it. "I looked at the economics: what are you trying to do, how many members [Sage Valley now has about three hundred], are you building

houses [for real estate, Wyatt wasn't], is it logical?" Fazio recalled in 2005. "Weldon told me, 'That's my side, I'll take care of that.' I never dreamed we'd build what we did"—what Fazio said was in the top 5 percent of courses he had created.

The annual Junior Invitational continues to draw to Sage Valley the best young players, including Justin Thomas (who played in the first invitational), Cameron Champ, Matthew Wolfe and Brandon Stone—all PGA Tour or European pros now. Tiger Woods and Rory McElroy have appeared to speak to contestants.

"A member from Augusta wanted us to do a fundraiser for the First Tee, but Dad said instead of a one-day thing, let's do our own junior event," Tom Wyatt said. Proceeds fund junior programs in Augusta and Aiken, as well as pediatric research.

For all its success, Sage Valley has never been rated one of South Carolina's most testing designs, but the Wyatts are fine with that. "We're not trying to market our golf course," Weldon Wyatt said. "In my mind, I know what Sage is. I'm not that concerned if we're recognized."

Recognition, the Wyatts said, is more about members' satisfaction with a day walking Sage Valley accompanied by a knowledgeable caddie, enjoying exquisite conditioning and the atmosphere of golf as it should be. "Weldon is proud to be compared to Augusta National," Dave Christensen said. "If you were to build a high-end watch, after all, the benchmark is Rolex."

THE FORDS

Charleston Golf Royalty

About the time Henry Ford was beginning to make his name in the fledgling automobile industry, another Ford was taking steps that would make him and succeeding generations household names in South Carolina golf.

The Ford name resonates far and wide in Palmetto State golf and beyond. Five generations of Fords have won on the local and state levels and competed on the national and international levels. They've also served the game as well, working as officers and committee members on the state, regional and national levels.

The Ford family golf universe centers on Frank Ford Sr. (1904–2004), whose collection of silver and crystal would have been the envy of any who have played the game. Hundreds and hundreds of trophies filled the shelves and walls of his Charleston home, and his offspring and their offspring also won their fair share of golfing hardware. His mother, Anne "Sissie" Gaillard Hanahan Ford (1880–1978), was a Country Club of Charleston women's club champion.

Frank Ford Sr. and his wife, Elizabeth "Betsy" Coker Ford (1906–1998), also the winner of multiple titles, had three sons: Frank Jr. (1930–1974), whose life was tragically cut short in an airline crash; Billy (1934–2005), who played at the University of North Carolina and won multiple titles; and Tommy (1944–), who won numerous club and regional titles.

The oldest son of Frank Jr. and his wife, Sarah (also a champion golfer), Frank III (1952–), captained the Furman University golf team and came into

Frank Ford Sr. was one of the state's top amateur golfers for many years. *Courtesy of the Ford family.*

his own as a mid-amateur, surpassing granddaddy's four Azalea Invitational titles by winning six and continued to star as a senior. His sister Anne won multiple women's titles.

Two of Frank III's and his wife Frances's children, Cordes (1976–) and Meghan Ford Norvell (1980–), also made contributions to the Ford treasure of golf trophies with Meghan winning a junior club championship while Cordes won the 1996 Carolinas Amateur and two Charleston City Amateurs. Altogether, the Fords won the city tournament twenty times. Frank Sr. had eleven wins, his brother John Drayton Ford won one time, Frank III was a City Amateur winner six times and Cordes had two wins.

Just as important as their accomplishments on the course was their service to the game. Most of them have served as board members and tournament directors for various organizations.

THE FORD PATRIARCH: FRANK FORD SR.

Frank C. Ford Sr. was born in 1904 in Summerville, South Carolina, one of three children of Frank C. Ford and Anne "Sissie" Gaillard Hanahan Ford. His father never played golf, but young Frank was introduced to the game by his mother and Wilkie Gleaton, an African American who worked as a yardman for the Fords and also caddied at Summerville Country Club. Ford recalled in a 1990 interview that Gleaton would bring him golf balls and helped teach him some basics of the game.

"We'd dig holes in the backyard—we had about twelve or fourteen acres—and when he wasn't working he'd be chipping. That's where I learned the fundamentals of golf," Ford said.

His first golf club was a mashie, comparable to a 5-iron.

When his father died in 1918, the Fords moved to Charleston. That summer, his uncle, William H. Ford, who lived in Canada, invited the family up to spend the summer, and that's where Frank played his first official round of golf, shooting a 126 at Beaconsfield Golf Club. His first golf trophy came two years later in 1920 when he won the fifth flight in a tournament at Asheville (NC) Country Club.

Frank's first international competition came in 1923 while attending Sewanee (TN) Military Academy when his uncle prevailed on him to play in the Canadian Amateur. Frank lost in the first round of his thirty-six-hole match, sending him into the consolation bracket, which he won with a birdie

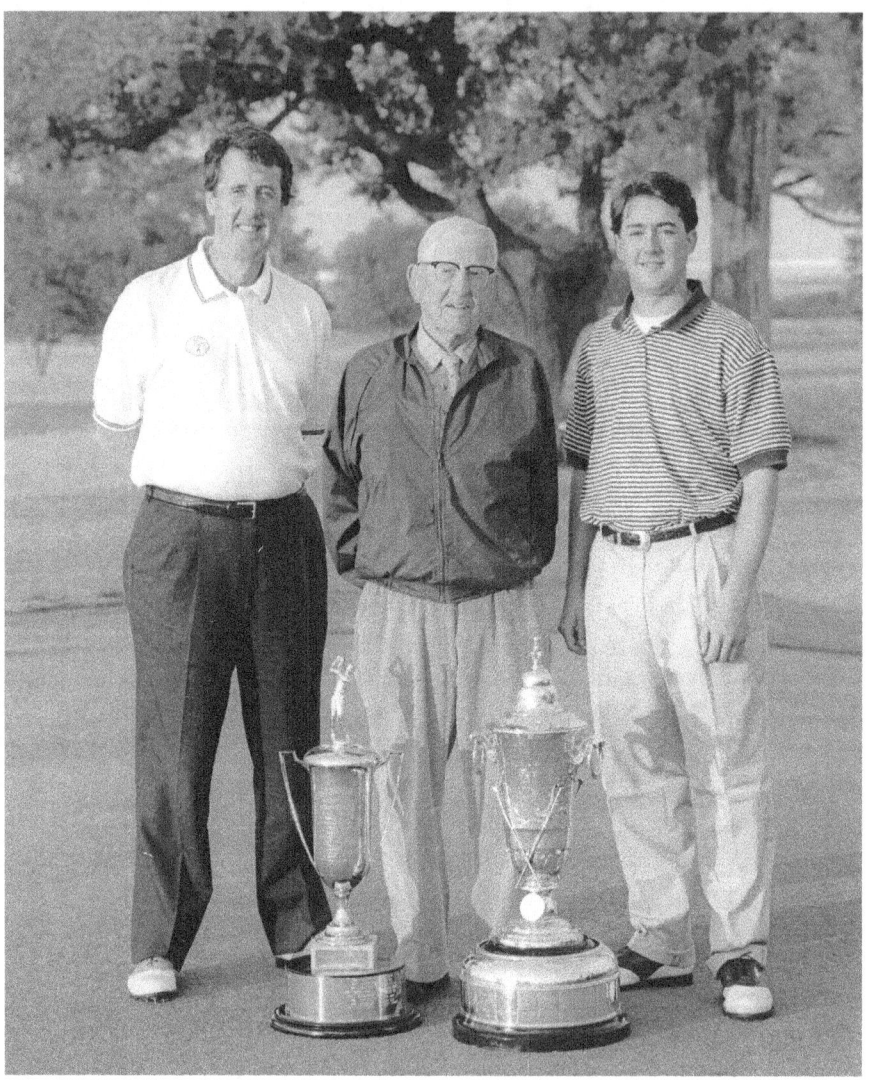

Frank Ford III (*left*) and his son Cordes Ford flank Frank Ford Sr. and show off their trophies in 1996 after Frank III won the South Carolina Amateur and Cordes won the Carolinas Amateur. *Courtesy of the Ford family.*

on the nineteenth hole. Later that year, he finished runner-up in the club championship at Belvidere, the forerunner of the present-day Country Club of Charleston. An article in the *Charleston News and Courier* touted the future of this teenage prodigy after he shot a 68 and helped lead a Charleston team to a win over Savannah.

While there was obvious talent, his game improved through competition and friendship. In 1925, Donald Vinton came from Massachusetts to become the winter professional at the Country Club of Charleston. Vinton brought with him as an assistant a talented teen, Henry Picard, who would go on to win the Masters in 1938 and the PGA Championship in 1939 and embark on a career that would land him in the World Golf Hall of Fame. Ford and Picard became fast friends and competitors. They teamed for several four-ball victories.

Ford was selected for membership in three halls of fame: the South Carolina Golf Hall of Fame, the Carolinas Golf Hall of Fame and the South Carolina Athletic Hall of Fame. In addition to his eleven city championships, Ford won the South Carolina Amateur seven times and finished second three more times. He won the prestigious Azalea Invitational four times and was the Country Club of Charleston club champion eighteen times.

Ford tried the U.S. Amateur only once, finishing as medalist at the sectional qualifier in 1934. His record was all the more remarkable when you consider that he pretty much put his clubs away every August when deer season opened in South Carolina, not to pick them up again until the new year began. And he was very passionate about the family concrete business, continuing to come into the office and make sales calls when he was in his nineties. Ford died in 2004 at the age of one hundred.

"He was a very busy guy with a business, then his own enjoyment of hunting and then playing golf and I think it was kind of in that order," said his youngest son, Tommy. "Business was first, hunting arguably was second and golf, he was just blessed with a lot of natural talent. Golf sort of fit in around the hunting, which was mostly all fall."

"He liked to hunt, and he did all his good playing on half time," added his grandson and namesake, Frank Ford III. "He could have taken his game on the road if he wanted."

A prized family possession is a framed one-dollar silver certificate signed by Horton Smith, the first Masters champion, as payment to Ford for a golf wager. As the Country Club of Charleston's star golfer, he was invited to compete in the Tournament of the Gardens, a professional tournament held in the 1930s on his home course that drew players such as Walter Hagen, Craig Wood, Byron Nelson, Paul Runyon, Sam Snead and others.

"He played with Bobby Jones several times," said Frank Ford III. "Granddaddy had an uncle that lived in Atlanta who was a good friend of Mr. Jones. Every time he would go to Atlanta, his uncle would get him a game with Mr. Jones. He thought Mr. Jones hung the moon."

A photo that hangs prominently in the Country Club of Charleston clubhouse shows Ford and club pro Al Esposito with Picard and Ben Hogan who competed as a foursome in an exhibition match held in 1959. Hogan and Ford both shot 68s, Picard posted a 69 and Esposito shot 76. But it was a four-ball match, and Ford made an eagle-3 on the fifteenth hole to set up the win for him and Picard. Back problems plagued him as he got older, but Ford continued to play. He shot 45 for nine holes at age ninety but decided that was enough. "Two times 45 is 90 for eighteen holes and I don't like shooting 90," he said.

But he still loved being at the golf course, watching his descendants and others compete at the Azalea. He was talented with the sand wedge, and even when he had to get around in a walker Ford often would take players into a bunker for a sand lesson. Tommy Ford said it wasn't uncommon to accompany his father to the Masters and have someone like Byron Nelson invite them out from the gallery to the fairway to talk during a practice round.

A FAMILY OF PLAYERS

Ford's wife, Betsy, was a talented golfer in her own right, winning six Country Club of Charleston women's club championships and two women's City Amateurs. Of their three sons, Billy was considered the most talented, and his father took special interest in him, pushing him hard. At the University of North Carolina, Billy competed against the likes of Wake Forest star Arnold Palmer.

Billy's biggest victory was the Biltmore Forest Invitational, a prestigious amateur tournament in Asheville, North Carolina, and he also won three Country Club of Charleston club championships. Billy enjoyed life—"He was the cat's meow," Frank III said—and helped run the family concrete business.

Frank Jr. (1930) battled polio as a youngster but developed into a decent athlete who played football in high school and was a 4- or 5-handicap golfer at his best. "He just didn't get to play much. He had an early family and was pretty much running the concrete business and didn't have time to pursue it," Tommy Ford said of his oldest brother, who died in an airplane crash in 1974.

Tommy, ten years younger than Billy, didn't find his game until much later but excelled as a senior, winning seven Country Club of Charleston

A four-generation gathering of golfing Fords. *Courtesy of the Ford family.*

club championships, three senior club championships, three City Senior titles and a handful of statewide team events. He played college golf for The Citadel. In 2012, he qualified for the Azalea Invitational at the age of sixty-seven and played in the event for the sixth straight decade.

"I think my father spent every waking minute on the golf course with my middle brother, Billy, who was very good, a fabulous athlete. I felt kind of second fiddle, but I didn't lose any sleep over it," said Tommy, who eschewed the family business and became a commercial photographer.

"When I was in my thirties, well out of college and two years out of the service, I won a club championship. I thought that was the greatest thing in the world. I can still remember the feeling. It kind of got me playing more."

THE LINEAGE CONTINUES: FRANK FORD III

It is unfair to compare the accomplishments of generations. Suffice it to say that Frank Ford III built a legacy his grandfather took pride in, both as a player and for contributions to the game. But it wasn't an easy transition to

adulthood when his father, Frank Jr., died on September 11, 1974, just a few months after he graduated from Furman. Frank III had gone to work for his father in the family concrete business, but things weren't working out so he began looking elsewhere.

A friend recommended him for a job with the Carolinas Golf Association, where executive director Hale Van Hoy became like a second father. He worked there for several years before applying and being hired at the age of twenty-seven as executive director of the Georgia State Golf Association. He remained there until 1984, when he returned to Charleston and began a career as a financial advisor in the investment business.

"I never felt any pressure to perform," he said. "I just liked to play golf. I played all the sports growing up, football in the fall, basketball in winter and you had to run track if you played football. Then we'd go play some matches in June or July. I went to Furman with promise but no record. I learned to play golf at Furman, no doubt about it."

Working in the administrative side of golf didn't allow him to play as much as he would have liked, but it also exposed him to opportunities for giving back to golf. His contract with the Georgia State Golf Association allowed him to play in a few events, and in 1982 he returned to Charleston and won his first Azalea Invitational. His fourth Azalea win came in 1989, and his grandfather was there to congratulate him and say, "Now you can stop right there."

"He didn't want anybody to beat his record," Ford III laughed.

During an eight-year period in which only six Azaleas were played (the 1990 and 1991 tournaments were canceled while the club recovered from the devastating Hurricane Hugo), Ford won five times. His first came in 1982, and after returning to Charleston he won again in 1986, 1988, 1989, 1992 and 1993.

Ford has competed in U.S. Amateurs, British Amateurs, U.S. Mid-Amateurs and the U.S. Senior Open. Ford also has served as president of the Carolinas Golf Association, the South Carolina Golf Association and the South Carolina Golf Hall of Fame. It was through his connections that the Country Club of Charleston landed the 2013 U.S. Women's Amateur followed by the 2019 U.S. Women's Open.

Perhaps his proudest moment as a golfer and golfing father came in 1996 when he won the South Carolina Amateur and that same summer his son Cordes won the Carolinas Amateur.

Frank had qualified for the U.S. Amateur that year and was playing a practice round with Buddy Marucci, Danny Yates and Tiger Woods, who

Frank Ford Sr. and grandson Frank Ford III talking with Arnold Palmer at a reception for the American Society of Golf Course Architects meeting at the Country Club of Charleston. *Courtesy of the Ford family.*

would win his third straight U.S. Amateur that year. "I was on my phone the whole time trying to keep up with how Cordes was doing, and Tiger's mother would keep asking me about how my son was going," he recalled.

"My first ten years after college, I didn't play much golf. I played with my buddies on weekends, and a few tournaments here and there. I didn't qualify for my first U.S. Amateur until I was twenty-seven and I was already over the hill to be competitive.

"I was a true amateur golfer. Golf was good to me, and that's why I was motivated to give back through service to the game."

4

THE GRAND STRAND

Myrtle Beach

I n the beginning, there was Jimmy D'Angelo, a smooth-talking, sharp-dressing, engaging club professional from Philadelphia who in the 1950s came up with an idea of promoting golf in a then-obscure coastal region of South Carolina—you know it now as Myrtle Beach.

In the end, there was Mike Strantz, an artistic midwesterner whose visions of golf course architecture evolved from charcoal drawings of how he thought golf holes should look, and play, and whose two stunning creations helped turn the Grand Strand from a "value" (read: inexpensive) golf destination to one that also can lure players seeking Top 100 golf experiences and willing to pay for them.

In between, there is Myrtle Beach, the self-proclaimed "Golf Capital U.S.A."—a golf oasis stretching some fifty miles along the Atlantic Ocean and containing, at one time, more than one hundred golf courses. It's a place that people who love golf think of immediately when winter arrives, its temperate climates, beaches and other amenities beckoning the snow-bound players.

For sheer volume alone—roughly one of every four South Carolina courses is located there—Myrtle Beach is the state's golf mecca. From family vacations to buddy trips to bucket-list outings, the coastal areas of Georgetown and Horry Counties have been luring players for decades. But it wasn't always that way.

When the Ocean Forest Hotel, a towering Golden Age beachfront edifice, added the Ocean Forest Golf Course (now Pine Lakes Golf Club) to its

Portrait of Jimmy D'Angelo, from the
Dunes Golf & Beach Club archives.
Courtesy of Dennis Nicholl.

attractions in 1929, Myrtle Beach's golf lineup consisted of just the one
course. By 1948, with the addition of The Dunes Golf & Beach Club,
a private course allowing outside play to guests of certain hotels, the list
reached two. Myrtle Beach was a beachfront backwater of fewer than 3,500
residents but one that aspired to become something big.

D'Angelo, hired in 1937 as Ocean Forest's "winter golf professional,"
spent the next thirty years officially, and even after his retirement in 1968,
helping build Myrtle Beach's reputation as a prime golf destination, luring
millions of players year-round.

A former secretary of the PGA of America's Philadelphia-area section,
D'Angelo believed in the power of the press. "Back in 1954"—six years after
he'd become head pro at The Dunes—"nobody had ever heard of Myrtle
Beach," he told the *Myrtle Beach Sun News* in 1994 upon his induction into the
Carolinas Golf Hall of Fame.

"I invited every newspaperman in the country to come down here. I
kept writing all my golf-writing friends to come see us. I told them I needed
some help."

In 1953, *New York World Telegram* sportswriter Larry Robinson took
D'Angelo up on the offer. According to the *Sun News*, Robinson suggested
a testimonial dinner for The Dunes' architect Robert Trent Jones—then a

relative unknown but ultimately perhaps the world's most famous course designer—to be held the week before the Masters, luring writers to stop off en route to Augusta. Eight writers, including Pittsburgh's Bob Drum, a confidant of Arnold Palmer, attended the April 4, 1954 inaugural event.

"And they all went back and wrote about this great golf course and what a great time they had," D'Angelo said. The outing evolved into the annual weeklong Golf Writers Association of America (GWAA) championship, a tradition for more than fifty years—and one that generated plenty of publicity for Myrtle Beach.

Also in 1954, Time-Life publisher Henry Luce flew sixty-seven writers and editors to Myrtle Beach, meeting at Pine Lakes to create a new weekly sports magazine: *Sports Illustrated*. Today, photos of that meeting—along with a monument next to the clubhouse—commemorate that founding.

Until his death in May 2000 at age ninety, D'Angelo continued to help boost Myrtle Beach golf. He served as the first president of Myrtle Beach Golf Holiday (now Myrtle Beach Golf Tourism Solutions); others, notably Cecil Brandon, a businessman who conceived the golf-and-hotel packages concept, followed in D'Angelo's footsteps.

"Thanks to Golf Holiday, Cecil Brandon and people like that, we now have a twelve-month season due to golf," D'Angelo said in 1994. "I attribute the fast growth of this community"—the Myrtle Beach metro area population was nearly 450,000 in 2016—"to golf."

Something else changed the Myrtle Beach dynamic in 1994. That was the debut of Caledonia Golf & Fish Club in Pawleys Island, the first solo design by architect Mike Strantz after his apprenticeship under Tom Fazio. Four years later, Strantz added another highly rated course, True Blue Golf Club, to Myrtle Beach's lineup.

Strantz, a Mount Pleasant resident who died of throat cancer in 2005, was recognized in 2000 by *Golfweek* magazine as one of the top ten course architects of all time. In Myrtle Beach, he is known as the man who brought high-end golf to the Grand Strand.

Other area courses also helped that reputation. From 1997 to 1999, nearby Wachesaw East hosted the LPGA's City of Hope Myrtle Beach Classic, and the Fazio-designed TPC Myrtle Beach had a one-year run in 2000 as home to the PGA Senior Tour Championship, which had spent the previous six years at The Dunes Club.

D'Angelo and Strantz, and the courses they promoted or built, encompass the Myrtle Beach experience: from everyman golf to connoisseur golf and everything in between.

The Granddaddy: Pine Lakes Golf Club

Pine Lakes Golf Club is known as "The Granddaddy" for its status as Myrtle Beach's first course. There's plenty of history there, from the clubhouse designed in the 1920s by course architect Robert White—the first president of the PGA of America—with many of its original floors and fixtures, to photos of the *Sports Illustrated* founding, to the plaques outside the clubhouse honoring D'Angelo, Brandon and others members of the Myrtle Beach Golf Hall of Fame.

But Pine Lakes is no anachronism: it is now one of twenty-one courses that make up Founders Group International (FGI), the largest collection of golf facilities on the Grand Strand. Steve Mays, FGI's president, is proud to show off that history and talk about how his group took great pains to help preserve it.

Previous owners Burroughs & Chapin undertook a renovation of Pine Lakes in 2009, addressing the state of disrepair of the clubhouse, establishing the Hall of Fame and replacing two holes with new ones by architect Craig

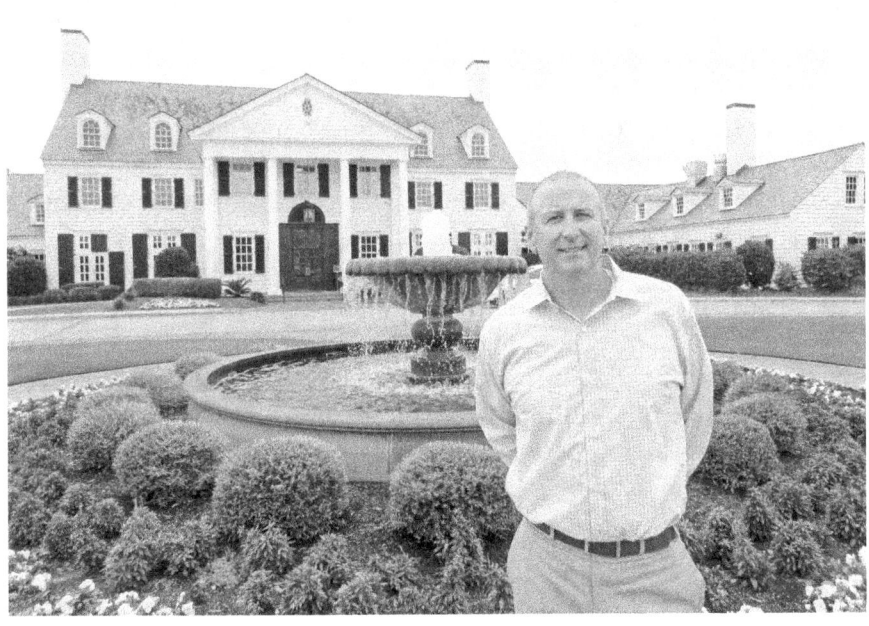

Founders Group president Steve Mays, standing in front of the historic Pine Lakes Country Club clubhouse. *Photo by Bob Gillespie.*

Schreiner. Mays, who helped oversee FGI's takeover in 2015 from then-owners National Golf Management, says those renovations and others since were needed to preserve the iconic golf course.

"This is one of the truly historic places in the area, one of few left from the Ocean Forest era, and FGI takes pride in that," Mays said. In 2015, the new owners began working to bring back some of the special amenities that had made the club stand out for decades.

"A lot of that was lost in transition," Mays said. Such traditions as staff members wearing kilts and knickers (which had gone away in 2007) and the on-course serving of clam chowder in cold months, mimosas in warm months—all those returned. "This was always a unique golf course with its original routing, but what was truly unique was the customer service and beyond. We wanted to bring all those aspects back."

Other renovations were less historic and more practical, such as replacing old grasses with salt-resistant paspalum, an innovation also used by Kiawah Island's Ocean Course. In 2020, FGI is considering removing the course's rough and going with one cut, à la the old Augusta National philosophy. "We want to make the golf experience here unique," Mays said.

Perhaps the most "unique" of Founders Group's innovations is its role in the annual PlayGolfMyrtleBeach.com World Amateur Handicap Championship, an event founded in 1984 to bring players from across the United States and some twenty foreign countries to Myrtle Beach during the weekend prior to Labor Day. The seventy-two-hole event, which groups entrants by their handicaps in nine divisions, is staged over sixty courses, including FGI members Grand Dunes Resort, Myrtle Beach National's three courses and Pawleys Plantation, among others.

Highlights of the annual event include a closing competition pitting all the handicap-division winners and access to the World's Largest 19th Hole, a nightly meet-and-greet with free food and drinks, held at Myrtle Beach's Convention Center. Celebrities who regularly appear include Golf Channel stars David Feherty and Brandel Chamblee, former GC regular Charlie Rymer and popular "people's golfer" John Daly.

The World Am was the brainchild of Paul Himmelsbach, owner of the area's Glens Group of courses, and Marvin Ornsdorf, a onetime sales representative for *Golf Digest*, which managed the tournament for original sponsor Rawlings and then for DuPont, the sponsor for twenty-plus years. The event's plan was "drawn up on cocktail napkins over drinks," Mays said, and brings in players during an otherwise slow tourism period.

Aerial view of Pine Lakes Golf Club, "The Granddaddy," which was the first golf course built in Myrtle Beach, in 1929. *Courtesy of Golf Tourism Solutions.*

"The first year, attendance was 683—not sure why I remember that number," Mays said, "and in 2001, it peaked at over 5,000. It's slowed some since, but still has 3,000 to 3,500 now."

At Pine Lakes, Mays said plans are in the works for Schreiner to return to work on the course's bunkers, creating Scottish-style "stacked" bunkers that now are more maintenance-friendly. Such touches will be done to enhance the course's historic aspects.

"Golfers don't realize all that [history] coming here sometimes… the clubhouse, the original architecture, the Hall of Fame," Mays said. "We want to remind people how significant this club is to Myrtle Beach. This is the crown jewel of our portfolio; we need to tell the story of Myrtle Beach."

ROBERT TRENT JONES'S BEST: THE DUNES GOLF & BEACH CLUB

If Pine Lakes is Myrtle Beach's "Granddaddy," The Dunes Club, a mere twenty years younger, has its own rich history. Foremost in its portfolio: its architect, the late Robert Trent Jones, whose son, Rees, has continued to serve as advisor for all changes and improvements.

Dennis Nicholl, The Dunes' head professional since 2007, tells how after World War II, a group of Myrtle Beach businessmen "held a now-famous meeting in 1947 at Chapin Cabin," an old fishing cabin where locals played poker, near what is now the course's eleventh tee. Shares of stock were issued, and D'Angelo was lured from Pine Lakes to be the club's head pro and marketer.

At the time, Robert Trent Jones also was building Atlanta's Peachtree Golf Club, and The Dunes has in its considerable archives—like Pine Lakes, the hallways are a virtual museum of club and area lore—letters between members and Jones, including tales of train journeys and a building process that took until 1950, using the land's natural contours since "they only had one tractor," Nicholl said.

The Dunes is recognized as one of RTJ's best works and for years ranked in the Top 100 lists of many golf publications, which led to the club hosting the 1962 U.S. Women's Open and a series of PGA Tour qualifying tournaments. When the rankings slipped over the years, Nicholl said, a 2013 renovation restored much of the course's past glory, and the 2014 PGA Professional National Championship, the 2016 Southern Amateur and the 2017 U.S. Women's Amateur Four-Ball kept the club on the nation's radar.

Probably The Dunes' spotlight moment was from 1994 to 1999, when it hosted the PGA's Senior Tour Championship, a run of five years that became six when, in 1999, Hurricane Floyd damaged the then-new TPC Myrtle Beach and resulted in a surprise swan song for The Dunes. Members still have fond memories of that span, Nicholl said.

"Hale Irwin sat in the restaurant and told stories," he said. "Gary Player came with his son as his caddie and introduced himself to every staff member—like they didn't know who he was." Also memorable: when the hurricane forced the Tour to return for one more year, "it was a testament to the way we keep the course that they did that on a month's notice," Nicholl said.

The Dunes was also home course for the late Carolyn Cudone, who won five consecutive U.S. Women's Senior Amateur titles (1968–72) and captained a U.S. Curtis Cup team. In its hallways, the club displays her Curtis Cup blazer and USGA championship medals. "We put her up there with Jimmy D'Angelo as part of the growth of golf, especially among women and juniors," Nicholl said.

Also renowned, among golfers at least, is The Dunes' thirteenth hole, a long and treacherous par-5 wrapped around Lake Singleton that plagued Senior Tour players and others. "Lee Trevino hated it, said they needed to

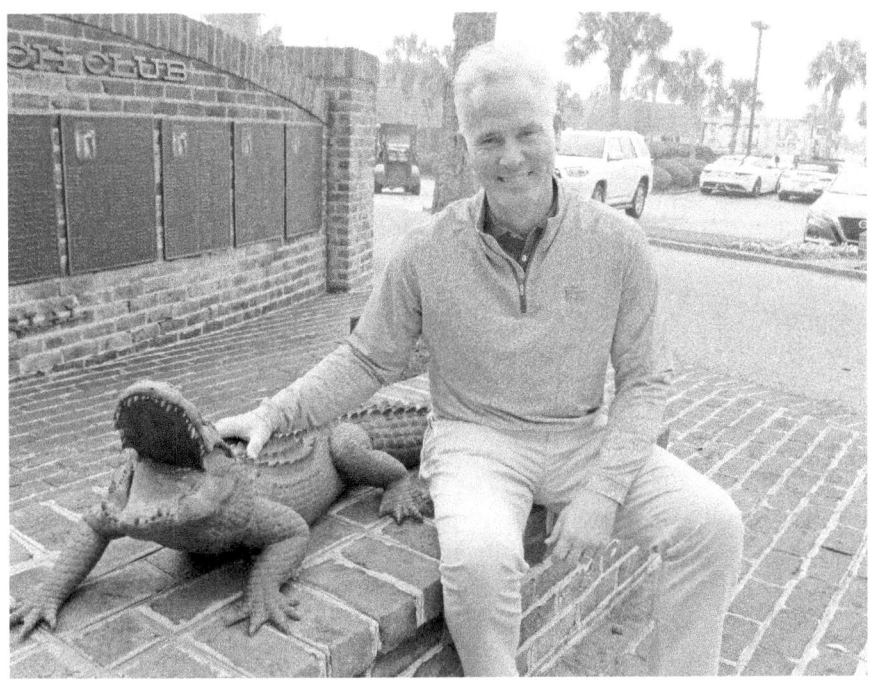

The Dunes Golf & Beach Club's director of golf Dennis Nicholl poses with the club's alligator mascot statue. *Photo by Bob Gillespie.*

blow it up and build condos there," Nicholl said with a laugh. "But others raved about it, and it's the most famous par-5 in Myrtle Beach."

Named "Waterloo," the thirteenth is the final hole of The Dunes' "Alligator Alley," a three-hole stretch (with the par-4 eleventh and par-3 twelfth) that reminds players of Augusta National's Amen Corner. "I would challenge anyone to put three holes in a row like Jones did here," Nicholl said. "The back nine is where the meat of the golf course comes," and No. 13 is the "sirloin" of difficulty.

Playing it requires a long drive avoiding the lake on the right, then a second shot over a corner of the lake and finally a shot to an elevated green surrounded by wicked bunkers. "*Sports Illustrated* named it one of the best par-5s in the nation," Nicholl said. "You talk to Rees, who rode the course with his father when it was being built, and he'll remind you there was supposed to be a peninsula green—but that was seen as too extreme."

Today, The Dunes remains popular among tourists even as Myrtle Beach has added newer, more "modern" clubs such as Caledonia and True Blue. "The Dunes has never really changed," Nicholl said. "We're private,

but we've always allowed limited guest play through member hotels and partner providers."

The reason members don't object to that arrangement? "The great golf courses of the world are meant to be shared," Nicholl said, quoting former club president Jack Bonner. "We've been doing it that way since the 1960s. It's built into the fiber of The Dunes Club, and it works well."

THE NEXT WAVE: MIKE STRANTZ, CALEDONIA AND TRUE BLUE

Mike Strantz's golf résumé runs to several pages—surprising, considering the Toledo, Ohio native only solo-designed seven courses before his death— but that takes into account his influence on others' work. In South Carolina, the list of golf courses bearing his fingerprints is impressive.

Starting in 1979, Strantz was involved in Hilton Head's Moss Creek Golf Club (North) in 1980; then Isle of Palms's Wild Dunes Links and Harbor courses (1980, 1985); Callawassie Island Club in Okatie, near Hilton Head (1984); Wachesaw Plantation Club in Murrells Inlet (1985); and Kiawah Island Resort's Osprey Point (1988). After leaving Fazio in 1987, he helped restore Wild Dunes following Hurricane Hugo (1987–90), worked with designer Arthur Hills on Dunes West in Mount Pleasant (1990–91), oversaw bunkering at Legends Resort's Parkland Course (Myrtle Beach, 1993) and redesigned bunkering and greens at Heritage Club in Pawleys Island (1993).

The last two projects brought Strantz to the attention of Legends owner Larry Young, who knew a group, Ponderosa Inc., interested in building on a piece of property near Pawleys Island. Bob Seganti, general manager of the golf properties under the Caledonia–True Blue umbrella, had just taken a job there in 1995, when Strantz was completing what would be probably his signature work.

"I heard the buzz in the area [about Caledonia], and it opened up and had instant success," said Seganti, like D'Angelo a Philadelphia product. "Folks were blown away by the entrance"—lined by ancient oaks—"and by the time I got there, they'd done almost forty thousand rounds and fifty thousand rounds the following year. It was a success from the jump."

Caledonia, a classic parkland course with fabulous trees and wetlands, epitomized the Strantz method. An artist by training, he would walk a site

The finishing hole over water at Caledonia Golf & Beach Club, with the clubhouse behind the green. *Courtesy of Golf Tourism Solutions.*

and envision how each hole would look, then do charcoal sketches of his visions. "Mike was on the property every day, on the bulldozer," Seganti said. "That's what he was known for."

Strantz became one of the hottest designers around, thanks to Caledonia. "It was amazing how fast the offers came to Mike," Seganti said. Two more courses—the Tradition Club at Stonehouse (Toano, Virginia) and Royal New Kent Golf Club (Providence Forge, Virginia), both built in 1996—also drew acclaim, and in 1998, Strantz was back at Pawleys Island to build Caledonia's sister course, True Blue. "It was the 'property across the street,' a bigger property (three hundred acres)," Seganti said, and the architect fashioned an inland links-style course—a total contrast to Caledonia, but almost equally beloved.

The courses drew comparisons, many initially calling Caledonia "the pretty one" and True Blue "the hard one." Seganti said the reality was something else. "Members since 2001 will tell you they score better at True Blue than Caledonia," he said, "because of the width of [True Blue's] fairways. There are a lot of bogeys under those trees [at Caledonia]."

The courses have one common element: they helped usher in an era where Myrtle Beach golf was no longer simply eighteen inexpensive holes. Both offered visual stimulation, playing challenges and unique styles—and players were willing to pay more to experience all that. Other high-end courses followed, notably Barefoot Golf Resort, with four courses by big-

name architects (Dye, Fazio, Love and Greg Norman), and Grande Dunes' Resort (Roger Rulewich) and Member (Nick Price/Craig Schreiner) courses.

"Folks came to view this marketplace a little differently," Seganti said. "[Owners] said, 'We can build this style of golf course in Myrtle Beach, and people will come to play.' Maybe they were the tipping point, and maybe we should take credit for opening the doors to other new courses like Grande Dunes Resort and Barefoot Resort," built by big-name architects, with superior designs—and heftier fees.

Also driving demand: Caledonia and True Blue quickly earned numerous national magazine "Best of" designations and still do. "Rankings are always listed now on any golf course," Seganti said. "If folks are putting together a trip and *Golf Digest* ranks [a course], you're going there.

"Now you come to Myrtle Beach and the quality of design is as good as anywhere in the country. Golfers want experiences [like] Bandon Dunes [Oregon], Pinehurst [North Carolina] and here, you can get that experience, but you can bundle a Caledonia with other, less expensive courses and get a good package [price]."

Myrtle Beach now is an "all things to all people" locale, with courses that match different budgets and tastes. From classic courses to the new wave, it's here. After all, "If you build it, they will come" has always been a Myrtle Beach philosophy.

THE HERITAGE OF GOLF
AT HARBOUR TOWN

More than three decades later, Davis Love III's memory of April 19, 1987, remains crystal clear. For different reasons, Steve Wilmot also remembers that day as a landmark in his career.

Late in Sunday's final round of the then-MCI Heritage Classic, Love, a former University of North Carolina All-American in his second full season on the PGA Tour, stood behind the eighteenth green at Harbour Town Golf Links on Hilton Head Island, South Carolina, convinced he had lost the tournament. Six days past his twenty-third birthday, Love moments earlier had finished a 5-under par 66, but a missed thirty-foot birdie putt at the final hole left him a shot behind tournament leader Steve Jones, playing a group behind him.

"I walked off the green disappointed," said Love, who would win twenty-one Tour titles in his career, including the 1997 PGA Championship. "But I'd come close, and Hale Irwin"—a three-time Heritage winner and U.S. Open champion who played the final round with Love—"said to me, 'Great finish, you played great and you're going to get one [victory] soon.' I felt like, okay, finishing second, I'd played well."

Then, with one errant swing, Jones changed everything.

"Not many hit it [out of bounds] at eighteen," Love said, amazement still in his voice. "All you've got to do is not hit it too far left—and he hit it too far right," Jones's drive sailing into condominiums just off the fairway. His resulting double-bogey left the stunned Love a first-time champion.

"A weird way to win," Love said.

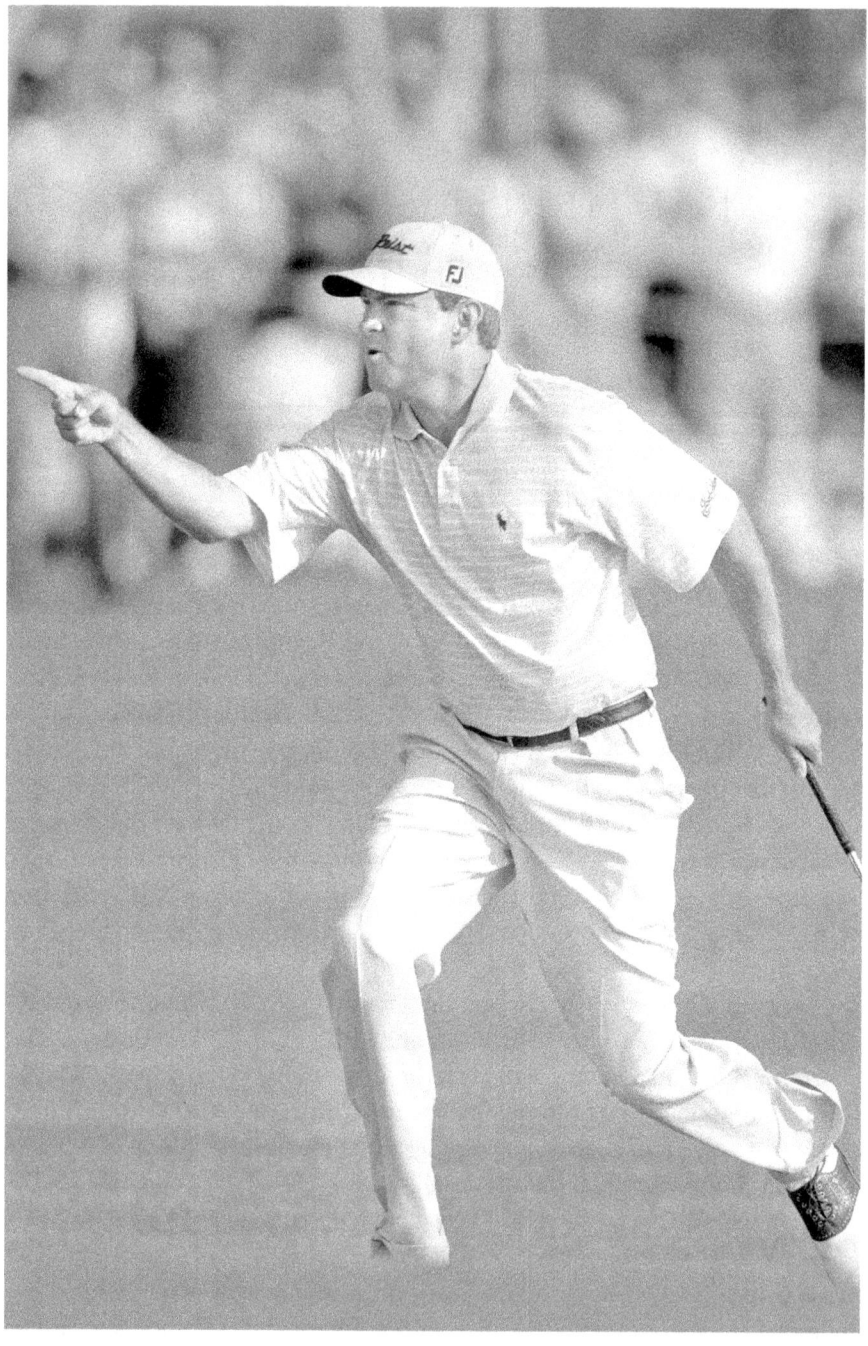

Davis Love III points to his brother and caddie Mark Love after chipping in at the eighteenth hole in 2003, en route to his fifth victory in the RBC Heritage Presented by Boeing. *Photo provided by Heritage Classic Foundation.*

That day, Wilmot—the Heritage's newly hired tournament director—was absorbed in his own responsibilities and thoughts. The twenty-seven-year-old had left the Carolinas PGA to work for Sea Pines Resort, owner of Harbour Town, but then the resort went into bankruptcy. "I thought I'd be here maybe ten months," before having to find a new job.

But that same year, the Heritage Classic Foundation was founded to run the event, and telecommunications company MCI became the new sponsor. And everything changed—for Wilmot, for Love and for the tournament.

Love ultimately won five Heritage titles, most of anyone and a quarter of his regular PGA Tour wins. His last came in 2003, when his dramatic chip-in at the final hole of regulation sent him to a playoff victory over Woody Austin.

"That final round, I kept missing greens on the back nine, and so I said, 'Well, I'll just chip one in,'" Love said. "I came close a couple of times, and it became kind of a joke between me and Mark [his brother and caddie].

"So when I missed the green at 18, walking up there, I'm thinking, 'Now I really need a chip-in.' And then I did it." Love pointed at his brother like, "'See, I told you,'" he said. "That was a neat way to get into a playoff." He won on the first extra hole.

"Winning it five times…you're comfortable there," Love said. "Success breeds success, so the more you play well there, the more comfortable you get."

Had the tournament gone away afterward over financial issues, would his career have been as successful? Who knows?

As for Wilmot, who worried where he might be working after that 1987 tournament: in 2020 he worked his thirty-fourth Heritage—now the RBC Heritage Presented by Boeing—and the event's status, and his own, are secure for the foreseeable future.

With RBC on board through 2023 and Boeing until 2021, the Heritage has the security to go with its iconic status. "This event has found its niche," Wilmot said. "Even today, when we run into folks at a restaurant, they tell us they appreciate what we do. They see the importance of the tournament," which in 2018 celebrated its fiftieth year as part of the PGA Tour.

Since moving in 1983 to the week after the Masters, the Heritage has become South Carolina's unofficial arrival of spring—drawing thousands to the island to vacation, buy homes or just watch golf—and a fixture on the state's sports calendar. Harbour Town remains one of South Carolina's (and the nation's) premier golf properties and a PGA Tour favorite; a *Golf Digest* poll of Tour players named Harbour Town as their second-favorite regular Tour venue, behind only Augusta National.

Aerial view of Harbour Town Golf Links' iconic par-4 eighteenth hole. *Courtesy of the Sea Pines Resort/Rob Tipton.*

Completed in 1969 just in time to play host to the first Heritage—and to sell property on the then-undeveloped island—the golf course is an indelible part of the South Carolina landscape. Built by then-little-known architect Pete Dye (who died in early 2020) with co-designer/superstar Jack Nicklaus, Harbour Town is known for its modest length, narrow tree-lined fairways, marshy environs and small, hard-to-hit greens. Those elements make it a "shot-maker's course," the ultimate compliment from Tour players.

"It's my favorite course [on Tour]," said two-time winner Jim Furyk, whose most recent win came in 2015 in a playoff, ending a five-year personal drought. "Just because it's so different from everywhere else we play; it's not that long, but you have all the elements there. You have to control your ball."

It's been that way for half a century, since two brothers conceived of a revolutionary golf course and a tournament that would boost development of Hilton Head as a real estate and tourism hot spot. Today, that leap of faith has weathered financial storms to remain South Carolina's crown jewel of golf.

REALIZING A DREAM: THE FRASERS, PETE DYE AND ARNOLD PALMER

Jim Chaffin was twenty-five in May 1969 when he arrived on Hilton Head Island, which had fewer than four thousand residents and a two-lane bridge connecting it to the mainland. He came to work in real estate for brothers Charles and Joe Fraser, who had a dream of transforming a swampy piece of property into a visitor destination. To promote that, Charles Fraser decided to build a world-class golf course, one able to host a PGA Tour event.

"Charles was a visionary," Chaffin said. "He had an insatiable thirst for knowledge about what people did for pleasure. His father had been part of a lumber syndicate that owned most of Hilton Head, and he wanted to preserve the natural beauty. He asked, 'What's a way to develop Hilton Head without destroying that?'"

Fraser's answer: create a resort with beaches, tennis and golf—and homes—that would draw buyers. Future U.S. Open and Wimbledon champion Stan Smith was hired to run the tennis operation. The Frasers' Sea Pines Plantation built two golf courses (then called Sea Marsh and Ocean), but the brothers were looking for something more impressive.

They decided to add a third course with a big-name architect, and in the 1960s, there was no name bigger than Jack Nicklaus. Simon Fraser, Joe's son and now attorney for Sea Pines, remembers how the brothers went to the PGA Tour to ask how to procure a tournament date.

"[Then PGA Tour commissioner] Deane Beman said Nicklaus was thinking about getting into golf course architecture," Fraser said. "Jack told them he didn't know that much about building a golf course, though he'd like to get into it, but he said 'there's a guy named Pete Dye that you ought to talk to.'"

Simon Fraser laughed, adding, "They cut a deal for Jack and Pete to collaborate on it. In those days, the talk was more about Jack. No one knew who Pete Dye was." Soon, that would change.

The finishing touch, Chaffin said, was when "Jack came into Charles's office and said, 'I think we've got something very special out here. It might be worthy of a [tournament] on the Tour. Do you mind if I approach the PGA Tour about this?' We're in marketing, thinking, 'Holy cow, what would that bring in?'"

As recounted in "The History of the Heritage: 1969–1989" by the late Terry Bunton, a sportswriter for the *Savannah Morning News*, the first public inkling came in July 1968 when Bill Dyer, named the Heritage's executive

Simon Fraser, son and nephew of Joe and Charles Fraser, founders of Harbour Town Golf Links and the RBC Heritage tournament, is part of the tournament leadership. *Photo provided by Heritage Classic Foundation.*

director, sent telegrams to news outlets about "the first major professional golf tournament to be held directly on the Atlantic seacoast," with dates set for Thanksgiving weekend. A month later, Dyer announced a delay until November 1969 because construction of Harbour Town had just begun.

As the 1969 Thanksgiving weekend approached, the course was still being finished. "They had twenty-four-hour shifts building the clubhouse with floodlights," Chaffin said. As for the golf course, Dye for years told how he was making last-minute "tweaks" at the par-4 thirteenth green's horseshoe-shaped bunker on the morning of the Heritage's first round.

"I'm in there pushing sand around and here comes the first player down the fairway," Dye said in a 2011 interview. "I climb out all dirty and walk behind the green, and two guys are standing there. One says, 'Look at this hole. Isn't it great how Jack designed it?'

"I knew Jack had never seen it, so I told the guys, 'Jack Nicklaus had nothing to do with this hole. A lovely lady [Alice Dye, Pete's wife and an accomplished architect in her own right until her death in 2019] designed it.'

"I start walking away and I hear the guy saying, 'There goes an early-morning drunk for you.'"

The inaugural Heritage Classic was a success, even with lousy November weather, for two reasons. First, the winner was Arnold Palmer, America's

most beloved golfer, whose victory ended a fourteen-month winning drought. "No question, Arnie was such an icon," Chaffin said. "Having him win, and being so positive about the golf course and the experience, and then having him come back year after year, was just huge."

Second, the publicity the Frasers had hoped for came, in large part, from *Sports Illustrated* golf writer Dan Jenkins, one of golf's most influential opinion-makers until his death in 2019. Jenkins wrote of Harbour Town that "Jack built a course that Arnie could win on," calling it "a course with rare bite" and predicting it would become "known as one of the ten best courses, old or young, in the country."

The success of Harbour Town and Sea Pines would ultimately lead to some two dozen golf courses in the area, including other resorts: Palmetto Dunes Resort, with three courses by big-name architects; Port Royal, also with three courses; and Palmetto Hall and Shipyard (two courses each). Sea Pines later updated its two original courses (Ocean and Marsh), producing Heron Point by Pete Dye and Atlantic Dunes by Love.

The best ongoing endorsements, besides yearly exposure, at first on NBC and currently CBS, came from the tournament's winners. Some of the game's biggest names won Heritage titles in the 1970s and 1980s: Nicklaus (1975), Irwin (three times), Johnny Miller, Tom Watson and Payne Stewart (twice each).

Success in the media and among players wasn't a guarantee of financial stability, though. In 1987 and again in 2011, the Heritage and Harbour Town faced challenges to both their stature and, in the case of the tournament, its very existence.

RBC: SAVING SOUTH CAROLINA'S GOLF GEM

Like Simon Fraser, Cary Corbitt worked at the 1969 Heritage, as a high school–aged gallery marshal, while his brother had a caddying job. "That helped me fall in love with Hilton Head," said Corbitt, now Sea Pines' vice president for sports and operations. "After that, it was always my aspiration to get back there," which he did in 1978, working his way up to head professional before moving into administration.

Corbitt's favorite memories are of working alongside Pete and Alice Dye, especially when the couple led a total restoration of Harbour Town in 2001. "We hadn't done that since 1969, and things were wearing out," he said. His

least enjoyable experiences came in 1983, when ownership of the Sea Pines Company passed to a string of investment groups—including one led by South Carolina native Bobby Ginn—whose business models threatened to sink both resort and tournament.

"In 1983, a new company came in, and then [Sea Pines] was sold to another company that turned out to be a bunch of crooks," Simon Fraser said. "That's when the course conditions went to crap. [Tour player] Kenny Knox set the Tour putting record on basically sand greens [a record broken in 2005 by David Frost]. It was terrible."

Following an involuntary bankruptcy, by 1987 a group of island businessmen and political leaders had formed the Heritage Classic Foundation, which raised a $1 million guarantee demanded by the Tour for maintenance and upgrades. The foundation became one of the first 501(c)(3) charitable organizations to operate a PGA Tour event, now the model for most tour events. MCI Communications Corp. became the tournament sponsor, and by 1988, the tournament's money problems seemed in the past.

But when MCI and later communications company WorldCom, which was placed in bankruptcy, experienced financial turmoil, so did the Heritage. "We actually terminated their [WorldCom's] contract," Fraser said. "Then MCI was bought by Verizon, which basically played out the contract. We knew the end of that was coming."

In 2010, Verizon announced the end of its sponsorship after that year's tournament. "Simon and I thought it would've been easy [to find a new sponsor for 2011], but it became very difficult," Steve Wilmot said. "Going into 2011, we talked to hundreds of companies." Wilmot recalled visits to Marathon Oil, AFLAC and Accenture—all, ultimately, to no end.

But Wilmot, Fraser and others were encouraged by support from state officials, notably Governor Nikki Haley and Senator Lindsey Graham. "I'm sitting in a conference room with [Haley] and she's saying 'no is not an answer' and the Tour is saying 'can't is not an answer,'" Wilmot said. "I'm thinking, 'I just want an answer.'"

The 2011 Heritage went on without a sponsor, using county and town funds plus Heritage Classic Foundation reserves. That spring, support came from Tour players and local and national media, notably broadcast partner CBS, whose Jim Nantz and Nick Faldo talked about the need to "save the Heritage" during the week's broadcast.

"When the last putt [of 2011] was made on CBS, we didn't know what our future was," Wilmot said. "Talk about the eleventh hour; it was the

Heritage tournament director Steve Wilmot and media director Angela McSwain stand in front of the Heritage winner's plaid blazer. *Photo by Bob Gillespie.*

twelfth hour. But we realized the Tour didn't want us to go away, and the state didn't want it to go away."

A few weeks later, Royal Bank of Canada (RBC)—which Heritage officials had first talked with in fall 2010—emerged as its savior. "It happened overnight," Wilmot said. "It wasn't a matter of an announcement in three weeks; it was day after tomorrow." On June 16, 2011, RBC officially became tournament sponsor, with Boeing (its East Coast headquarters based in Charleston) signing on as presenting sponsor.

"What turned the corner for us, I think, was when [two-time Heritage winner] Tom Watson and other players said, 'That tournament should not go away,'" Fraser said. "We got more attention from the Tour after that, and the idea that 'we've got to find [a sponsor].' RBC had this level of money, and we needed this level.

"The rest is history. And it's been good ever since."

THE PGA TOUR: THE ARRIVAL OF SPRING

If the business end of the Heritage has seen its share of potholes, the golf tournament has grown in stature over a half century. Its first eight winners, and thirty of the first thirty-six Heritage champions (1969–2004), were also winners of golf's "majors"—the Masters, U.S. Open, British Open and PGA Championship.

Matt Kuchar, winner in 2014, said the real test of Harbour Town is that players of different talents have won there. "Davis [Love] has won five times, and he's been one of the longest hitters on Tour," he said, "and then you've got guys like Furyk, some of the shorter hitters. It's just a matter of keeping it in play, and then you have a chance to win.

"The golf course is fantastic, so unique. We don't see anything remotely similar to this [on Tour]. You know it just requires good golf, because it's so demanding off the tee."

In 2014, Kuchar was tied for the lead at the eighteenth hole when his approach shot came up short in the front bunker. But his blast from the sand trickled in, setting up his one-shot win. "I had three-putted 17 to give a shot back, and 18 was playing about as hard as I ever remember it playing," he said. "To hole out that bunker shot, knowing that pretty much sealed the win....I could not have been more excited."

Furyk also knows about dramatic moments at Harbour Town. In 2015, the 2003 U.S. Open champion shot a closing 8-under par 63, then birdied two playoff holes to defeat Aiken, South Carolina native Kevin Kisner. "To finish it off the way I did, on a very difficult day, making a putt on top of Kevin at 18...and then on 17, I made another 15-20-footer [to win the playoff]," he said. "When you go through long dry spells [since 2010 in his case] without winning, to win that day was exciting."

Boo Weekley, one of three players to win back-to-back Heritage titles (along with the late Payne Stewart, 1989–90, and Love, 1991–92), had not one dramatic Sunday moment, but two, in his 2007 win. Ahead by a shot, he chipped in to save par at the par-3 seventeenth...and moments later did it again at the eighteenth to edge Ernie Els.

"I ain't heard of too many wins coming from back-to-back chip-ins," Weekley said. "I'd have to say that was one of the biggest wins for me. And [the next year] when I got here it was like, 'Okay, we're back home again.'"

Weekley was a popular winner with fans, but even he took a back seat in 2017—one year before the Heritage celebrated its fiftieth anniversary—when Columbia's Wesley Bryan became the first South Carolina native to win his home state tournament.

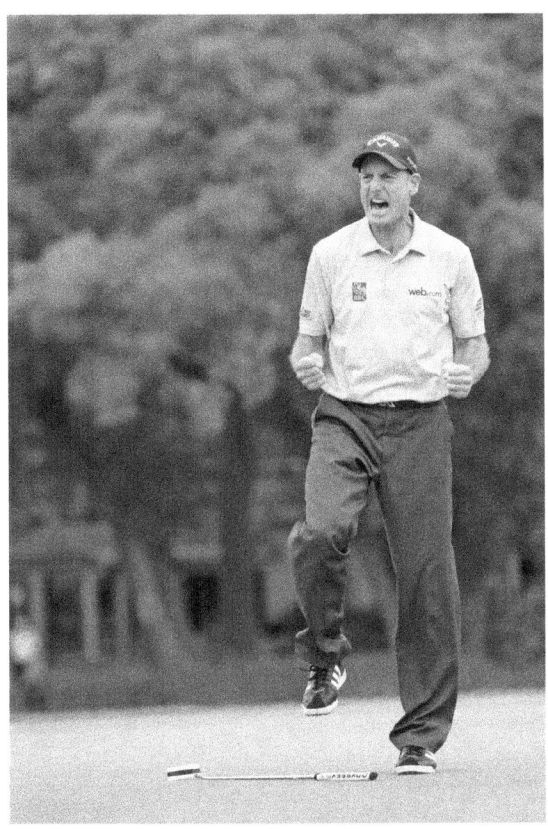

Left: Two-time Heritage winner Jim Furyk celebrates with a fist pump at the eighteenth green. *Photo provided by Heritage Classic Foundation.*

Below: Wesley Bryan (*left*) was the first South Carolina–born winner in 2017, shown with his brother, mini-tour player George Bryan IV. *Photo by Bob Gillespie.*

In 2004, the then-fourteen-year-old Bryan had watched his father, teaching pro George Bryan III, compete in the Heritage. Thirteen years later, after trailing third-round leaders by four shots, Wesley Bryan closed with a 67 to beat Luke Donald by a shot. It was thrilling for local fans and pretty special for the Bryan family, too.

"Growing up, you always have that vision" of winning the Heritage, Bryan said. "We had family friends who had a house in Sea Pines, and we used to go and stay during the summer. I always had a dream to play in it. All those years later, to compete in the same event was really, really neat. And then, obviously, to win was the icing on the cake."

Bryan missed the 2019 Heritage with an injury. But he looked forward to many more trips to Harbour Town and the Heritage. Winning once doesn't mean the thrill of victory—especially for a native son—ever goes away. "Shoot, to this day, I don't know if it's sunk in," Bryan said. "It's like a fairy tale saying I won it. It's still pretty surreal.

"[In 2019] I was pulling for the other South Carolina guys. But they can't take away the fact I'll always be the first."

As long as there's a Heritage, and Harbour Town, winning there will be every state player's special moment.

THE OLD COLLEGE TRY

The Championship Teams

C lemson University golf coach Larry Penley recalls the 2003 NCAA Golf Championship, played at Oklahoma State University's Karsten Creek course, mostly as the time junior Jack Ferguson nearly gave him heart failure.

On the final day of a season when the Tigers consistently ranked No. 1 in the nation, Penley, Clemson's coach since 1983, arrived at the eighteenth fairway where Ferguson was waiting to hit his second shot on the tough par-5. Moments before, Penley had determined Ferguson—paired with Oklahoma State's Hunter Mahan, a future PGA Tour player—needed only to par the eighteenth for Clemson to win.

"When D.J. [Trahan, the Tigers' first-team All-American and future PGA Tour winner] birdied the eighteenth, I did the math and realized we had a two-shot lead," Penley said. "I ask [Ferguson] what yardage he wants for his third [lay-up] shot, and he says, 'I've got 235 [yards] to the front of the green. I think I can get a 5-wood there'" in two shots.

Penley looked at the green, surrounded by water and other trouble, and almost fainted. Then he saw Ferguson grinning.

"Jack says, 'I'm just messing with you; I want 95 yards [for his third shot],'" Penley said. A two-putt par later, Clemson ended more than a decade of title frustration.

The Tigers' 2003 title started a four-year run of titles for South Carolina college golf programs. That same month, in Sunriver, Oregon, Francis Marion University won the NCAA Division II championship, beating

Rollins College by fourteen shots. A year later, the University of South Carolina–Aiken's nine-shot victory over Chico State (California) in the NCAA Division II was the first of the Pacers' three straight titles (2004–6). In 2005, USC Aiken defeated Armstrong State (Georgia) by five shots, and junior Dane Burkhart—a largely overlooked Aiken native until Aiken coach Michael Carlisle signed him—claimed the individual title. In 2006, the Pacers won by twelve over Columbus State (Georgia).

South Carolina's first national golf title came thirty years before Clemson's and Francis Marion's. In 1973, Wofford won the National Association of Intercollegiate Athletics (NAIA) title by fourteen shots over Campbell College (North Carolina). In 1984, Limestone College beat Saginaw Valley State (Michigan) to claim the NAIA crown.

Perhaps the most star-studded South Carolina championship team was the 1976 Furman University women's squad, led by future LPGA stars and World Golf Hall of Famers Beth Daniel and Betsy King. The Paladins defeated Florida and Tulsa, led by another Hall of Famer, Nancy Lopez.

Eight national titles by five South Carolina programs is a legacy rich with stories of dominance—and a few surprises.

FINALLY, A TITLE FOR THE TIGERS: CLEMSON 2003

Before Clemson's 2003 title, Penley's teams had finished in the top ten at the NCAA Championship eight of ten years, including two runner-up finishes, the last in 2002. Lucas Glover, later 2009 U.S. Open champion, who wrapped up his Clemson career in 2001, said the Tigers were a perennial contender for one reason: Penley.

"He does an unbelievable job," Glover said. "When I was there, it was recruit the best and let them beat on each other and improve that way. Larry's biggest asset was in knowing when to step in or step back. If guys were playing well, he'd say, 'You don't need to change anything. Just go play.'"

Matt Hendrix, a redshirt junior in 2003, remembers close calls his first two seasons (the Tigers finished third and second in the NCAA) and the Tigers' determination following the 2002 near-miss. "We came back that fall with a lot of focus after a good summer," Hendrix said. That was especially true for Trahan, who was captain of the U.S. Palmer Cup team that summer.

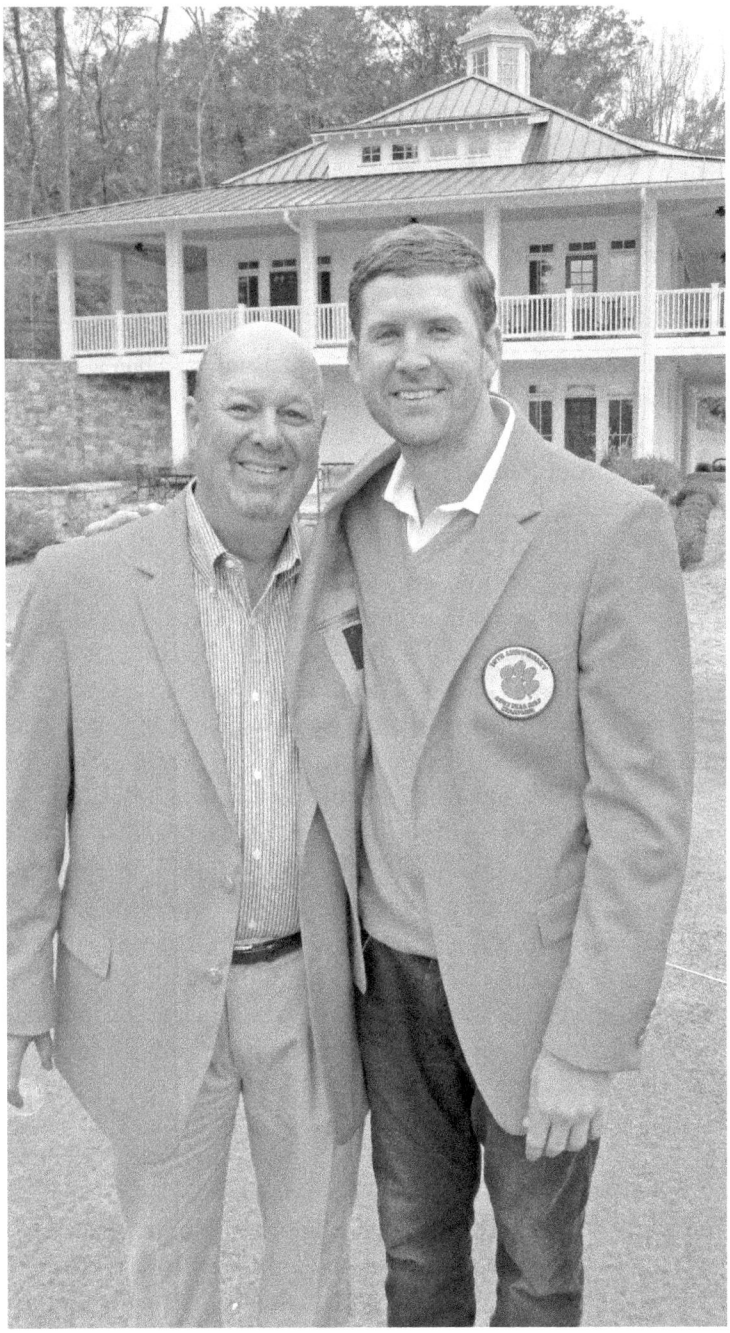

Former Clemson player D.J. Trahan (*right*), with Tigers coach Larry Penley, played on the Tigers' 2003 national championship team. *Photo by Bob Gillespie.*

The 2003 Tigers were ranked No. 1 in preseason, and "we saw no reason we couldn't compete every week," Hendrix said. "We started out with a win, and we got used to playing with a target on our backs. We embraced it."

Still, the Tigers got their biggest boost when Trahan—whom many observers thought might turn pro after he won college golf's Ben Hogan Award—decided to return for his senior year. "He left a million dollars on the table to not turn pro," Penley said. "It would've been very easy for him to move on."

Trahan told his coach in July, "I'm only coming back for one reason; tell the team that reason is to win a ring." Said Penley, "That was the easiest coaching job I ever had. D.J. held everyone accountable every day."

Penley always recruited heavily in South Carolina, and that season, all ten players were from the state. Most were products of the SC Junior Golf Association's development programs. "We got all the competition at home that we needed," Hendrix said. "And we all knew each other well from playing all those years together."

The Tigers won or placed second in ten of eleven tournaments—their record against opponents was 186-8-2—and captured the Atlantic Coast Conference and NCAA East Regional titles. Still, in Stillwater, despite Clemson's No. 1 ranking, home-standing Oklahoma State was the favorite.

The two teams shared the first-round lead with Auburn and NC State at 11-over par 299 on the difficult Karsten Creek course. UCLA surged to a one-shot lead over OSU's Cowboys, three up on Clemson, after the second round. But in the third round, the Tigers shot 1-under 287—by three shots the tournament's best one-day score—and held a one-shot lead on OSU going into the final round.

Hendrix shot a 3-under 69 in that crucial third round, Clemson's best of the week by three shots. "[Karsten Creek] was one of those courses where it was difficult to score," he said. "There weren't many birdies out there; it was survival mode all week."

In the final round, Trahan (a final 74), Gregg Jones (75) and especially Ferguson (a steady 77) led the way. "That was Jack's game," Hendrix said. "He was 'Cool Hand Luke' all year, not a guy you'd point to as the best under pressure—that was D.J.—but he wore down Hunter that day."

Ferguson finished nineteenth overall, a shot better than Trahan, and was named second-team All-American, with Trahan first team and Hendrix third team. Penley was named NCAA Coach of the Year, and the Tigers were the first NCAA team to win conference, regional and national titles in the same year.

All five Clemson players finished among the top fifty-two, the only team to do that. "D.J. was the only one with much of a pro career [afterward], but bits and pieces fell together," Penley said. "[Fifth man] Ben Duncan shot 85 the first day, but then shot 73-74, his two biggest rounds of the year."

After all the previous close calls, Penley said the title was "more than joy, sort of 'thank goodness we got it done.' I thought back to 1998, when we finished second, as good as I've seen a team play and not win." Clemson shot 31-under that year, beating the NCAA record by seven shots, but lost to UNLV's 34-under.

Visitors to Clemson's practice facility can still get a taste of the title. "We found seven of those highway signs [posted by the SC Department of Transportation, proclaiming the championship]," Penley said. "We put one on the driving range and gave one to Michael Sims, who didn't make the trip to Stillwater.

"Michael was the glue who kept us together, and he tutored guys. I told him he graduated with two degrees: his and Gregg Jones'." That was the story of Clemson's championship: all for one, one for all.

THREE FOR THREE:
USC AIKEN AND MICHAEL CARLISLE

Michael Carlisle never set out to be a college coach, let alone build a University of South Carolina–Aiken program that won three consecutive NCAA Division II titles. After playing golf at Clemson (where a teammate was Penley), he tried professional golf and then worked for the SC Golf Association and its juniors program before arriving in Aiken in 1990.

He was playing one day at Palmetto Golf Club when he met Randy Warrick, USC Aiken's athletics director, whose program was moving from NAIA to NCAA Division II. "I always thought the second-best job in golf—if you're not a PGA Tour player—would be coaching in college," Carlisle said.

The 1991 Pacers team had been solid in NAIA, and Carlisle quickly upped the ante. Seeking advice from Penley, South Carolina coach Steve Liebler and others, "the first thing that came across is that No. 1 is recruiting," he said. "Then you've got to have a good place to play"—historic Palmetto Golf Club—"and then you need a good tournament schedule." A relationship with Cleveland Golf allowed USC Aiken to host an annual event at Palmetto.

Longtime USC Aiken coach Michael Carlisle, standing in front of the Pacers' All-American plaques. *Photo by Bob Gillespie.*

Carlisle's Pacers placed fifth in the 1992 D-II championship and posted runner-up finishes in 1995, 1996 and 1998, behind three-time champion Florida Southern in 1998–2000. In 2002, Carlisle signed North Augusta native and future PGA Tour player Scott Brown. A year later, Burkhart came on board.

In 2004, with the additions of Clint Smith and James McGee, the Pacers hit their stride. Burkhart, who had one scholarship offer (USC Aiken) before winning the SC Junior title, said chemistry was crucial for the Pacers. "Me and Brownie [Scott Brown] had this special relationship—we wanted to beat each other," he said. "After a while, with that mentality, there weren't a lot who could beat us."

The 2004 squad was unheralded until arriving at Victoria Hills Golf Club in Orlando, Florida. "We didn't shoot fantastic scores, but we held it together" to beat Chico State by nine shots. Carlisle called the title "a relief. I'd been here thirteen years and wondered if we'd ever win one."

The win unleashed a wave of confidence—and success. Through 2006, "we won about everything we played," Carlisle said. In its three

The USC Aiken golf team was the first of three consecutive NCAA Division II national champions. *Courtesy of USC Aiken.*

championship seasons, USC Aiken captured twenty-three of twenty-eight tournament titles.

"Winning the first time, out of the blue, gave us a bunch of confidence," Burkhart said. "Next thing you know, we're one of the best in the country."

The Pacers took their second national title in 2005 at Savannah Harbor, beating Peach Belt Conference rival Armstrong State (Georgia) by five. Carlisle got a pre-tournament read on his team when Brown told him, "Coach, nobody's going to beat us."

"And pretty much no one did," Carlisle said. "It was just a matter of what the final margin was going to be."

That year, Burkhart claimed the individual crown, shooting 5-under for four rounds. He topped Nick Mason, one of the nation's best, sinking a 5-foot birdie putt on the seventeenth hole. "When I was chosen Division II player of the year, I was blown away," Burkhart said.

The 2006 NCAA Championship at Glade Springs, West Virginia, was the Pacers' easiest. With Roberto Diaz (a future PGA Tour player) and Matt Giftos, one of Carlisle's top recruits ever, the team romped to a 12-shot victory over Columbus State. Burkhart narrowly missed a closing birdie to finish second by a shot to Jamie Amoretti of St. Mary's (Texas). Brown was named D-2 Player of the Year.

The Pacers remained contenders after Burkhart and Brown departed but have yet to win it all again, as of this writing. "The hardest thing when you win like that is to continue winning," Carlisle said. "We got back to the tournament, but not that close to winning it again."

Today, Brown is a past champion on the PGA Tour; Burkhart played professionally for eight years and now works for a Savannah River Site subcontractor. And Carlisle is approaching thirty years in "the first and only coaching job I've ever had." Near his office, in a glass case, stand three championship trophies.

SPIRIT OF '76: FURMAN'S LEGACY OF WOMEN'S GOLF

Beth Daniel, a LPGA and World Golf Hall of Fame member, won two U.S. Amateur titles (1975 and 1977), an LPGA Championship and more than thirty professional tournaments. But one of her most nerve-wracking moments came as a sophomore on one of the greatest women's college teams in history.

At the 1976 AIAW championship at the Forest Akers West Course in East Lansing, Michigan, Daniel, the last day's final player for Furman University, stood on the tee of the par-3 eighteenth hole. The Paladins, Florida and Tulsa, the last led by future LPGA Hall of Famer Nancy Lopez, were locked in a taut battle, and Daniel didn't know where things stood—until she did.

Future LPGA Hall of Famer Beth Daniel was a standout for the Lady Paladins' AIAW champions in 1976. *Courtesy of LPGA Photo Archives.*

"I'm on the tee with a 6-iron in my hand," Daniel said. "Cindy [Ferro, a senior and the Paladins' team captain] walks up, leans in and whispers, 'If you make par, we win.'

"So of course, I miss the green right, but I pitch it up to three feet and made it. I walked straight off the green and right up to Cindy and practically yelled at her, 'Why'd you say that to me?' Of course, we laugh about it now."

Daniel's par gave Furman a one-shot victory over Florida, and Daniel and her teammates figured it was about time. "Florida was great, and Tulsa might've been the best in the country," she said. "But we were determined to win it."

Under coach Gary Meredith, Furman finished third in the 1974 AIAW championship

and fifth in 1975. A year after their championship run, the Paladins finished third again in 1977. (The AIAW was absorbed by the NCAA in 1982.)

Furman had only started its women's team in 1972, but winning the national championship surprised no one, least of all Daniel, who along with Ferro, Greenville native Sherri Turner and fellow Hall of Famer and two-time U.S. Women's Open winner Betsy King would become LPGA Tour stars. "We knew from the get-go we were one of the best teams," Daniel said. "We were winning a lot, and we had too many good players. We were good, and we knew we were good." The arrival of Turner enabled Furman to capture its title, Daniel said. "She was the missing piece of the [championship]."

Daniel played on the 1976 and 1978 U.S. Curtis Cup teams, going 4-0 against the best amateurs from Great Britain and Ireland. She turned professional, joining the LPGA Tour in 1979. Now in her sixties, Daniel returns to South Carolina each year to host a SC Junior Golf Association tournament named in her honor.

Occasionally she stops by the Furman University Golf Club, where photos of All-Americans, LPGA and PGA alumni are hung. Daniel, King, Turner and Ferro combined for seventy LPGA victories and eight major championships. They'd tell you now it all started in 1976.

A WORKMANLIKE TITLE: WOFFORD 1973

Furman's 1976 team sent four players on to pro golf; the first South Carolina team to win a national title sent its players to work. That was the 1973 Wofford College men's golf team, which claimed its NAIA crown in relative obscurity.

Besides championship rings (which four of the five players bought themselves; Marion Moore, an Orangeburg realtor, refused to buy one), the best Wofford memory of 1973 is a framed ten-by-twelve-inch black-and-white photo of players holding a banner that reads "1973 NAIA National Champions."

"It's so far removed from now, it's hard to believe," Moore said. "But every day, I appreciate it more. We're a piece of history."

In the 1970s, Wofford's golf team regularly competed against bigger opponents. "Golf-wise, Wofford was ahead of its time," Moore said. Still, it was a small-time operation. The coach, W. Earle Buice, who died in 1983,

TERRIERS TAKE HOME THE NATIONAL CHAMPIONSHIP
JUNE 8, 1973

GRAMLING, S.C.—Wofford's Terriers stunned the rest of the NAIA National Golf Tournament field with a sizzling final round to win the national championship by 14 strokes at the Village Greens Country Club.

The Terriers' title marks the first national collegiate championship won by a South Carolina team in any sport, and the victory margin was among the largest posted in NAIA national golf competition. Campbell College of Buies Creek, N.C., nine shots back after the second round, turned in a fine 297 total, but could only watch as Wofford rolled over the hill-laden course for a 73-72-75-72--292 showing.

The Terriers posted the best team total in each of the tournament's three days. But, as fate and the bounce of the ball would have it, the individual crown eluded Wofford. The top individual Terrier was sophomore Marion Moore, who produced a par 72 to finish three shots back of the leaders at 216. Wofford's Paul Hyman was fourth at 217 and the Terriers' Pat Crowley tied for seventh at 220.

Wofford's top four players received NAIA All-American honors. Wofford coach Earl Buice was named the NAIA Coach of the Year after adding the national championship to his list of four district championships and two state crowns.

Wofford was never challenged the last day as none of the other 16 schools could mount a charge.

*Excerpt taken from Mike Hembree's story in the Spartanburg Herald-Journal

THE 1973 CHAMPIONSHIP TEAM CLAIMED THE FIRST NATIONAL TITLE FOR ANY COLLEGIATE TEAM IN THE STATE OF SOUTH CAROLINA.

NATIONAL CHAMPIONS REUNITE
APRIL 15, 2013

2013 marked the 40th anniversary of Wofford's NAIA National Championship. In honor of the event, all five members of the '73 championship team recreated the photo they took 40 years prior, holding the national championship banner and standing in the same order they stood that same day. In place of Wofford's late head coach Earl Buice and the NAIA Commissioner pictured in the original photo, both children of the late head coach Earl Buice held the championship trophy.

The event was held in conjunction with the Coca-Cola Wofford Invitational at the Country Club of Spartanburg. After watching the men's golf team finish its round, the national championship team took part in a dinner and ceremony to commemorate their accomplishments.

TOP ROW: (LEFT TO RIGHT) VERNON HYMAN '74, MARION MOORE '75, STAN LITTLEJOHN '73, PAUL HYMAN '73 AND PAT CROWLEY. PICTURED IN FRONT OF THE BANNER ARE THE SON AND DAUGHTER OF THE LATE HEAD COACH EARL BUICE.

@WOFFORDTERRIERS

27

2017-18 WOFFORD MEN'S GOLF MEDIA GUIDE

The 1973 Wofford men's team captured South Carolina's first national college golf title. From the Wofford golf media guide. *Courtesy of Wofford College.*

worked as the school's cafeteria director and often spent his own money on team expenses.

In 1973, the NAIA District 6 champions hosted the national tournament, and Buice selected the Village Greens course, close to the school's Spartanburg campus, as the site. By the time other teams arrived, the Terriers knew the course well and took a two-shot lead in the first of four scheduled rounds, shortened to three by heavy rains.

"I didn't know where we stood nationally," Moore, then a sophomore, said, "but [his teammates] all said, 'We're good enough to win it all.'" Wofford increased its lead to nine shots after the second round and won by fourteen, then an NAIA record margin, over Campbell College.

Moore, the youngest Terrier to compete, shot rounds of 71-73-72 to place third individually. Paul Hyman (fourth), Pat Crowley (eighth) and Stan Littlejohn (twelfth) all earned first-team All-America status. Afterward, the players retreated to Hyman's apartment to eat and talk about what they'd done.

"Then we sort of said, 'Now what?'" Littlejohn said. "The next day, for [the seniors], it was, 'Uh oh, time to go to work.'"

Today, they have their rings (except Moore), All-America certificates—and the pride of being South Carolina's first national champions.

MILAN GETTYS, LIMESTONE AND FRANCIS MARION

Of South Carolina's two other national champions, Limestone College in 1984 was no surprise to anyone following NAIA golf. The Saints finished third nationally in 1983 and were dominant in 1984, winning seven tournaments. Their top player, and their coach, was an equally dominant individual.

When Randy Hines stepped down as coach prior to the 1984 season, Milan Gettys, a four-time NAIA All-District 6 player, took over. At thirty-one, the Gaffney native was a decade older than any of his teammates and was Limestone's second-ever scholarship player when he signed at age twenty-eight.

The Saints trailed host Saginaw Valley State by five shots entering the championship's final round, but Gettys and teammates Chip Johnson and Grant Hoffman turned it on to beat Saginaw Valley by seven shots. Johnson was the star that day, his tournament-best 3-under par 285 earning NAIA All-American honors, along with teammate David Lamb.

Gettys led Limestone in 1984, winning two tournament titles, including the District 6 individual championship. In 1983, Limestone was the first NAIA team invited to compete in the Southern Intercollegiate, and in 1984 the Saints placed tenth against NCAA teams Clemson, South Carolina and Georgia. In 1985, the school named Gettys full-time head coach, and he continued to be a Gaffney legend until his death in 2015.

Nearly two decades after Limestone's NAIA title, Francis Marion University emerged from nowhere to capture the 2003 NCAA Division II title. "Jonathan Burnette was their coach, in his last year in the job," USC Aiken's Carlisle said. "They weren't ranked at all, but they played a career tournament to win it all."

Francis Marion was competing in only its third NCAA national championship, but the Patriots had a strong golf tradition. Before joining D-II in 1992, FMU appeared in seven NAIA nationals, with six top-ten finishes capped by a fourth in 1976.

Playing at Crosswater Golf Club in Sunriver, Oregon, the Patriots led the entire championship, building a 19-shot lead before settling for a 14-stroke margin over Rollins. FMU shot 3-under par 1,149—the only one of the field's eighteen teams to finish under par. The Patriots' big guns were junior Fredrik Ohlsson (fifth at 3-under par 285) and senior Dylan Keylock (sixth at 2-under 286). Senior Matt Dura, who in 2002 had finished third, finished fourteenth.

Five South Carolina teams, each with its share of stars, some as favorites and others as surprises, but all ultimately were national college champions.

FOR LOVE OF THE GAME

The Amateurs

D oc Redman started not to answer his cellphone that night. It was the evening before the finals of the 2017 United States Amateur Championship, and the nineteen-year-old Clemson University golf team member was driving to dinner after his semifinals victory at Los Angeles's Riviera Country Club.

"I normally wouldn't answer it," said Redman. "But it was a Greenville-Spartanburg area code [864]." He laughed. "It's fortunate I decided to answer that one."

Indeed. The caller was Dabo Swinney, head football coach at Clemson and a fan of golf and all things Clemson. "He said he was proud of me and gave me a little pep talk for the next day," Redman said.

A day later, the coach of the 2016 (and later 2018) college football champions called again to congratulate Redman on his come-from-behind victory over Texas's Doug Ghim in one of the great finishes in U.S. Amateur history. Trailing by two holes with two to play, Raleigh, North Carolina native Redman's eagle-birdie finish forced a playoff, and he won on the first extra hole.

"It's got to be near the top" of his golf experiences, Redman said. "That got me a spot in the Masters and some PGA Tour events. It was an invaluable experience, and I'll forever be a U.S. Amateur champion, which is awesome."

Redman, who turned professional after the NCAA Tournament in 2018 and earned a spot on the PGA Tour in 2019, joined a long list of South Carolina–affiliated golfers who won major U.S. Golf Association amateur

titles. The most impressive amateur accomplishment was by the late Carolyn Cudone of Myrtle Beach, who from 1968 to 1972 won five consecutive U.S. Women's Senior Amateur titles.

Other winners include former Clemson players Kevin Johnson, D.J. Trahan and Corbin Mills, who won the now-defunct U.S. Amateur Public Links in 1987, 2000 and 2011, respectively; former University of South Carolina player Brett Quigley (1987 U.S. Junior Amateur); Furman women's players Alice Chen and Taylor Totland (2017 U.S. Women's Amateur Four-Ball); and former Furman men's player Todd White (2015 U.S. Amateur Four-Ball, with Nathan Smith).

Each achievement is a highlight of a career. But the U.S. Amateur—men's or women's—is at the top for nonprofessional golfers. Four South Carolina–linked golfers can claim such an achievement.

Furman's Bruce Fleisher captured the 1968 U.S. Amateur. Charleston native Beth Daniel won the Women's Amateur in 1975 and 1977 while becoming an All-American at Furman. And in 1989, Simpsonville native Chris Patton, another Clemson product, became the state's second men's Amateur titlist.

While not a USGA event, the NCAA championship individual title is also one of amateur golf's top titles. In 1975, Wake Forest golfer Jay Haas—a forty-year resident of Greenville, South Carolina—won the men's NCAA title. Columbia native Charles Warren duplicated that feat at Clemson in 1997. Women didn't compete for NCAA titles until 1982, but Florence native Kathy Baker-Guadagnino won the inaugural individual title while at Tulsa; in 2011, Austin Ernst, a native of Conway, took home the individual title for LSU.

Some were also members of championship teams—Baker-Guadagnino's Tulsa squads won three national titles (AIAW and NCAA), while Daniel helped lead Furman to the 1976 AIAW crown—but often the winners were surprises to golf experts and even themselves.

Patton, a self-described "country boy" who weighed nearly four hundred pounds then, overcame insensitive jokes about his size to claim his title. Warren rode a final-round rally and sudden-death playoff to take home his championship six years before Clemson won its 2003 NCAA team title.

And then there was Redman, who overcame major hurdles en route to the best week of his amateur career.

THE COMEBACK KID: DOC REDMAN

Through thirty-six holes of stroke play to determine the sixty-four players to contend in match play, Redman—who also reached match play at the 2016 Amateur—was one of thirteen players tied for the final eight spots. At the first playoff hole, his 5-foot par putt got him safely in.

"That was a fresh start for me," he said. "I knew I was one of the better players [in the Amateur] and was playing well. Once I was in, I figured I had as good a chance as anyone."

Redman won his first five matches and got off to a hot start in the thirty-six-hole final. Called Clemson's best putter ever by coach Larry Penley, Redman had a string of twelve one-putt greens over the first eighteen holes while shooting a 66—but Ghim kept pace with a 67 that left him one back after eighteen holes of the scheduled thirty-six-hole match.

In the afternoon, "we both played well again, but the course was getting windier and firmer," Redman said. Ghim took his first lead with a birdie at the thirteenth hole, and a par at the match's thirty-fourth hole left him needing only to halve one of the final two holes to clinch the win.

At Riviera's par-5 seventeenth hole, Ghim was just off the back of the green in two shots, and his chip left him with a putt for birdie. But then

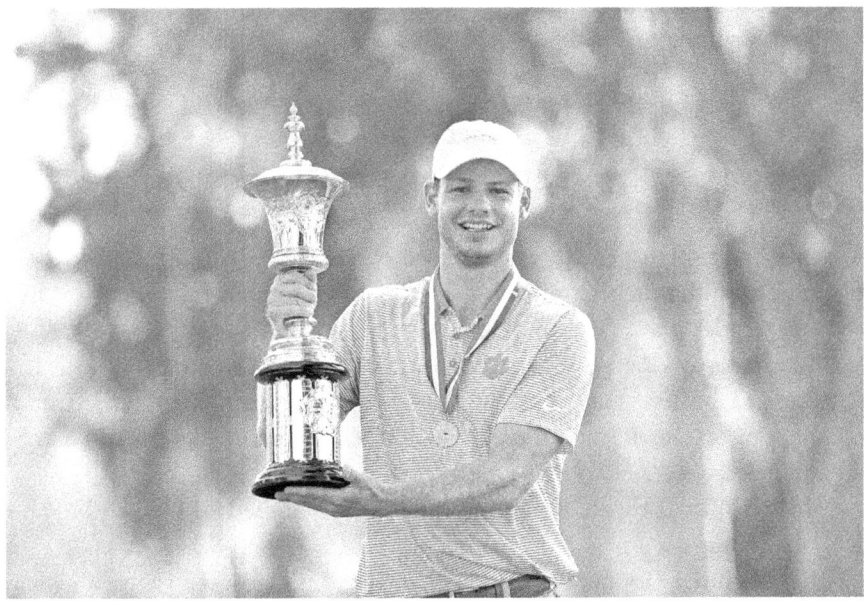

Doc Redman of Clemson hoists his trophy from capturing the 2017 U.S. Amateur Championship. *Courtesy of Clemson University.*

Redman—who also reached the green in two—rolled home a sixty-foot putt for eagle.

"I had a lot of confidence" before the putt, Redman said. "I had putted well, and I thought I saw the line well." The putt broke a few feet to the left, and "I moved to where I could be looking as it went in. It was a clutch situation, it had to go in—and it did."

Redman said after that putt Ghim "was a little rattled," but he regained his composure with his tee shot at the par-4 eighteenth. Redman's drive was slightly right with his line to the green obscured by trees, but his fade approach stopped ten feet below the hole. His birdie putt to deadlock the match was "in all the way," he said.

Losing his two-hole lead apparently unnerved Ghim on the playoff hole. Redman played two solid shots to the green, but Ghim's tee shot flew left, and three shots later, facing a putt for bogey, he conceded the match.

Redman afterward told USGA.com, "It was about never giving up and believing in myself." He credited Clemson sports psychologist Cory Schaffer for that attitude. "He made me more mentally resilient. I had played well for thirty-four holes and there was no reason to be down about whatever happened on seventeen and eighteen.

"If he won, I knew I didn't beat myself. I was prepared either way—but it wasn't surprising to me that I made those putts."

Dabo Swinney, no doubt, felt the same way.

First Time's the Charm: Beth Daniel

Like Redman, Beth Daniel was nineteen when she burst onto the U.S. golf scene by winning the first of her two Women's Amateur titles in 1975. But the tall, slender player was more of a novice to USGA events.

"I started working with [instructor] Derek Hardy when I was fifteen," she said. "The first year, we spent changing my swing plane, and I started playing better. Derek said to my parents, 'Beth should try to play in a U.S. Amateur.'

"[In 1975] I decided to sign up. I went there, qualified for match play, and won the thing."

At Brae Burn Country Club in West Newton, Massachusetts, a classic Donald Ross design, "from the get-go, I felt comfortable on the golf course," Daniel said. "Growing up on a Seth Raynor design [1920s-era Country

Charleston native Beth Daniel, an All-American at Furman, won two U.S. Women's Amateur titles in three years. *Courtesy of LPGA Photo Archives.*

Club of Charleston], there were a lot of similarities, so that was a comfort zone for me."

Daniel earned a spot in the match-play field via an eighteen-hole qualifier and then rolled to the finals. Along the way, she beat such notables as future fellow Hall of Famer Nancy Lopez and renowned amateur Carol Semple Thompson.

Her closest match came in the semifinals, where she faced Noreen Freel (now Mohler); Daniel missed her approach to the eighteenth hole to the right, but "I pitched it to three feet and made par, and everyone seemed amazed," she said. "I knew that shot because I played [the Country Club of Charleston] all the time." Daniel won on the nineteenth (first extra) hole.

Her competition in the finals, Donna Horton, was a North Carolina native with whom Daniel had played in junior golf and knew well. Familiarity showed as Daniel defeated Horton 3 and 2. "It was a pretty special week," Daniel said. "I had no expectations, which was a good thing. No one expected anything from me, so I went in there under the radar and won the darn thing."

Daniel defended her title in 1976 at Del Paso Country Club, near Sacramento, California, but this time Horton (now White) won over Marianne Bretton, 2 and 1. Daniel was low qualifier but lost in the first round.

In 1977, Daniel was on her way toward an LPGA and Hall of Fame career. At Cincinnati Country Club, "I went in with all the expectations, unlike my first time," she said. "I wasn't as comfortable as I had been at Brae Burn, though, so I consider that a really good, tougher win."

In the finals, her opponent was Canadian Cathy Sherk, who presented Daniel with a Canadian flag after their match. Hardy, her old instructor, had flown in for the final, and standing on the tee at the sixteenth hole, Daniel was 3-up and couldn't lose in regulation.

Sherk made it interesting, holing her second shot on the par-4 sixteenth. But Daniel closed it out on the seventeenth, winning 3 and 1. A year later, in a repeat of 1976, the previous runner-up (this time, Sherk) would win.

Capturing the Women's Amateur in her first try was special but winning twice was all that and more. "Absolutely," Daniel said. "Anytime you win a USGA title, it's special. To have won two is even more so."

In her thirty-four-win LPGA career, Daniel twice almost won the "other" USGA title—the Women's Open—but fell short. Still, as she demonstrated in 2019 by serving as co-chair for the Women's Open at her home course in Charleston, the organization and its competitions remain preeminent to her.

In a 2019 USGA.com interview, Daniel reflected on her two championships. In 1975, "I remember we only made [motel] reservations day-to-day," she said. "I was such an unknown....I really just took each day as it came."

In 1977, "it was much tougher....There were high expectations," mostly hers. "I really wanted," Daniel said, "to prove the first time wasn't an accident."

BIG MAN, BIG GAME: CHRIS PATTON

Like Daniel, Chris Patton won the first U.S. Amateur he ever entered. But in 1989, Patton was a seasoned college player who, as a junior, led Clemson to a third-place NCAA finish. (Patton was twenty-first individually.) Yet when he arrived at Merion Golf Club, outside Philadelphia, the treatment he received was, he says, hardly respectful of his accomplishments—and he said that mostly had to do with his size, not his golf.

At 385 pounds, Patton looked like a football lineman. "That was the most frustrating thing, that they treated me as an overweight guy, like it was a 'miracle' I could walk eighteen holes," he said. "[TV analyst] Bob Rosburg asked me if I could make it around the last eighteen [in the thirty-six-hole finals], and [I was thinking] 'if you keep your old ass up with me, you'd be okay.'

"I was [thinking]: 'Wow, I can't believe I'm being questioned like this after three days of thirty-six holes each.' I was like, 'Hey, I live in the South. This is like semi-air-conditioned.'"

Before facing Danny Green in the finals, Patton blitzed a lineup of past and future USGA champions. Tying for third in qualifying, he beat Randal Lewis (2011 U.S. Mid-Amateur winner), 1985 Japan Amateur champion Tokohiro Nagawaka, 1984 Mid-Am winner Michael Podolak, NCAA player of the year Kevin Wentworth and 1971 U.S. Junior winner Michael Brannan.

In the finals, Patton took command at the eleventh hole when Green (who later won the 1999 U.S. Mid-Am) made double bogey. In the second eighteen holes, Green again stumbled to a double bogey at the eleventh, putting Patton 3-up. The match ended when Green took an unplayable lie at the seventeenth while Patton was making a routine par for his 3 and 1 decision.

Despite both being long-shots, Patton had little interaction with Green that day, on purpose. "Larry [Penley, his coach at Clemson] told me, don't

Chris Patton of Simpsonville won the 1989 U.S. Amateur while playing for Clemson. *Courtesy of Clemson University.*

watch his [homemade] swing," Patton said. "Mine [also forged at home] was more classically [constructed], good tempo and rhythm. Later, I found out the TV people gave Danny a hard time [on-air] about his swing, but he could play, obviously."

Patton could, too. Growing up on a three-hundred-acre cattle farm in Fountain Inn, he often hit golf shots across pastures. His game came together at nearby Fox Run Golf Club, in part because other kids—whose games were already good—refused to play with a beginner.

"I worked hard so they would want to play with me," Patton said. By the time he was seventeen, "I was shooting a lot of mid-60s [rounds] consistently. If I shot a 69, I was disappointed. If you can produce those scores, you can be competitive."

At Clemson, Patton played No. 2 as a freshman. Outside college golf, though, the cost of amateur events restricted him. "My parents were a

teacher and a farmer, so I tried to stay local, more affordable events," he said. In 1989, he had enough money for one big tournament; he chose the U.S. Amateur.

"I was the last qualifier out of South Carolina, but I won't lie, I was very ready," he said. "I knew if I played well, I'd be difficult to beat."

Patton turned professional in 1990 and competed internationally, though never making the PGA Tour. He retired in 2004 due to injuries, and today—at a trimmed-down 253 pounds—his golf mostly involves following his son, Colby, who also plays at Clemson.

"I took over the family farm [in 2007] when my mom passed away," he said. "It's fantastic being back here; we live across from my dad, so I get to be with him."

As for Colby's golf, "I'm laissez-faire—hands off," Patton said. "I wait to be asked. I'm impressed with his ball-striking—he hits it better than I did—but the thing with him is how he scores the ball and putts. When he learns to dial in his short game and be a good putter, he can win anything."

Like father, like son.

NCAA KING: CHARLES WARREN

Charles Warren reflects on his 1997 NCAA individual title with a mixture of pride and regret. Actually, the regret came a year later, when he finished second as an individual; more painfully, his Clemson team shot a record-breaking score but finished second.

In 1997, Warren won the Atlantic Coast Conference individual crown (his Tigers also won the team title), and he finished third at the NCAA regional, where Clemson was runner-up. "I had a lot of momentum [in the NCAA Finals], and that course [Conway Farms, in Lake Forest, Illinois] was a good one for us," he said. The Tigers shot a collective 17-under par, but Pepperdine—led by future PGA Tour player Jason Gore—built a large lead and won the team competition.

In the final round, Gore held a one-shot lead, but his double bogey on the final hole dropped him to a tie for third. Texas's Brad Elder seemed likely to claim the title but finished with a 1-over 72; Warren shot 4-under 67, the Tigers' best score of the week.

"We were playing as teams, so I wasn't playing with those guys I was competing with [individually]," Warren said. "Larry [Penley, Clemson's

coach] started following me midway around the back nine, so I figured something was happening."

At the sixteenth hole, "I had a good idea I needed at least pars the last three holes," Warren said. His 6-iron shot from a fairway bunker "ran up the flagstick" to set up a par, and pars at the final two holes left him tied with Elder.

Elder's tee shot on the first playoff hole veered right, and Warren's steady par was good for the title. Winning that final hole was the first time he led in the entire tournament.

"Without a doubt, that was the defining moment of my career, because what most people associate me with is the NCAA," he said. Warren played several years on the PGA Tour before taking his current job in commercial insurance with Arthur J. Gallagher.

In 1998, as a senior at Albuquerque, New Mexico's University Course, Warren had a chance to repeat, and the Tigers might've won their first team crown. Instead, Warren made par on the par-5 final hole to lose by a shot to Minnesota's James McLean, and Clemson shot 31-under—an NCAA record—only to see the University of Nevada–Las Vegas finish at 34-under.

"My senior year, we should've won," Warren said. That was a more bitter loss than not winning the individual title again, he said. "I had a good chance to make birdie [on the final hole] but didn't come through."

One lasting memory from 1997 occurred later. At the team hotel, "three random guys" approached, and one asked if Warren and his friends were golfers. "He said 'I just love the Clemson logo, love the shirt.' So all five [Clemson players] signed my shirt and gave it to him."

Three years later, a Las Vegas casino host approached Warren, asked if he was "a Clemson guy" and if he knew any golf team players. "He said, 'I've got something for you to take to them,' and the next day he gave me a bag with that shirt from that night at the NCAA. So I got my shirt back."

The autographed golf shirt now hangs in Warren's closet but could become a piece of Clemson memorabilia. "I'll probably give it to Larry so he can put it up in the [team] clubhouse," he said. Perhaps it will appear alongside Clemson's 2003 NCAA team trophy.

Columbia native Charles Warren won the 1997 NCAA Championship individual title as a player at Clemson. *Courtesy of Clemson University.*

OVERCOMING BARRIERS

South Carolina African Americans in Golf

S omewhere, Adrian Stills has a copy of the November 15, 2010 issue
of *Golfweek* magazine—the one featuring a photo of him and the story
of how he became, as he put it, "the ultimate golf Trivial Pursuit
question."

That week, the Pensacola, Florida native and general manager/head
professional at his hometown Osceola Golf Course since 2003—as well
as a four-time NAIA All-American at South Carolina State College (now
University) in the 1970s—was still the most recent African American to earn
a PGA Tour card by way of the Tour's Qualifying School, a span of twenty-
five years. (Tiger Woods, who joined the Tour in 1996, bypassed "Q School"
by winning a tournament.) An honor? Well…sort of.

Actually, Stills said then, his quarter-century "streak" was more about the
difficulties facing all Black golfers—mostly money and opportunity—trying
to reach golf's ultimate level.

Six weeks after the article appeared—talk about timing—Stills's record
since 1985 came to an end, as former Stanford player Joseph Bramlett
survived Q School to earn his card for 2011. No one was happier than Stills,
who as a teaching pro works to open doors for aspiring Black professionals
and amateurs.

"It was fantastic to see him [do that]," Stills said. As for the future of
African American aspirants to the PGA Tour, though, "I think it's even more
difficult now," he said. Today, players qualify for the "big money" tour via
the Korn Ferry (formerly Web.com) Tour, a route requiring less luck than Q
School but more time and expense.

Adrian Stills, former S.C. State All-American golfer, is now the longtime head professional and general manager at Osceola Golf Course in Pensacola, Florida. *Courtesy of Adrian Stills.*

Stills played the 1986 PGA Tour season and earned a spot in the U.S. Open but failed to keep his playing privileges and ultimately decided to teach instead. That experience is why he became part of Advocates USA, a group of Black men in golf committed to making a difference for their successors.

"I was asked to do a clinic in Las Vegas [in 2009], and we raised $15,000 to give out $1,500 scholarships" for aspiring minority players. Afterward, Stills told the event's chairman that "[1970s Black Tour players] Lee Elder and Charlie Sifford would play small events to get experience. And he said, 'Why don't we recreate that?'"

Thus was born a ten-event developmental tour, which each year puts 125 mostly minority players on regular PGA Tour courses with "a chance to sharpen their skills, and not cost them an arm and a leg." In 2019, the Advocates' leading money winner earned $52,000; the tournaments also offer kids' programs, career development and more.

Stills, sixty-three in November 2020, remembers when money and access weren't the only things holding back Black golfers. In 1974, he and his father attended the Monsanto Open in Pensacola, where Lee Elder won to become the first Black man to qualify for the Masters, a day Stills recalls with misty eyes.

The history of African American golf, in South Carolina and elsewhere, is a history of racial barriers and frustration. Forget the PGA Tour; once, just getting on a golf course recreationally took determination and, often, bravery. Yet Stills and others refused to be denied the right to play a game they loved. Today, barriers of economics and opportunity remain—and he and others work to tear down those barriers, too.

A CITY COMES TOGETHER: ORANGEBURG'S HILLCREST GOLF COURSE

In 1896, John Shippen—son of a Black man and a Shinnecock Indian—was the first African American to play in a U.S. Open, at New York's Shinnecock Hills, though not without white players protesting. It would be a half century before Ted Rhodes became the second Open contestant of color in 1948. By the 1960s, progress was coming, if slowly. Sifford was the first Black player to earn a PGA Tour card in 1961, the same year the PGA of America removed its "Caucasian-only clause" from its bylaws. In 1963, tennis legend Althea Gibson—from Silver, South Carolina—became the first African American woman to compete on the LPGA Tour.

In 1973—five years after the horrific Orangeburg Massacre, when three South Carolina State students were killed by Highway Patrol gunfire following protests over a segregated bowling alley—school president Dr. Maceo Nance Jr. was seeking a way to bring white and Black citizens of the town together. An avid golfer, Nance partnered with city administrator and golfer Bob Stevenson, a white man, to get funding to turn SC State's two-hundred-acre dairy farm into a city-owned recreational complex, dubbed Hillcrest, including a golf course, open to all.

The land was leased to the city for one dollar for fifty years, and SC State students and faculty received reduced rates, while the SC State golf team (founded in 1970) played and practiced for free. "We were running around trying to find some place to play golf," Nance told the *Times & Democrat* newspaper in 1998, Hillcrest Golf Course's twenty-fifth anniversary. "The nearest place was Columbia. There was no place for most of the citizens to play in this community—not only Blacks, but [many] whites."

Governor John West opened the facility on September 1, 1973. "We've come a long way," Nance, now deceased, said in 1998. "A lot of people are playing golf in the community, and if not for Hillcrest, they wouldn't be playing."

Stills—who followed his older brother, Royce, to SC State, both on golf scholarships—played his college career at Hillcrest. Bulldogs men's teams ultimately won seven Mid-Eastern Athletic Conference titles, three National Minority College Championships and two National Minority Invitational Championships, before the program was suspended in 2009. SC State's women's teams played from 2003 to 2016.

Among other attendees at that 1998 ceremony was future Congressman Jim Clyburn, a member of West's staff in 1973. He told the *Times & Democrat*,

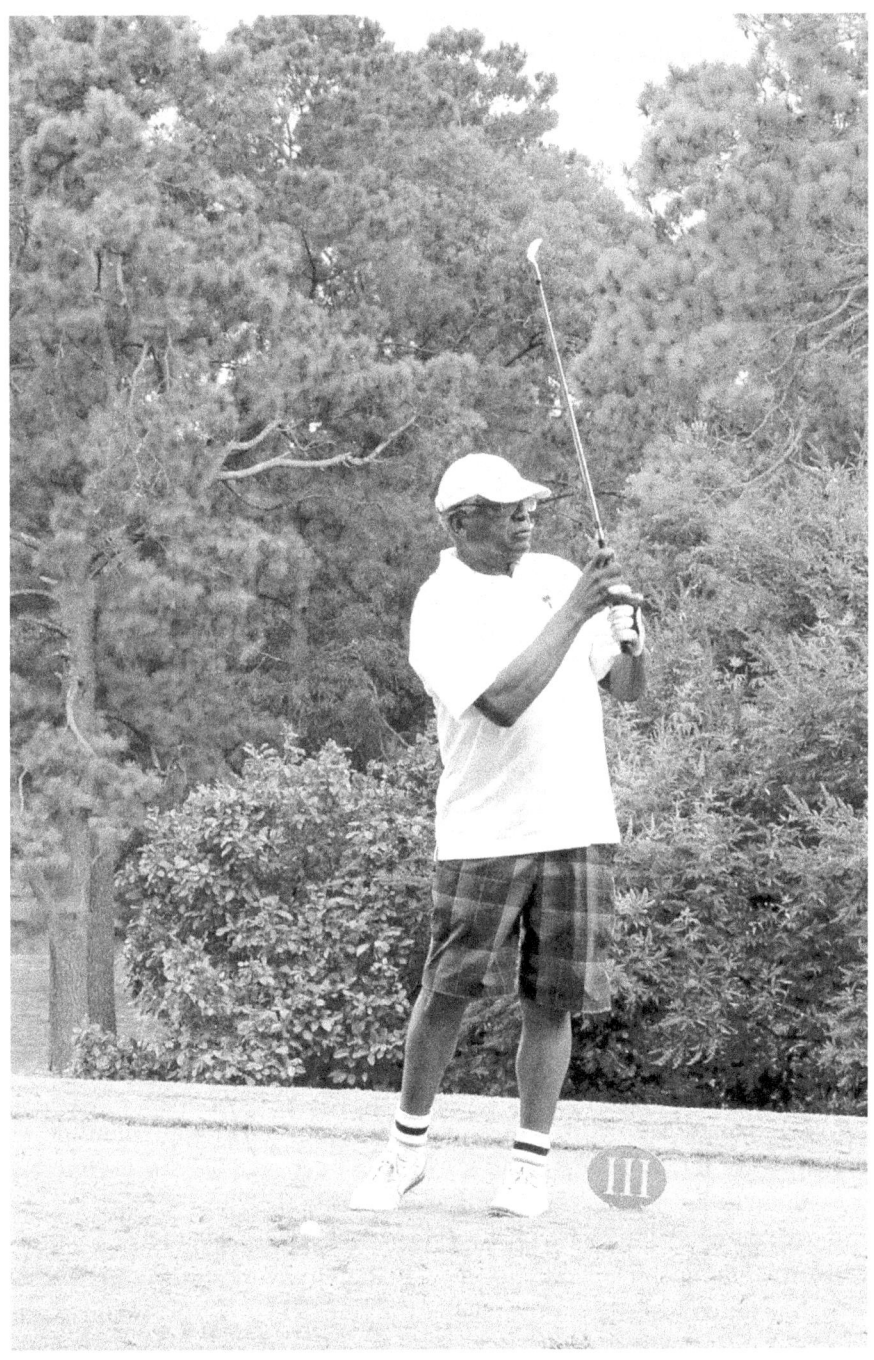

Congressman Jim Clyburn has been an avid golfer since age nine. *Courtesy of the Office of U.S. Representative James E. Clyburn*

"If we use the kind of vision that went into this facility 25 years ago…we will be able to enhance the quality of life to secure our children's future."

Also on hand in 1998 was Martin Roache, another former Bulldogs All-American. "This is where I grew up playing golf.…Dad [Hillcrest commission member Lewie Roache] and mom would drop me off out there and I'd stay out here all day," he said. "I'm grateful for Hillcrest because it's really propelled me in my career."

BEATING SEGREGATION ONE HOLE AT A TIME: JAMES E. CLYBURN

Clyburn went on to become U.S. House of Representatives majority whip and a major player in Democratic politics. In 2007, the City of Columbia named its inner-city golf facility the James E. Clyburn Golf Center. He still played regularly into his eighties, mostly at Fort Jackson Golf Course and Woodlands Country Club in Columbia and the formerly all-white Orangeburg Country Club, and makes no secret of his love of the game.

"Golf has helped me build bridges among my [congressional] colleagues on both sides of the aisle," he told Columbia's *The State* newspaper. "I always say if I play a round with a guy, I can tell you a whole lot about him."

Each year, Clyburn plays in numerous charity and scholarship golf outings, including the "Grand Clyburn," a Congressional Black Caucus fundraiser, and the Rudolph Canzater Memorial Classic, named for a late friend and playing partner. The Canzater has funded more than three thousand scholarships to SC State and South Carolina.

But unlike Stills and, later, Roache, whose fathers were golfers, Clyburn's path to the game was more typical of a Black man growing up in the 1940s and 1950s.

When James was seven, his father, Enos, a Presbyterian minister in Sumter, gave him a wooden golf club and rubber golf ball for Christmas, even though the elder Clyburn had never played the game. "I don't know why my dad did that," Clyburn said. Maybe, he speculated, his father recognized in his son a competitiveness that golf would satisfy.

"It's so individualized, just you against the elements," Clyburn said. "You can be competitive and not have to rely on others. And I really do believe we reap what we sow, so a sport where you're obliged to call penalties on yourself…helps mold you into a much better person."

The James E. Clyburn Golf Center in Columbia is testament to the congressman's support for golf with inner-city youngsters. *Photo by Bob Gillespie.*

Growing up, Clyburn dug holes in his family's yard and hit the rubber ball from one to the other and later built a "course" at his father's church, playing with hand-me-down clubs and learning from a family friend who caddied at Sumter's Sunset Country Club. As a student at SC State, he hit balls on the ROTC drill field, and while a teacher in Charleston, he played at an all-Black course and later at the city's Municipal Golf Course.

Clyburn saw Governor West use golf to advance desegregation. One day, West took Clyburn to play at Santee-Cooper Resort, which had a white-only policy. "John West was always in his own way challenging those things," Clyburn said. "It wasn't about me; it was about the institution of racism."

When Clyburn ran the state's Human Affairs Commission (1974–92), he and a friend, using American Cancer Society Cards good for golf discounts, would "get a white girl to call a club we knew wasn't integrated and make tee times, then we'd show up," he said. One day, the two men decided to play in Dillon. "Someone said, 'They don't have any Black people playing out there,'" Clyburn said. "I said, 'They're going to have some today.' We walked in, presented the cards...what could they say?"

Clyburn also recalled how two sheriff's patrol cars were waiting in the parking lot when he and his friend finished that day. "I walked in and said, 'Sheriff Lee, how you doing, man? I didn't know you played golf.' He looked up, said, 'Clyburn? I didn't know that was you out there.'"

As a first-term congressman, Clyburn helped organize a Congressional Black Caucus charity tournament. When a representative from Kansas "was convinced he could beat me at golf," Clyburn—who believes golf without a bet isn't golf—said, "I relieved him of a lot of 'cabbage.'"

Clyburn worked with Bank of America executive (and future Masters chairman) Hootie Johnson of Columbia to end segregation in banking, and later Johnson invited him to play Augusta National. Johnson, now deceased, said in 2007, "I don't remember what his handicap [once as low as a 10] was, but he took $5 off me."

Stills has a Clyburn story, too. "In 2015, I was elected to the National Black Golfers Hall of Fame," he said. "In Tampa, I check into the hotel, and I thought I recognized this man. He looked me in the eye and said, 'Mr. Stills? Representative Clyburn.' He was the guest speaker.

"I said, 'I haven't seen you since...' and he finished my sentence: 'South Carolina State.'"

SC STATE'S ALL-AMERICANS: ADRIAN STILLS, MARTIN ROACHE

Martin Roache, an Orangeburg native, grew up playing Hillcrest with his father, Nance and Dawson—"three great men and me in a foursome," the one-time mini-tour professional said. Roache played for Orangeburg-

Former SC State All-American golfer Martin Roache (*center*), with school president Thomas Elzey (*left*) and athletics director Paul Bryan. *Courtesy of South Carolina State University.*

Wilkinson High's golf team, and when he moved on to SC State, his father—a vice president at the school—traveled with the Bulldogs team.

While at SC State, Roache met Stills, his All-American predecessor. Later, when Roache and Stills both played the Golden Bear Tour, they shared a house. After finishing college in 1992, "I bounced around several tours" in the two Carolinas and Georgia, Roache said, barely missing the PGA Tour via Q School and playing in South America from 1999 to 2002.

As with other young players, especially African Americans, expenses cut short his pro career. "I got tired of having to raise money," he said. "You've got to be on the [PGA Tour] to make money, and I was getting older and the players were getting better every year." After working in various real estate jobs, in 2018 he moved to Bluffton, where he sells properties in Palmetto Bluff, home to May River, one of South Carolina's finest golf courses.

When Tiger Woods won the 1997 Masters, golf experts predicted a "Tiger Effect" would bring more minorities into the game at all levels. As Stills would testify, that didn't happen at the professional level, and twenty-plus years after Woods's first major championship, it largely hadn't at the youth levels, either.

Roache hoped to be part of that "Tiger Effect" wave at the professional level but learned how tall a climb that was. Now the father of a son and a daughter who both play golf, he understands their hurdles as well.

"At the highest levels of Black college golf, I was the best in America for two years [as National Minority champion]," he said. "But it takes exposure, access and especially money to play the best golf courses…and that's to get to college.

"Growing up, I never played the private club in my hometown [Orangeburg Country Club since has opened to all races], so what kind of access is there to play May River, or [Graniteville's] Sage Valley or whatever the best is in Columbia? It takes more than a kid being inspired by Tiger Woods to get to that level. Money and finances are the elephant in the room, and that issue isn't color-blind, either."

Roache admits he was lucky, growing up with golf and playing with his dad and SC State higher-ups. He had other role models, too, some of whom helped bankroll his brief pro career: Frank Tourville, owner of Orangeburg Country Club, and a local dentist, Kevin Williams.

Iconic former SC State football coach Willie Jeffries, still a part of the Orangeburg scene, "had more impact on my career" than anyone, Roache said. "He's had a far-reaching effect on every athlete to come through South Carolina State. He introduced me to people who helped me. He'd tell me, 'Marty, you just need more chances.'"

In 2014, Roache was inducted into the SC State Hall of Fame, joining two other golfers: the late Ralph King, a Columbia amateur, and Stills. Will there be more in the future? Roache and Stills admit they don't know, but say they'll do what they can to help it happen.

"My sons [Justin and Joey] are good golfers, and even better, good people," Stills said. "We want kids playing golf because it's a networking tool, a way to build relationships. I've been playing golf for fifty years, starting when I was ten. I look forward to keeping on sharing that."

A FIELD OF DREAMS

Options for African American golfers in Charleston were limited before the Municipal Golf Course was integrated in 1961. On November 1, 1958, twelve African American men wrote a letter to Charleston City Council addressing their right to play. Later that year, two African American golfers, Jack White

and Clarence Brown, were turned away. Charleston City Council threatened to sell the golf course, but a stipulation in the deed stated that the property had to remain a public golf course or it would revert to the family that sold the property. The battle ended on May 26, 1961, when the course was integrated "with no incidents." Jack White was the first player to hit a ball that day.

Before Municipal was integrated, Black golfers had few options. Those with military connections could play the nine-hole course at Charleston Naval Base or travel several hours to Wilmington, North Carolina, to a city course that had already been integrated. Or they could travel to James Island, where in the 1950s Richard "Lunk" Smalls built his own six-hole field of dreams.

Smalls, who caddied as a youngster at Charleston Municipal and at the Country Club of Charleston, borrowed $900 from a local finance company in the early 1950s and purchased 7.8 acres of property on Grimball Road, telling the sellers he was buying the land to farm because he didn't think they would let him purchase the property if he planned to build a golf course.

Smalls slowly began acquiring worn-out equipment—a tractor, mowers, cups and flagsticks—and dug a pond that filled with rainwater for irrigation. He built a two-story clubhouse and rented rooms to out-of-town golfers. He named the place Little Rock Golf Club because of all the small rocks he found while clearing and planting the course. Most of what is known today about Little Rock is anecdotal. There were anywhere from one to four par-4s, while the rest were par-3s.

"You play Little Rock, you'll play any golf course. It was narrow," Jack White, the man who helped spearhead the integration of Charleston Municipal Golf Course, told the Charleston *Post & Courier* in 2004. "The first hole, the tee was right behind the club, the fairway straight ahead. To the right was a cornfield, right alongside the doggone fairway. So you better not go out of bounds, out in that cornfield. First, you'd have trouble finding your ball. Second, you ain't gonna get no free drop."

White said golfers had to arrive early if they wanted to play. The cost was two dollars for six holes, and if you wanted to play more, you had to come up with another two dollars.

Walker said the club was a "structured, organized group of men and women that was used for practicing and playing." That structured club was the beginning of Port City Golf Club, which still holds tournaments at Municipal Golf Course.

When Municipal was integrated, the need for Smalls's layout died out. Eventually, the property was sold, and it is now a housing development.

THE WAR BY THE SHORE

Ryder Cup 1991

From an American viewpoint, the drama of the 1991 Ryder Cup Matches played at Kiawah Island Golf Resort's Ocean Course could not have been scripted any better.

Golf's balance of power had shifted overseas. Seve Ballesteros, Nick Faldo, Bernhard Langer and Ian Woosnam had won six of the previous twelve Masters and four of eight British Opens. Europe had ended a U.S. stranglehold in the biennial Ryder Cup team competition in 1985, won again in 1987 and retained the Cup with a tie in 1989. Ballesteros said the American golfer would not admit that the Europeans were better, and in turn the Americans felt like the Europeans were rubbing in their recent successes.

Making the '91 Ryder Cup even more contentious was the fact that the event had been nicknamed the "War by the Shore," playing off the recent Gulf War known as Operation Desert Storm. The Americans wore Desert Storm camouflage hats, and the allies in the Gulf War were cast as bitter rivals, a feeling that echoed through the galleries until the final match, the final hole, the final putt: Hale Irwin versus Bernhard Langer for all the marbles on Sunday. Europe could keep the cup with a tie, but the United States needed a half point from Irwin to regain possession of Samuel Ryder's trophy.

Langer, who had been 2-down to Irwin, brought the match back to even with wins on the fifteenth and seventeenth holes. Irwin hit an errant drive into the wind on the par-4 eighteenth, missed the green with his 3-wood, chipped to twenty feet and then missed his attempt for par with Langer

The American team celebrated its victory over Europe in 1991's War by the Shore Ryder Cup matches with a photo in the dunes near the Ocean Course's eighteenth hole. *Courtesy of Kiawah Island Golf Resort.*

conceding the bogey. Langer reached the green in regulation but rolled his first putt six feet by the hole.

The stoic German needed to make this to keep the Ryder Cup in European possession. But his putt slid just over the right edge of the hole. Langer's knees buckled as he brought his putter to his head in dismay. The half point gave the American team a $14\frac{1}{2}$-$13\frac{1}{2}$ win.

Loud cheers erupted from the crowds gathered around the green: "U-S-A! U-S-A!" and "Hale Yes!" The euphoric Americans picked up their captain, Dave Stockton, and carried him across the dunes and gave him a celebratory toss into the Atlantic Ocean.

IN THE SPOTLIGHT: KIAWAH'S OCEAN COURSE

How this storybook Ryder Cup came to Kiawah Island, South Carolina, is a tale all its own. As a resort, Kiawah Island had endured its ups and downs. But on May 18, 1989, just a few months after Landmark Land Co. purchased the resort, a press conference was called in downtown Charleston. There, PGA of America officials announced that the 1991 Ryder Cup was being moved from PGA West, another Landmark property in La Quinta, California, to Kiawah Island, which at the time had three golf courses: Cougar Point designed by Gary Player, Turtle Point designed by Jack Nicklaus and Osprey Point designed by Tom Fazio.

The Ryder Cup, however, was going to be played in just over two years on a fourth course on the eastern end of the island designed by Pete Dye. If the Ocean Course wasn't ready, then the event would be played at Turtle Point. A big reason for moving the event to the East Coast, the PGA of America said, was the ability to broadcast the event in prime time to Europe, something that was impossible four time zones to the west.

"I don't think any of us had any idea that was coming," said Brian Gerard, now the director of golf for the resort but at the time a young assistant professional who worked at Turtle Point. "We were excited when Landmark purchased the resort because of their history and their other properties—PGA West, Mission Hills [California] and Oak Tree in Oklahoma, Palm Beach Polo."

Gerard said the golf employees knew there was room for a course on the end of the island, but until Landmark made its announcement, the area that would become the Ocean Course was a remote jungle that the resort used for Jeep safaris. The swampy area where Dye was going to build his golf course was filled with windswept scrub oaks and inhabited by deer, alligators, rattlesnakes and all sorts of bird life.

Dye, at first, was reluctant to get involved with the project. He was involved with another project nearby, Secession Golf Club in Beaufort, South Carolina, but after looking at the Kiawah property told Landmark official Joe Walser, "I'll kill you if you don't let me build it."

Ocean Course architect Pete Dye credited his wife, Alice. with the suggestion to raise the fairways so golfers would have a view of the nearby Atlantic Ocean on every hole. *Courtesy of Kiawah Island Golf Resort.*

As Dye and his crew cleared the underbrush, the course slowly began to take shape. There was plenty of pressure to get things done in a timely manner in a fitting way for a Ryder Cup, and Dye faced incessant challenges from the ocean breezes that overnight would reshape the sandy soil that had been sculpted the day before. He eventually put in a special irrigation system to wet the sand at night so it wouldn't blow away.

"When this golf course opens, it can't be just any old golf course. It's got to be Miss America," said Chris Cole, president and project director of Kiawah Island Golf and Tennis Club at the time.

Four months after the Ryder Cup announcement, with many of the PGA of America and Kiawah officials at the Belfry in England for the 1989 Ryder Cup matches, another story was brewing in the Atlantic. Hurricane Hugo was headed for South Carolina and would make landfall on September 22 at

Pete Dye was presented with the ultimate piece of property when he was chosen to design the Ocean Course at Kiawah Island Golf Resort. *Courtesy of Kiawah Island Golf Resort.*

Sullivan's Island, just a few miles up the coast from Kiawah Island. Television news coverage of the Category 4 hurricane with 140-mile-per-hour winds painted a bleak picture, and indeed it took months for the area to rebound.

Because Kiawah Island was in the southern quadrant of the storm, the damage was not as severe, and Dye and his crew were able to resume work after only a short stoppage.

The front nine played from the middle of the property out to its easternmost point, four holes out, a turn on the fifth hole and four holes back. There was a big gap between the ninth green and tenth tee, something Dye blamed on a misplaced survey stake by a government entity. The back nine played in the opposite direction, four holes out, a turn on the fourteenth hole and five holes back. And every hole had a view of the Atlantic, thanks to Dye's wife, Alice, who suggested that he elevate the fairways and greens to provide that view.

Two years later, the golf course had a name—Ocean Course—and a few months before the Ryder Cup, it was opened for play. During its construction, many of the American team members had taken opportunities, prodded by their captain Dave Stockton, to visit the Ocean Course and learn its subtleties. European team members were able to offer their view after arriving in Charleston on the Concorde the week of the matches.

"It's not like something in Ireland or Scotland. It's like something from Mars," said David Feherty, who would be playing in his only Ryder Cup. Woosnam, the reigning Masters champion, called the course "unique" but added that it was "pretty good and demands that you hit your ball well."

"It is one of the toughest courses I have ever played. It's not a seaside course as we know it," said Sam Torrance.

"HALE YEAH!" USA EDGES EUROPEAN TEAM

The actual competition would begin on Friday, but on Wednesday shots were being fired in the War by the Shore. A local radio DJ obtained phone numbers of some of the European team members and began making early morning calls in a "Wake Up the Enemy" campaign. An opening banquet was held Wednesday night in downtown Charleston, an hour away from the Ocean Course, with the players transported in limos. On the way to the banquet, there was a crash involving several limos, and American Steve Pate, who had been playing as well as any of the U.S. golfers, was injured, bruising his ribs.

Pate would get to play in an afternoon four-ball match on Saturday but on Sunday was held out of his singles match. The banquet itself drew the ire of the European team members as a video presentation seemingly highlighted only American accomplishments.

Thursday's practice round and the opening ceremony went smoothly, but the competitive fires shone brightly in Friday's opening match, foursomes

(alternate shot) pitting the formidable Spanish duo of Seve Ballesteros and José María Olazábal against Americans Paul Azinger and Chip Beck.

The Spanish team struggled on the front nine, visiting spots Pete Dye had never seen while building the course, as they hit shots into marshes and lagoons and rattled balls off trees. Things began to boil on the ninth hole when Olazábal hit his tee shot into a hazard and Ballesteros asked for a favorable drop, only to have Azinger tell him to let the match's referee determine where he should drop.

The Americans won the hole to go 3-up at the turn, and things really got testy on the next tee when Ballesteros and Olazábal asked the official to rule on whether Azinger and Beck had used the wrong ball on the seventh hole. The Americans had used a ball with a different compression, but the referee ruled that the incident had to be brought up before the hole was concluded.

"Well, we certainly aren't cheating," Azinger said testily.

"We don't say that," Ballesteros said. "There's cheating, and there's breaking the rules." And he smiled and patted Azinger on the shoulder.

That moment seemingly turned the momentum, and the Spaniards went on to secure a 2 and 1 victory, something they would repeat in an afternoon four-ball rematch. Still, the Americans owned a 4½–3½ advantage after the first day.

The American team looked extremely strong after Saturday's foursome matches, winning three of four possible points in the morning session, and stretched their lead to 7½–4½. But the momentum swung like a pendulum that afternoon with the Europeans very nearly completing a sweep. Fred Couples and Payne Stewart, who were 2-up over Ballesteros and Olazábal with six holes remaining, somehow managed to scratch out a halve against the dominant Spanish duo when Olazábal missed a six-foot birdie try on the final hole.

That left the teams tied, 8–8, heading to Sunday's twelve singles matches. Europe needed to win 6 points to retain the trophy while the Americans needed to score 6½ points to regain the Ryder Cup.

Pate was unable to play on Sunday so his singles match with David Gilford was deemed a halve. The matches went back and forth. Mark Calcavecchia had a chance to earn an all-important point in his match with Colin Montgomerie when he went 4-up with four holes to play but then collapsed down the stretch. Calcavecchia lost the fifteenth and sixteenth holes with a triple bogey and bogey. On the par-3 seventeenth, both players hit their tee shots into the water and proceeded to the drop area. Montgomerie hit his next shot on the green and two-putted for double bogey, but Calcavecchia

Spectators gather on the sand dunes to watch the competition during the 1991 Ryder Cup Matches played at the Ocean Course at Kiawah Island Golf Resort. *Courtesy of Kiawah Island Golf Resort.*

three-putted and lost the hole. He also bogeyed the final hole, and his 4-up lead was gone.

Calcavecchia disappeared into the dunes to cry, thinking he had lost the trophy for the United States. But Lanny Wadkins defeated Mark James in the penultimate match to give the United States fourteen points and assure them of a tie, putting the Ryder Cup Trophy in the balance of the Irwin-Langer match, which came down to the final hole and Langer's missed six-foot par putt.

"There's no way I would ever wish what happened on the last hole on anyone. I feel extremely sorry for Langer," Irwin said. "The pressure was incredible. Being in the last group, and having a sneaking suspicion that it was going to come down to the last group....Knowing that I had not played the last five holes well—as a matter of fact, I don't know if I played them at all—with twelve other guys depending on you."

Irwin said the fans cheering "U-S-A" had taken him to the point where "I couldn't breathe. I couldn't swallow. Making the turn at 14, I could hardly hit the ball." He added, only half-joking, "The 'sphincter value' was high."

It was a Ryder Cup no one would forget and one that would elevate the event to a new level.

A decade later, Irwin told *The State* newspaper that the 1991 Ryder Cup was a great week for golf and he didn't think either team won or lost. "I think it was probably one of the few Ryder Cups that came down literally to the last blow," Irwin said.

Added Raymond Floyd, who had captained the 1989 Ryder Cup team and was selected to play in '91: "I don't think anyone that was a competitor that week will ever forget the finish. That's the most compelling, vivid thing."

Individual Results

United States
Paul Azinger 2-3-0
Chip Beck 1-2-0
Mark Calcavecchia 2-1-1
Fred Couples 3-1-1
Raymond Floyd 2-2-0
Hale Irwin 2-1-1
Wayne Levi 0-2-0

Mark O'Meara 1-1-1
Steve Pate 0-1-1
Corey Pavin 1-2-0
Payne Stewart 2-1-1
Lanny Wadkins 3-1-1

EUROPE
Seve Ballesteros 4-0-1
Paul Broadhurst 2-0-0
Nick Faldo 1-3-0
David Feherty 1-1-1
David Gilford 0-2-1
Mark James 2-3-0
Bernhard Langer 1-1-1
Colin Montgomerie 1-1-1
José María Olazábal 3-1-1
Steve Richardson 2-2-0
Sam Torrance 0-2-1
Ian Woosnam 1-3-0

Friday

FOURSOMES
Ballesteros-Olazábal (Europe) def. Azinger-Beck (U.S.), 2 and 1
Europe 1, U.S. 0
Floyd-Couples (U.S.) def. Langer-James (Europe), 2 and 1
Europe 1, U.S. 1
Wadkins-Irwin (U.S) def. Gilford-Montgomerie (Europe), 4 and 2
U.S. 2, Europe 1
Stewart-Calcavecchia (U.S.) def. Faldo-Woosnam (Europe), 1-up
U.S. 3, Europe 1

FOUR-BALL
Richardson-James (Europe) def. Pavin-Calcavecchia (U.S.), 5 and 4
U.S. 3, Europe 2
Couples-Floyd (U.S.) def. Faldo-Woosnam (Europe), 5 and 3
U.S. 4, Europe 2
Wadkins-O'Meara (U.S.) halved with Torrance-Feherty

U.S. 4½, Europe 2½
Ballesteros-Olazábal (Europe) def. Azinger-Beck, 2 and 1
U.S. 4½, Europe 3½

Saturday

FOURSOMES
Azinger-O'Meara (U.S.) def. Faldo-Gilford (Europe), 7 and 6
U.S. 5½, Europe 3½
Wadkins-Irwin (U.S.) def. Feherty-Torrance (Europe), 4 and 2
U.S. 6½, Europe 3½
Calcavecchia-Stewart (U.S.) def. James-Richardson (Europe), 1-up
U.S. 7½, Europe 3½
Ballesteros-Olazábal (Europe) def. Floyd-Couples (U.S.), 3 and 2
U.S. 7 1/2, Europe 4 1/2

FOUR-BALL
Woosnam-Broadhurst (Europe) def. Azinger-Irwin (U.S.), 2 and 1
U.S. 7½, Europe 5½
Langer-Montgomerie (Europe) def. Pavin-Pate (U.S.), 2 and 1
U.S. 7½, Europe 6½
James-Richardson (U.S.) def. Wadkins-Levi (U.S.), 3 and 1
U.S. 7½, Europe 6½
Stewart-Couples (U.S.) halved with Ballesteros-Olazábal (Europe)
U.S. 8, Europe 8

Sunday

SINGLES
Gilford (Europe) halved with Pate (U.S.)
U.S. 8½, Europe 8½
Feherty (Europe) def. Stewart (U.S.), 2 and 1
Europe 9½, U.S. 8½
Faldo (Europe) def. Floyd (U.S.), 2-up
Europe 10½, U.S. 8½
Montgomerie (Europe) halved with Calcavecchia (U.S.)
Europe 11, U.S. 9

Pavin (U.S.) def. Richardson (Europe), 2 and 1
Europe 11, U.S. 10
Ballesteros (Europe) def. Levi (U.S.), 3 and 2
Europe 12, U.S. 10
Azinger (U.S.) def. Olazábal (Europe), 2-up
Europe 12, U.S. 11
Beck (U.S.) def. Woosnam (Europe), 3 and 1
Europe 12, U.S. 12
Broadhurst (Europe) def. O'Meara (U.S.), 3 and 1
Europe 13, U.S. 12
Couples (U.S.) def. Torrance (Europe), 3 and 2
Europe 13, U.S. 13
Wadkins (U.S.) def. James (Europe), 3 and 2
U.S. 14, Europe 13
Irwin (U.S.) halved with Langer (Europe)
U.S. 14½, Europe 13½

BEST OF THE BEST

South Carolina's Major Champions

Dustin Johnson buried a lot of demons in June 2016 at Oakmont Country Club near Pittsburgh, when he sank a five-foot birdie putt on the final hole of the 2016 U.S. Open, giving him a long-awaited victory in America's biggest major championship.

The thirty-two-year-old from Columbia exorcised six years-plus of catastrophic near-misses in major championships that Sunday, and while his almost laconic response to winning the 2016 Open seemed subdued, those who knew him understood: this meant the world.

But if winning the Open was both relief and affirmation, Johnson's second major championship—at the 2020 Masters, accomplished in record-setting fashion—was something else: pure, unadulterated joy. And this time, he shed tears afterward.

After Augusta National Golf Club's traditional ceremony on the eighteenth green, where five-time Masters winner Tiger Woods draped the new winner's green jacket over Johnson's shoulders, CBS reporter Amanda Balionis asked Johnson—DJ to friends, family and fans—his reaction to winning. That's when the habitually stoic player found himself choking up, at a loss for words.

"I've never had this much trouble gathering myself," he said into the cameras, wiping his eyes. Earlier, his brother and caddie, Austin, had shed tears on the final hole, causing DJ to elbow his sibling before the emotions overcame him, too.

"On the golf course, I'm pretty good at controlling my emotions, because I'm out playing golf," Johnson said later. "I had a tough time there, just because it means so much to me.

"It means so much to my family, [fiancée] Paulina [Gretzky], the kids [sons Tatum and River]. They know it's something that I've always been dreaming about, and it's why I work so hard."

That hard work demonstrated itself in a victory for the ages. Johnson led the Masters wire-to-wire, firing a record 20-under par 268 to eclipse the previous mark (270) set by Woods in 1997 and tied by Jordan Spieth in 2015. Johnson shot a pair of 7-under par 65s in the first and third rounds—no other player had ever managed more than one round that low in a single Masters—and DJ's closing 68 gave him a five-shot win over runners-up Cameron Smith and Sungjae Im.

While the 2016 U.S. Open will always mark his breakthrough, the 2020 Masters for Johnson clearly was something special. "Just growing up so close to here, it's always been a tournament that since I've been on [the PGA] Tour, since I played my first Masters, it's been the tournament I wanted to win the most," he said.

Growing up and practicing at Weed Hill Driving Range near Columbia, Augusta was part of DJ's childhood dreams. "Always around the putting green, it was putts to win the Masters," he said. "It was always to win at Augusta."

Johnson is recognized as perhaps the most athletic and talented player since Woods, and his Masters' victory gave him twenty-four for his career, with at least one triumph every year as a professional since 2007. Three weeks later, he recorded his 107th week as No. 1 in the world, trailing only Woods and Greg Norman for career weeks atop the world rankings.

Until 2016, Johnson had lacked only a major title to fulfill his outsized promise. Yet each time he seemed poised to win one, there was a stumble or self-induced miscue—"almost freak things," in his words—that had kept him from doing so. Until the 2020 Masters, he had led all four majors through fifty-four holes without closing the deal (he came from behind in his 2016 Open win).

In 2010, he led the U.S. Open at Pebble Beach by three shots, but a string of poor shots led to a closing 82. Later that summer, with a chance to make a playoff for the PGA Championship at Whistling Straits in Wisconsin, he incurred a two-shot penalty when he grounded his club in a barely recognizable "bunker"—and afterward admitted he'd failed to read the rules sheet that defined such hazards.

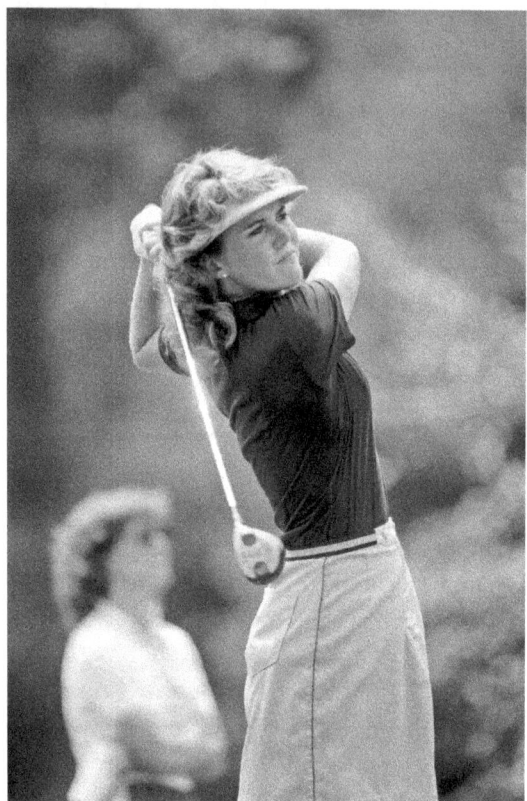

Kathy Baker Guadagnino of
Lake Wylie scored her first
professional win in the 1985 U.S.
Women's Open. *Courtesy of LPGA
Photo Archives.*

A year later at the Open Championship at Royal St. George's in England, he hit a shot out of bounds to derail his chances of catching eventual winner Darren Clarke. The worst blow came in 2015 at Chambers Bay, Washington, where he three-putted the final hole when one putt would've won and two putts would've tied winner Jordan Spieth. As recently as the 2020 PGA Championship, DJ led through three rounds only to be passed by winner Colin Morikawa.

"I think it's difficult to win out here, and a major is just that much more difficult," Johnson said. "I'd been so close so many times, and other than at Pebble…I felt like I did everything right. I played well, but just crazy things happened. Sometimes it didn't seem in my control."

Since Oakmont, Johnson had regularly contended in majors before his Masters win. A year earlier, he tied for second behind Tiger Woods in the 2019 Masters, giving him runner-up finishes in all four majors. Now, with two majors, he forever has a place of honor among the ranks of South Carolina players with major championships on their résumés.

The majors "queen" is Betsy Rawls, a Spartanburg native who won eight majors on the LPGA Tour, including four U.S. Women's Opens (1951, 1953, 1957, 1960). Five other women followed Rawls, including three members of the 1976 Furman University AIAW national championship team: Betsy King (six majors, including back-to-back U.S. Opens in 1989–90), Beth Daniel (1990 LPGA Championship) and Sherri Turner (1988 LPGA). Lake Wylie's Kathy Baker Guadagnino and Summerville's Jane Geddes won U.S. Opens in 1985 and 1986, respectively.

On the men's side, Henry Picard, a Massachusetts native who made his golfing reputation in Charleston, won the 1938 Masters and 1939 PGA. After Picard, it was seventy years until the first native-born South Carolinian, Greenville's Lucas Glover, won a largely unexpected 2009 U.S. Open at Bethpage Black on Long Island.

For some, winning a major was a crowning achievement on their careers. For others, it was a surprising highlight. For Johnson, in both of his major victories, it was something of a catharsis in a career, and a life, that was always harder than he made it look.

FINALLY BREAKING THROUGH: DUSTIN JOHNSON

A child of divorce, tall and athletic beyond his years as a youngster, Johnson ran with an older, tougher crowd. As a young teen, he and other juveniles were involved in a string of robberies masterminded by a friend's older brother, including the theft of a gun later used by the older brother to commit murder.

Try dealing with that before you've turned sixteen.

Johnson did have a support group watching out for him. Jimmy Koosa, his first golf instructor and lifelong confidant, delighted in every win by the player he'd always called "Hickory Nut" for his toughness. Coastal Carolina University coach Allen Terrell, who now runs Johnson's eponymous golf academy in Myrtle Beach, and especially his grandmother, the late Carole Jones, helped him get through his college years, though Jones's death in 2009 seemed to knock Johnson off-course for a time.

Two extended absences from the PGA Tour—self-imposed for "personal issues" or unannounced Tour drug suspensions, take your pick—raised questions about Johnson's maturity. But his engagement to Paulina Gretzky,

daughter of hockey's Wayne "The Great One" Gretzky, and the birth of their two children seemed to help put him on the path to success.

That growing maturity was evident in 2015, when his three-putt loss to Spieth left his support group in shock, and Johnson said, in effect, "Hey, no one died today." That composure would be tested again, a year later, at Oakmont.

He started the final round of 2016 four shots behind Shane Lowry, but "it's a tough golf course, and I knew if I played a good solid round, I had a really good chance to win," Johnson said. "I'd played well all week, and that Sunday, I didn't do anything special; I just didn't make any mistakes."

But a "Johnson moment" seemed poised to raise its ugly head at the fifth hole. As he prepared to tap in a putt for par, his ball seemed to move—a potential penalty stroke. An on-site official ruled Johnson hadn't caused the movement, but USGA officials began viewing video replays. When Johnson arrived at the twelfth green, he was informed the situation was under review, and he might incur a penalty—or not.

With that uncertainty hanging over him, he played on, catching the leader and moving in front. "The reason that never affected me is I knew I didn't do anything to cause the ball to move, so I believed I'd never get a penalty,"

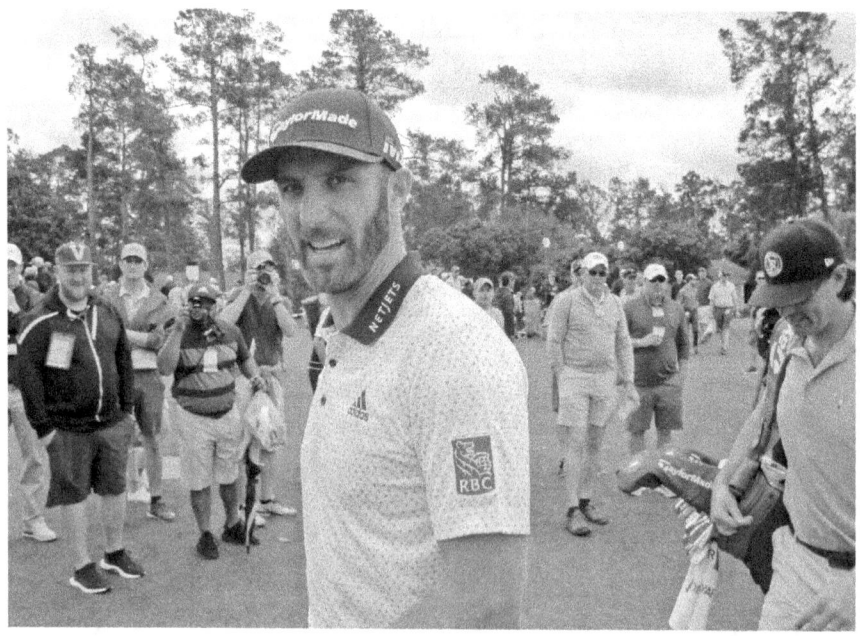

2016 U.S. Open and 2020 Masters champion Dustin Johnson of Irmo walks through the crowd during the Masters at Augusta National. *Photo by Bob Gillespie.*

Johnson said. "Even when [officials] wanted to review it afterward, I was fine with it.

"I just stayed focused on what I was doing." He smiled. "And it turned out to be a very good day."

By the time Johnson reached the final hole, his lead was four shots, and the penalty (which he was assessed after the round) was a moot point; his winning margin was three. "It seemed like they were somehow trying to get it away from me with the penalty," he said, then laughed. "For me that day, I hit a lot of good shots [and] I controlled the golf ball very well, which in a U.S. Open you've got to do."

Winning the Open changed not only the way the PGA Tour viewed Johnson but also how he viewed himself. "That was a big win for my career," he said. "It's kind of catapulted me to get where I am: No. 1."

After winning the 2020 Tour Championship and FedEx Cup titles, plus the 2020 Player of the Year award, Johnson—unseated by Brooks Koepka in May 2019—was back at No. 1 when he arrived at Augusta National, which had been delayed from its usual April dates to November due to the Covid-19 pandemic. In an ironic twist, Johnson was not the pre-Masters favorite; instead, the smart money was on 2020 U.S. Open winner Bryson DeChambeau and perennial Masters hopeful Rory McIlroy.

From the first day, though, Johnson sat atop the leader board, and after his second 65 on Saturday, he lead the field by four shots. His pre-tournament putting work with Greg Norman, a World Golf Hall of Famer, showed as he finished with just four bogeys in 72 holes, another Masters record. Yet he admitted after his triumph that his Sunday was hardly a walk in the park.

"It was a battle all day, an internal battle with myself," Johnson told reporters. "It never got easier. I thought it would, but it never did, not from the first tee until the last putt. Yeah, the first major is the hardest, but the second one is just as hard."

After struggling pars on the first two holes Sunday, Johnson birdied the third hole before back-to-back bogeys at the fourth and fifth holes cut his lead over Sungjae Im to a single stroke. But DJ then hit his shot at the par-3 sixth hole to seven feet and sank the birdie putt, while Im bogeyed.

From there, Johnson asserted his dominance. A birdie at the par-5 eighth hole gave him some breathing room, and three straight birdies at the thirteenth, fourteenth and fifteenth holes put him firmly in control.

Until, that is, the eighteenth green, when his brother's tears forced Johnson to refocus on his final putts. Then it was time to celebrate—and let loose a flood of emotions.

"I played unbelievable golf all week," Johnson said afterward. "It's an incredible feeling. Dreaming about winning the Masters as a kid and having Tiger put the green jacket on you; it still feels like a dream."

The victory erased any lingering questions about Johnson in majors. In 2016, he overcame adversity and rallied to win; in 2020, he held off all challengers. "This definitely proved I can do it," he said. "There were doubts in my mind…(but) I knew I was playing well enough to do it."

The Johnson of past years—whose demeanor rarely displayed emotions—was this day a thing of the past. "I couldn't be more happy," he said, and grinned hugely. "And I think I look pretty good in green, too."

THE QUIET CHAMPION: BETSY KING

Betsy King knows about No. 1. Over six seasons, 1985 to 1990, the Pennsylvania native won twenty LPGA Tour events, more than any other player during that stretch. She finished her career in 2005 with thirty-four titles, including eight majors, and in 1995 was elected to the World Golf Hall of Fame.

But King's heyday coincided with that of outgoing star Nancy Lopez; King, a more reserved personality, never got the fan or media attention of her contemporary. "For me, it was a challenge," she told USGA.org in 2011. "Sometimes it was a little hard for me to maybe respond or open up as much while I was competing."

So while King says the 1992 LPGA Championship was "the best I ever played from beginning to end"—she won by eleven strokes and set the then-record for lowest score in a major, female or male—it was her first of back-to-back U.S. Women's Open wins that "was special. As a kid, you always stand over a putt and say, 'This is to win the U.S. Open.'"

The 1989 Open, at Indianwood Golf & Country Club near Detroit, likely was special for another reason: her four-shot victory, fueled by an opening 67, came at the expense of Lopez. King's primary foe that week was Patty Sheehan, who was tied with King after fifty-four holes but stumbled to a closing 79 to tie for seventeenth. Their gallery of twenty-five thousand for Sunday's final round was then the largest in U.S. Women's Open history.

"To be honest, I don't remember each hole, but I know [Sheehan] struggled," King said. "It was special, too, because my parents were there—they saw both my Opens—and at the end, they had bagpipes at the ceremony; my dad

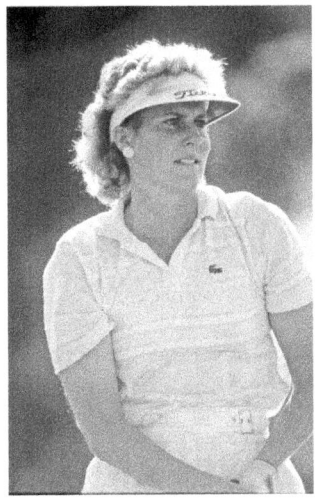

Betsy King, former Furman star, won six LPGA majors. *Courtesy of LPGA Archives.*

was of Scottish/English heritage and he loved bagpipes."

It was a perfect highlight to her best season ever, as King won six times in 1989, including three of the year's first eight events. She credits longtime instructor Ed Oldfield, who helped her with her swing and especially her putting. "Those were the two things that turned me from an average player to a good one," she said.

A year later at the 1990 Open, King trailed Sheehan by five shots entering the final round. Due to bad weather, the field played thirty-six holes on Sunday—"the only time ever in my Tour career," King said—with only thirty to forty-five minutes between rounds.

"I wasn't paired with Patty but was playing ahead of her. Late in her round, I was in the TV tower being interviewed." King—who'd closed with a 2-under par 70 for a 4-under 284—watched Sheehan again crumble down the stretch, shooting a 76.

"It was ironic that both wins, [Sheehan] was my main opponent," King said. Also ironic: the last person with a chance to catch her that day was another Furman product, Dottie Pepper, who closed with a 66 to finish two shots back.

King needed six-plus years to win her first LPGA title, in 1984. "Then I won three more times, was player of the year, and that switched a light on," she said. "You usually don't win thirty-four times when you take that long to start winning." She credits Oldfield and, in 1980, becoming a Christian and "getting serious about my faith."

The latter has defined her post-golf life. King has traveled to Africa regularly since 2006 with Christian groups, helping to provide clean water for villages in Rwanda, Kenya and Zambia, among other nations. She also helped found Golf Fore Africa (www.golfforeafrica.com), which focuses on water, sanitation and hygiene and has raised $13 million, including $3 million in 2019.

"I know golfers are charitable, and $50 brings clean water for a lifetime per person," King said. "We've been blessed with support from golfers of all ages. We take them to see villages without water, and they can see the difference it makes."

In retirement, that's King's real "No. 1."

SO CLOSE, THEN VICTORY: BETH DANIEL

For Charleston native Beth Daniel, whose thirty-three LPGA victories (forty-one total) earned her a place in the World Golf Hall of Fame in 2000, the subject of major titles produces mixed emotions. Her 1990 LPGA Championship at Bethesda (Maryland) Country Club is the highlight of a long and honored career; Daniel's final victory, at the 2003 Canadian Women's Open, made her the oldest winner (forty-six years, eight months, twenty-nine days) in LPGA history.

But two U.S. Women's Opens that got away (1981 and 1982) perhaps unfairly defined her majors' career. Daniel admitted that "those things hurt" during the 2019 U.S. Women's Open at her home course, the Country Club of Charleston.

At the 1981 Open at the LaGrange Country Club in Chicago, Daniel trailed eventual winner Pat Bradley going into the final round. "It was a gunfight from the first hole," Daniel said. She shot a closing 68, making birdies on the final two holes and leaving an eagle chip just short at the eighteenth hole.

"I left it on the lip," she said. "If I'd made it, we'd have been tied and in an eighteen-hole playoff." But Bradley, who shot 66 that day, including a seventy-foot birdie putt at the fifteenth hole, hit a wedge to two feet for birdie at the eighteenth to avoid that.

"When it first happened...it stings, and took a while to get over that," Daniel said. "I thought, 'I played my best golf and lost, so how can I be that good? Later, the reality hit me and I was proud of how well I played under pressure."

A year later, Daniel, coming off three LPGA Tour wins, led after fifty-four holes at Del Paso Country Club in Sacramento, California. She was 4-under par and facing a ten-foot putt for birdie on the eighth hole when her best chance at an Open victory turned sour.

"I marked my ball—this was in the days when if your ball moved, it was a penalty," and after she replaced the ball, "I walked around the hole to line up my birdie putt," Daniel said. "I always put my ball down the same way, and when I got back to it, it had moved a quarter-rotation.

"I said, 'I think it moved.'" Daniel was assessed a one-stroke penalty, and "after that, I wouldn't ground the putter because I was afraid [the ball] would move." Daniel bogeyed four holes on the back nine and tied for second, six shots behind Janet Alex, who won only a couple of times on Tour.

"And that one," Daniel said.

It took eight more years, but Daniel finally won her major. In 1990 at Bethesda, she was playing on the same course where the year before, she'd won the Greater Washington Open.

This time, it all came together as Daniel shot a blistering 66 Sunday to come from behind. "It was a course with small greens, narrow, tree-lined, and I normally didn't win on that type course," she said. "But I was playing really well, focusing on every shot.

"The last six holes, the crowds gave me a standing ovation every time I reached the green because of my win the previous year. They all stood clapping, and I had tears in my eyes every hole."

Unlike her Opens experience, this time someone else wound up disappointed. "To this day," Daniel said, "Rosie Jones [who finished second by a shot] tells me I took her major. But I was exceptional that last day."

SINGIN' IN THE RAIN AT BETHPAGE: LUCAS GLOVER

Growing up in Greenville, Lucas Glover dreamed of someday winning a major championship. But the one foremost in his mind, and heart, wasn't the one he would eventually capture—the 2009 U.S. Open—to become South Carolina's first native son major winner.

With Glover's biological father out of the picture, it was Dick Hendley, a Clemson Hall of Fame athlete, who took his young grandson to Augusta each April for the Masters Tournament. Later, as an All-American golfer at Clemson, Glover played the fabled Augusta National course a number of times with his Tigers teammates.

"I knew even as a kid that [the Masters] was different," Glover said. "Watching the other majors on TV, you get it ingrained that, okay, these are big deals, too. But Augusta for me, mainly due to location and the history there, means a lot. [Every year] I'm still itching to get back there."

His first invitation to the Masters came in 2006. But in 2002, the twenty-two-year-old played in his first U.S. Open, at Bethpage Black State Park in Farmingdale, New York, the Open's first visit to the Long Island public course. "My first major out of college," he said. "Ten-over was the cut that year, and I shot eleven-over. I remember a little about that."

Glover's second trip to Bethpage Black would be more memorable. What he remembers most about 2009 was heavy rains that scrambled the

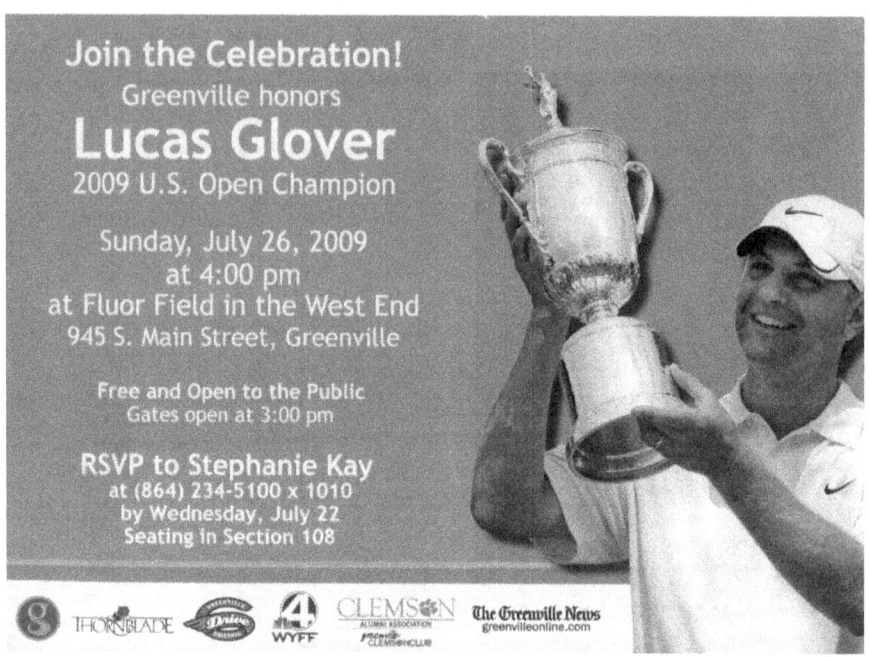

Join the Celebration!
Greenville honors
Lucas Glover
2009 U.S. Open Champion

Sunday, July 26, 2009
at 4:00 pm
at Fluor Field in the West End
945 S. Main Street, Greenville

Free and Open to the Public
Gates open at 3:00 pm

RSVP to Stephanie Kay
at (864) 234-5100 x 1010
by Wednesday, July 22
Seating in Section 108

An invitation to Greenville's celebration of Lucas Glover's 2009 U.S. Open victory, which was held at downtown's Fluor Field. *Photo by Bob Gillespie.*

tournament schedule and how he began the final round on Monday at the second hole. "Any U.S. Open, you're just trying to survive and stay in play," Glover said. "But that week was just odd: I didn't hit a shot on Thursday, played just five holes Friday. You were in your [hotel] room at 9:30 every night and up at 5:00 a.m. the last three days."

Still, his confidence grew all week. "I was playing good, executing, hitting it where I was looking, and I was really putting well from eight to ten feet and in," Glover said. "It was one of those weeks where it was all clicking."

The delayed final round featured a little-known leader in Ricky Barnes, with two of golf's biggest names—Phil Mickelson and David Duval—giving chase. And then there was Glover, who slowly climbed toward the top.

"At the end of the [final] round, it kind of turned into a free-for-all," Glover said. When he arrived at the par-3 sixteenth hole, he shared the lead. "I hit a great tee shot, had a good number for an 8-iron and just flagged it," he said.

"Then I had one of those putts downhill at a U.S. Open, which is traditionally fast, but if you read it right and get it on line, it's getting to the

hole." When his birdie putt dropped to give him the lead, "that set me up where I didn't have to play too aggressive the last two [holes]."

A winner by two shots over runners-up Barnes, Duval and Mickelson, Glover's next few days were a whirlwind: he toured New York City and appeared on late-night TV shows. And then he headed to the next Tour event in Hartford, Connecticut, honoring his commitment when many Open winners would've justifiably taken time off.

That July, Greenville honored him with a Lucas Glover Day at the city's Fluor Field, presenting him with a Greenville Drive jersey with the number "-4" (his winning score). "It was really cool and surreal to have that many people I'd never even met just pulling for me," he said. "That was pretty amazing."

A decade later, a divorce behind him and with two children by his second marriage, Glover still is reminded of 2009. "Most weeks [at tournaments], I get announced as a former U.S. Open champion, which never gets old to hear," he said. "Honestly, it's a good reminder when you're not playing well that, hey, I did it once. You couldn't ask for much more as far as a career experience." At least until/unless a Masters victory comes along.

11

BACK TO THE SHORE

The 2012 PGA Championship

When the participants in the 1991 Ryder Cup Matches left Kiawah Island, almost to a man they said the Ocean Course was not a place they would want to have to play and post a score that counted. Match play, where the worst you could do would be to lose a hole, was one thing; writing down a number for every hole was quite different on the wild and scenic layout where every hole was exposed to the elements.

But twenty-one years later, professional golf would be back at the Ocean Course for a major championship, a stroke-play event where every shot counted.

Rory McIlroy's brilliant performance in the 2012 PGA Championship, an event in which he shot 13-under-par 275 over four rounds and ascended to the No. 1 ranking in golf, was proof positive that the Pete Dye design labeled as the toughest golf course in America could be played in respectable fashion as a stroke-play event. And it set the stage for a PGA Championship return in 2021.

Wind was as much a culprit as Dye during the 1991 Ryder Cup Matches. The course can measure nearly 8,000 yards from the very back tees and is listed at 7,873 yards. Dye designed such length in the course, knowing that the prevailing winds could change from day to day. Setting the course up properly is imperative, or things could get out of control if the longer holes were played into the wind and shorter tees were downwind—which is exactly what happened at the start of the 1991 Ryder Cup Matches.

Rory McIlroy celebrates his eight-shot victory in the 2012 PGA Championship at Kiawah Island Golf Resort's Ocean Course. *Courtesy of Kiawah Island Golf Resort.*

Wind was a factor again when the pros returned in 2012 for the PGA Championship, but this time the setup took the wind into consideration. To be sure, almost all of the contestants had their troubles in 2012, McIlroy included. He struggled to a 3-over-par 75 in his second round, but that was sandwiched around a pair of 67s with a 66 to close out the event.

RETURN TO THE SHORE: KIAWAH PURSUES A MAJOR

Following the '91 War by the Shore, Kiawah Island Golf Resort officials made it known that they would like to bring another big golf event to the Ocean Course. But a lot took place between 1991 and 2012.

- Landmark Land Company, which had purchased the resort in 1988, declared bankruptcy in an effort to keep the Resolution Trust Corp. from taking over a number of its properties, including Kiawah. Eventually, Virginia businessman Bill Goodwin was able to purchase the Kiawah properties and transform it into a world-renowned destination.
- The Ocean Course hosted a Shell's Wonderful World of Golf match between LPGA superstars Annika Sörenstam and Dottie Pepper in 1996. Pepper won the event, shooting 75 to Sorenstam's 77. Asked if she would like to see a stroke-play tournament played on the Ocean Course, Pepper said it would depend on the wind. "If the wind blows, it would have to be a tournament with marshals galore [to look for lost balls], and you would have to have a setup so you would have morning and afternoon starts to even out the wind for all the players," Pepper said.
- The World Cup of Golf, an event pitting two-man teams from thirty-two countries, was brought to the Ocean Course in 1997. Because of the disparity of golf throughout the world, the course had to be set up at a relatively easy 6,800 yards. The Irish team of Padraig Harrington and Paul McGinley shot a combined score of 31-under-par 545 to win by five strokes over Scotland's Colin Montgomerie and Raymond Russell.

 Montgomerie, one of the storylines with his match against Mark Calcavecchia in the 1991 Ryder Cup, was the individual champion, shooting 68-66-66-66-266, 22 under par. Germany's Alex Cejka shot 63 in the opening round and Sweden's Per-Ulrik Johansson posted a 64.
- In 2001, the first UBS Warburg Cup pitting the United States against the Rest of the World (ROW) was played at the Ocean Course, with teams of six players in their forties and six more players at least fifty. The U.S. team, which was captained by Arnold Palmer, defeated Gary Player's ROW team, 12½-11½.
- During the playing of the 2003 World Cup, by then part of the World Golf Championship circuit, hints of a major championship coming to Kiawah leaked out. The format for the event this time was better-ball, and South African's Rory Sabbatini and Trevor Immelman, who began the final round with a seven-stroke lead, shot 73 for a 13-under total of 275, four better than England's Paul Casey and Justin Rose.

In the post-round press conference, Casey said he had just been told that a PGA Championship would be coming to the Ocean Course. "It's going to be embarrassingly difficult, I think, when it comes here. It was a really tough but fair golf course. It definitely rewards good golf. There is no luck out there," said Casey, then twenty-six years old and ranked twenty-fifth in the world.

Rose said the Ocean Course showed its teeth when the wind picked up: "It's exposed to the elements, and I really like that type of golf. It's in great condition, and it's a hell of a test." He added, "If I was to say anything negative and something I feel, the eighteenth hole is not as tough as it should be." The weak finishing hole would soon be changed, and the effort to bring the PGA Championship was well underway.

Too Tough? Ocean Course Wins Converts

Roger Warren, now the president of Kiawah Island Golf Resort, was hired in April 1993 as the new director of golf, replacing Tommy Cuthbert, who had served in that capacity since the resort opened in 1976. The fifty-three-year-old Warren was a rising star in the PGA of America hierarchy who would ascend to the presidency of the organization.

During his interview with Kiawah owner Bill Goodwin, Warren said, the owner told him that bringing a major championship to the Ocean Course was a goal. But Warren made it clear he didn't want there to be a conflict of interest between his Kiawah position and the PGA of America post and would recuse himself from decisions involving Kiawah.

"By that time [Goodwin] was already in discussions with the PGA of America about having an event here," Warren said. "Those discussions led to the decision to host the Senior PGA in 2007, to really test the site…from the standpoint of size and available space to support a major championship like the PGA Championship.

"It was clear in everybody's mind that the golf course itself was a major championship caliber golf course. That was never a question if it would test the players. It was just if we were going to be able to handle the infrastructure of a major championship. And it turns out that we can and did and will."

Kiawah had already agreed to host the PGA of America's Club Professional Championship in 2002. But issues with the turf grass led to a

Spectators watch the action on the seventeenth hole of the Ocean Course during the 2012 PGA Championship played at Kiawah Island Golf Resort. *Courtesy of Kiawah Island Golf Resort.*

switch to 2005. When the turf grass issue came to light in 2002, Goodwin didn't balk. Instead he told his staff to go all in; doing so included redesigning the aforementioned eighteenth hole and some other less noticeable changes in a $1.7 million renovation.

The 2003 World Cup was the first big test of the newly renovated Ocean Course, which it passed with flying colors. The 2005 Club Professional Championship also showcased the Ocean Course with University of Illinois golf coach Mike Small shooting a four-day total of 289, 1-over par, to win the event and earn a spot in that year's PGA Championship.

That same week it was announced that the PGA Championship would be coming to the Ocean Course in 2012.

The 2007 Senior PGA was something of a test run for 2012. Held in late May, wind would certainly factor into the event. Argentina's Eduardo Romero had no problem, posting an opening-day 68 to lead the field, and he continued to lead with a second-round 70. A 1-under-par score the third day put him two ahead of Nick Price going into the final round.

"You have to be very careful on this golf course because when you lose concentration for a couple of seconds, you can make a double or triple bogey very quickly," Romero said. "I know this course is very difficult. You have to be very patient, very quiet. I know two strokes on this course is nothing."

That proved prophetic, but it wasn't Price that Romero should have been worried about. Instead, it was Zimbabwe's Denis Watson, who hadn't won a golf tournament in twenty-three years. A bogey on the par-4 thirteenth and a double bogey on the par-3 fourteenth, where Romero's tee shot plugged in the soft sand of a greenside bunker, allowed Watson to pass him for the lead.

"I missed two shots this week, at 13 and 14 and it cost me a lot, "Romero said. Watson, who hadn't won since 1984, said the win was validation of his will to overcome two painful decades that included a divorce, numerous surgeries and self-doubt.

Watson said the turning point for him was making the long ride back to the clubhouse after he double bogeyed both his seventeenth and eighteenth holes (he started on the back nine, so it was Nos. 8 and 9). He was feeling low but happened to look over and spied a vision-impaired fan.

"That got to me," Watson said. "I thought to myself, 'You have no right to be unhappy with yourself. You get to play golf and that guy will never play golf.'" It gave him a fresh perspective, and he went on to win the Senior PGA Championship, shooting a final-round 68 for a 9-under-par total of 279.

Tiger Woods hits from the dunes at the Ocean Course during the 2012 PGA Championship played at Kiawah Island Golf Resort. *Courtesy of Kiawah Island Golf Resort.*

With all the dress rehearsals out of the way, that set the stage for the 2012 PGA Championship. The biggest pre-tournament concern wasn't how well the Ocean Course would hold up to the golfers but about getting the expected 210,000 fans to the golf course and then around it in the August heat.

WEATHER WOES, THEN A WORTHY CHAMPION

The front gates of Kiawah Island are roughly forty-five minutes from downtown Charleston, where all the visitors, including the national media, would be housed. (Players and officials were housed on the island.) And the Ocean Course is another twenty minutes or so distant from the main gate. Public parking would be just off the island. There are only a couple of ways to Kiawah from downtown Charleston, both with major traffic bottlenecks. An elaborate bus system was set up to bring visitors from downtown Charleston as well as transport spectators from the public parking area.

Six inches of rain prior to the tournament and an absence of wind left the Ocean Course vulnerable, and as a takeoff on 1991's War By the Shore moniker, people began referring to the 2012 PGA Championship as the "Pour by the Shore." Sweden's Carl Pettersson led after the first day with a 6-under 66, and twenty-four players were able to post scores in the 60s.

But wind returned with a vengeance on Friday, gusting to thirty-eight miles per hour and players responded by turning in the highest average score in PGA Championship history, 78.11, or nearly five shots higher than Thursday's round. Vijay Singh was the only golfer to crack 70, shooting a 3-under 69. There were forty-four scores under par in the first round and only five on Friday. Pettersson (74), Singh (69) and Tiger Woods (71) shared the midway lead at 140. Rory McIlroy was a couple of strokes back at 142.

An afternoon thunderstorm hit Saturday, halting play and wreaking havoc as spectators had to scramble for bus rides to the parking area. Singh and McIlroy were the leaders when play was halted, and Woods was five shots back on the eleventh hole, setting up a long Sunday finish.

McIlroy still had nine holes left in his third round when Sunday morning arrived, and he polished it off for a 67. Singh and Woods finished up matching 74s to drop off the pace.

McIlroy was untouchable the final eighteen holes on Sunday, shooting a bogey-free 66 to finish at 13-under. England's David Lynn, a relative

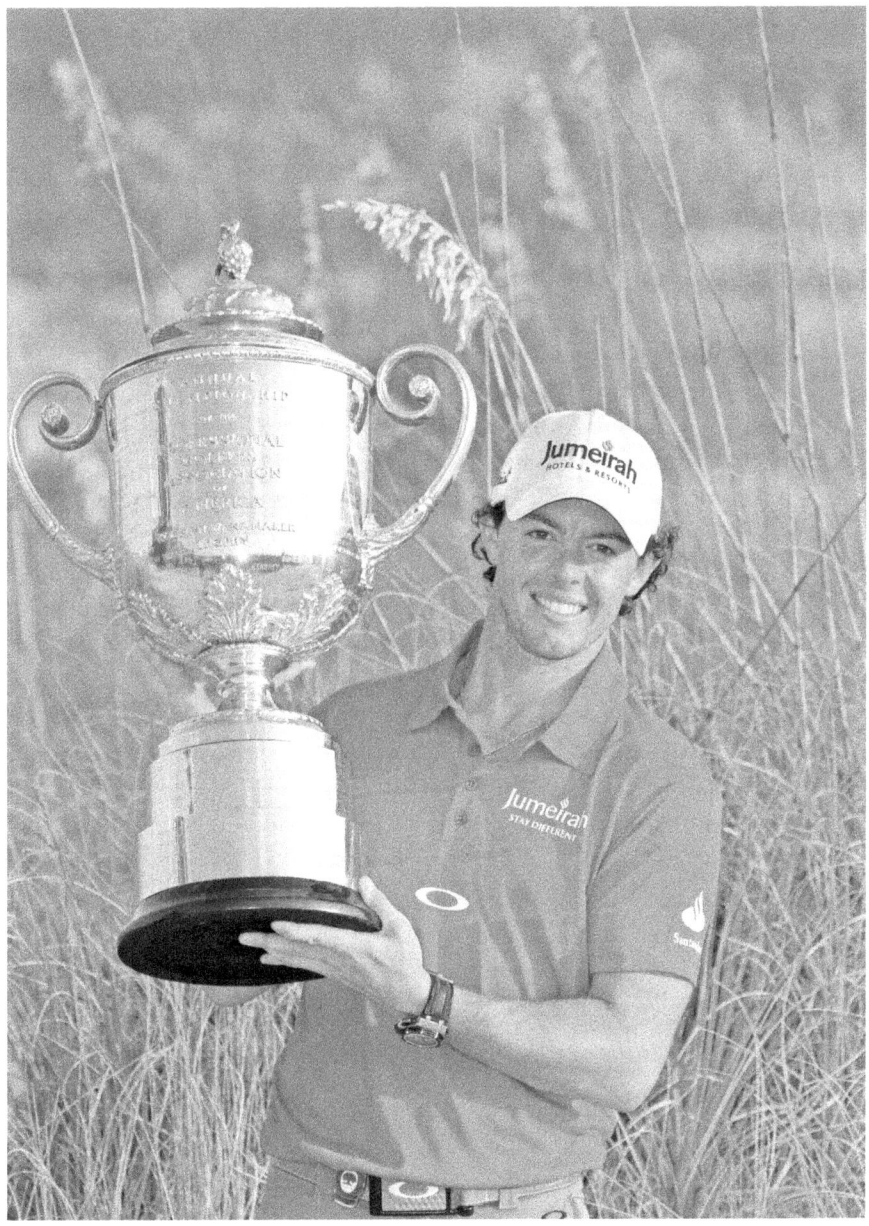

Rory McIlroy with the Wanamaker Trophy after winning the 2012 PGA Championship at Kiawah Island Golf Resort's Ocean Course. *Courtesy of Kiawah Island Golf Resort.*

unknown on this side of the Atlantic, took second with a closing 68 and 5-under total. Defending champion Keegan Bradley (71), Pettersson (72), Ian Poulter (74) and Justin Rose (66) tied for third at 284. Woods (72) tied for eleventh at 286 and Singh (77) tied for thirty-sixth at 291. Twenty-six players finished under par for the tournament.

It was the twenty-three-year-old McIlroy's second major championship and returned him to the No. 1 spot in the world rankings. The golfers offered high praise to the Ocean Course as a major championship venue, and many voiced support for a return visit at some point. Financially, the event was a $90 million-plus boost to the local economy.

"My best memories of 2012 was the whole experience of settling some of the doubt in the minds of people that the state of South Carolina and Charleston County, Charleston and Kiawah would be able to support the event in the way the PGA of America was accustomed," Warren said. "We had great fan support. We had a great financial performance for the event.

"And [the Ocean Course] proved itself to be a very, very worthy site for the PGA. At the same time, we set ticket sales records for the championship. Just for me, it was personally exciting to see all that come together to be such a great event."

Warren acknowledged issues with traffic access and moving fans off the course on Saturday. "Certainly we had some challenges with the storm and some of the traffic," he said. "But I don't think any of that ever did anything to overshadow the quality of the event, or Rory's win and how well the golf course stood up to the great players that played it."

LADIES' CHOICE

The U.S. Women's Open Comes to Charleston

F ans of numerology know that the number 6 is considered the only number harmonious with all other numbers. And 6 was certainly a harmonious number for the winner of the 2019 U.S. Women's Open played at the Country Club of Charleston.

Six-under-par 278 was the winning score of Jeongeun Lee6, whose curious last name was the way the twenty-three-year-old differentiated herself from the five other Jeongeun Lees already on the Korean LPGA Tour when she turned professional. Lee6 was the only player to post rounds under par every day of the Women's Open on the par-71 course.

"My goal was, if I win the tournament, I can eat ramen. That was my goal. If I finish top five, I can buy shoes. But now I can buy shoes and eat ramen, so it's a double," said Lee6, whose fellow competitors doused her with champagne afterward.

It was an emotional moment for Lee6, whose father was paralyzed in an automobile accident when she was just four years old. That made it difficult for her family to travel to tournaments, and she turned professional with hopes of supporting her family.

Sometimes observers wondered why golf hadn't come calling on the Country Club of Charleston earlier than 2019. Why did it take a U.S. Women's Open, held almost a century after Seth Raynor built the golf course, to bring it such richly deserved notice?

In actuality, the history was already there; it was the public at large that didn't appreciate the Country Club of Charleston.

The club was one of the founding members of the Carolinas Golf Association. The Tournament of the Gardens brought professional golfers to Charleston from 1933 through 1937, just eight years after the course opened. Walter Hagen won the first, Paul Runyan the second and Henry Picard—the 1938 Masters champion and 1939 winner of the PGA Championship—took the next three.

Picard, in fact, enjoyed home-course knowledge, as the Country Club of Charleston is where he got his start as an assistant golf professional and the place where he would eventually return to in retirement.

For nearly seventy-five years, the country's top male amateurs have gathered each spring, just prior to the Masters, to compete in the Azalea Invitational. Before winning the 2012 U.S. Open, Webb Simpson was a two-time winner of the Azalea. A look down the list of

Jeongeun Lee6 of South Korea won the 2019 U.S. Women's Open by two shots at the Country Club of Charleston. *Courtesy of the LPGA Archives.*

past champions back to the tournament's beginning in 1946 offers names recognizable to generations of golf fans.

In addition to Picard, the Country Club of Charleston also produced Beth Daniel, giving it two World Golf Hall of Fame members. Daniel never won the Women's Open, finishing second twice, but she won thirty-three times on the LPGA Tour, including one major, as well as three Vare Trophies for low scoring average, three money titles and three player of the year titles.

COUNTRY CLUB OF CHARLESTON MAKES ITS CASE

The United States Golf Association finally settled on the Country Club of Charleston around 2010, after the club had made it known that at some point members would be interested in hosting a USGA national championship.

"The club had harbored interest in hosting a USGA event for a long time," said club member Frank Ford III, who served on USGA committees

over the years and also competed in numerous USGA championships. "[Club president] Rob Wilson was talking with me one day and asked: 'Do you think we could host a USGA event?' I said, 'Absolutely.' The golf course is plenty good enough. He turned me loose to see what we could do."

Discussions with USGA officials began, and soon the Country Club of Charleston was asked to host the 2013 U.S. Women's Amateur. The request came on short notice after another club bowed out, but the Country Club of Charleston put on a spectacular event won by Emma Talley, a University of Alabama golfer from Paducah, Kentucky, who defeated Yueer "Cindy" Feng of China by a 2 and 1 margin in the scheduled thirty-six-hole final.

Was that 2013 Women's Amateur a test run for something bigger? The golf course, at around 6,800 yards and par-71, was too short by modern standards for a men's U.S. Open or a U.S. Amateur but could be a perfect fit for a Women's Open.

After the Women's Amateur concluded, USGA senior director Shannon Rouillard was noncommittal when asked about a future USGA event. "I think it certainly posed a wonderful site for the Women's Amateur," she said.

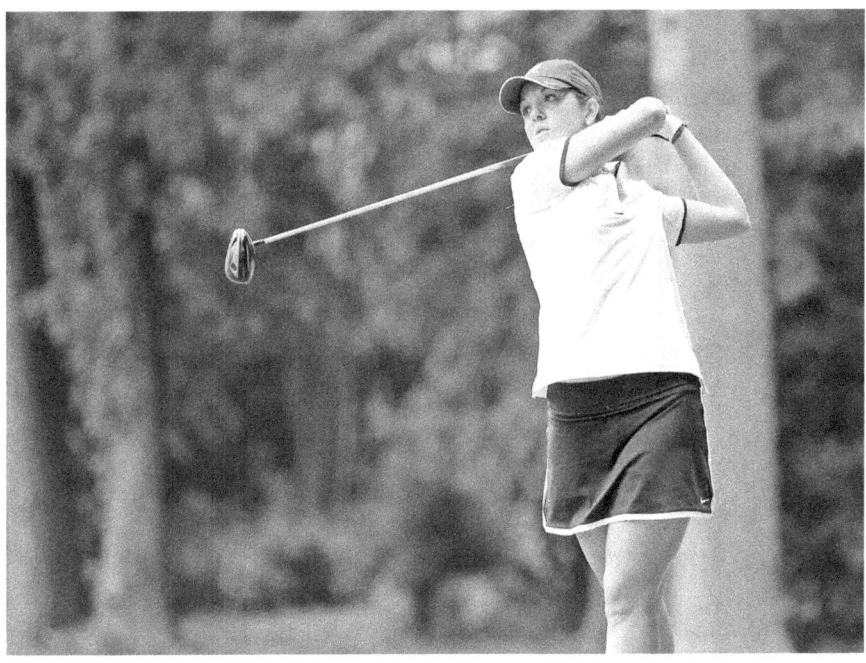

University of Alabama golfer Emma Talley of Paducah, Kentucky, won the 2012 U.S. Women's Amateur at the Country Club of Charleston. *Courtesy of the University of Alabama.*

"It definitely would be another wonderful venue for a USGA championship; which one, I'm not sure.

"I think [the Women's Amateur] has gone tremendously well. The club has gone above and beyond what is required of them to host this championship. They've done it with such grace, such poise [and] such love for the game."

The club membership was equally pleased. "Things went so beautifully with the Women's Amateur,' Ford said. 'We had a great champion, and fourteen months later the president of the USGA asks, 'Why haven't you asked us back?' I asked what I should ask for, a Senior Open or a Women's Open? We talked a few months later, [and] we decided the Women's Open made more sense."

The LPGA golfers were familiar with Beth Daniel, the Hall of Famer who learned to play at the Country Club of Charleston. Daniel played on eight Solheim Cup teams and captained the 2009 U.S. Solheim Cup squad. She was able to talk the event up with current players, who peppered her with questions about the course, particularly its notorious par-3 eleventh hole.

Daniel told them that while the course was open, it was important to put your tee shot in the proper position to hit the correct quadrant of the green. "It's a second-shot golf course. It's the greens, putting and chipping around the greens," Daniel said.

When tournament week finally arrived, the event got unexpected—and unwanted—talking points after famed teaching pro Hank Haney made an ill-advised (and racially tinged) comment on his SiriusXM radio show on Wednesday, saying that he "couldn't name you six players on the LPGA Tour. Maybe I could. Well…I'd go with 'Lee,' if I didn't have to name a first name."

The response from top-name female golfers was fast and furious. Michelle Wie, who missed the 2019 Women's Open because of an injury, as well as Annika Sörenstam and Karrie Webb, were among those chastising Haney, who apologized for his flippant comment. Haney was suspended from the radio show and later fired.

LIGHTNING STRIKES FOR JEONGEUN LEE6

Wind can often turn the Country Club of Charleston into a beast, but the weather was calm as golfers teed off for the first round. Mamiko Higa of Japan set the pace with a 6-under-par 65 and would continue to lead at the midway point with an even-par 71.

Participants at the 2019 U.S. Women's Open found the Country Club of Charleston greens were challenging. *Photo by Bob Gillespie.*

The biggest drama of Friday's second round took place while play was suspended because of weather conditions. A lightning bolt slammed into an oak tree between the club's famous eleventh green and the eighteenth fairway. A Fox Sports television camera focused up the eighteenth hole toward the clubhouse had been left on and caught the lightning hitting the massive oak tree. Fortunately, no one was injured, and it led to an amusing tweet by Daniel, who said that it showed "that even God can't hit the eleventh green."

When players arrived at the course on Saturday morning to complete the second round, there was no evidence that the tree had even existed.

There was plenty of jockeying going on in the third round, with former Duke teammates Céline Boutier and Yu Lin tied for the lead at 7-under 206. Lexi Thompson was one shot back of the co-leaders along with Jaye Marie Green and Higa, the leader after both the first and second rounds. Lee6 was another shot back at 5-under.

But on Sunday, with everything at stake, Lee6 found herself exactly where she wanted to be after making birdies on the eleventh, twelfth and fifteenth

Frank Ford III, a standout Charleston amateur, chaired the 2019 U.S. Women's Open played at the Country Club of Charleston. *Photo by Tommy Braswell.*

holes. She then held on despite bogeys on sixteen and eighteen, winning for the first time.

Her birdie on the eleventh hole, which features a Redan green with a huge false front, came after her 7-iron settled about eight feet from the hole and gave her the lead alone. Lee6 was the only player in the field to finish under par in every round: an opening 70, 69s on the second and third days and another 70 on Sunday.

As happy as Lee6 was, so were the USGA and the Country Club of Charleston. "From our standpoint, it's been a magnificent week. This is a special place, the Country Club of Charleston," said John Bodenhamer, senior managing director of Championships for the USGA. "We always knew that. We knew that before we had our Women's Amateur here [in 2013].

"I think if the club would have us back, we'd love to come back for the U.S. Women's Open. We'd love to have a U.S. Women's Amateur. But we'd certainly entertain other tournaments as well. We love it here. This is exactly what we like to come to."

Bodenhamer also praised the course's design features. "The architecture here, Seth Raynor [was] one of the classic designers in the history of the game," he said. "You come to a place like this and you just don't have to do

Comedian and actor Bill Murray, who lives in Charleston, examines the U.S. Women's Open trophy with 2018 champion Ariya Jutanugarn of Thailand. *Photo by Tommy Braswell.*

a whole lot to the golf course. It just takes care of itself. It's been wonderful. The golf course, from our ability to present a U.S. Open test for the players, is as close to perfect as we can provide."

Ford, a six-time Azalea winner who chaired both the Women's Open and Women's Amateur, said he always believed the historic course would stand

up against the world's best female players. "I thought the winning score would be 6-under," he said. "I just didn't think 10- or 12-under was going to be happening.

"It's hard to play this golf course and not make some bogeys when it's set up for that kind of tournament. This course has stood up for a long, long time to whoever is playing it. That's the bottom line."

The other bottom line: The Country Club of Charleston and the U.S. Women's Open turned out to be a perfect match.

THE MASTER OF THE MASTERS

Hootie Johnson

The Letter, as it came to be known in the golf world, arrived at Augusta National Golf Club, home of the world-famous Masters Tournament, in mid-June 2002. Addressed to the club and its tournament chairman, William Woodward Johnson, from Martha Burk, chair of the National Council of Women's Organizations (NCWO)—a coalition of 160 women's groups purportedly representing six million members—the Letter addressed Augusta National's lack of women among its three-hundred-plus members.

In the letter, Burk asked—or demanded, depending on one's point of view—that the club add women to its rolls, sooner than later. "We know that Augusta National and the sponsors of the Masters do not want to be viewed as entities that tolerate discrimination against any group, including women," the letter concluded.

The subject was hardly new. For several years each April during the Masters, reporters would ask about the possibility of adding female members during the chairman's annual "State of the Tournament" address. Every time, the current chairman—Johnson, known by his childhood nickname, "Hootie," was the fifth chairman in the club's history since its 1931 founding—would mostly good-naturedly but firmly dismiss the question, citing the club's policy of not discussing membership.

This time, Johnson's response to Burk's letter was anything but good-natured.

The late Hootie Johnson of Columbia (*center*) greets Sam Snead (*left*) and Byron Nelson at Augusta National's first tee for their ceremonial drives. *Courtesy of Augusta National.*

In a three-page statement, Johnson called the Letter "clearly coercive," with the intent of using pressure on the Masters sponsors to influence the club. "Our membership alone decides our membership, not any outside group with its own agenda," he added. Then he went further.

"We will not be bullied, threatened or intimidated," Johnson wrote. "We do not intend to become a trophy in their [NCWO] display case....There may well come a day when women will be invited to join our membership, but that timetable will be ours and not at the point of a bayonet."

The Letter morphed into MarthaGate—a public dispute that would hang over the Masters for two-plus years, though changing nothing about Augusta National's membership. Burk staged protests at the 2003 and 2004 tournaments, the protesters' numbers small the first year and nonexistent the

second. Johnson, in response to the possibility of Burk pressuring sponsors, dismissed the tournament's only three (IBM, AT&T, CitiGroup) and staged the event commercial-free for two years.

Ultimately, impact of the Letter was minimal. But the dispute cast a shadow on Johnson's lifelong reputation as a progressive businessman in his native South Carolina, where he had helped found NationsBank (later Bank of America), the United States' first interstate banking operation. Friends and business associates struggled to match his "no women" stand at Augusta with the man they knew as a quiet, behind-the-scenes advocate of racial and gender equality, both in business and in South Carolina higher education.

Then, on August 20, 2012, ten years after MarthaGate (and six years after Johnson had stepped down as chairman), Augusta National announced its first two women members: former U.S. Secretary of State Condoleezza Rice and finance mogul Darla Moore—the latter a Lake City, South Carolina, native and longtime friend of Johnson's. Later that day, Johnson issued a statement through the club to *The State*, his hometown paper in Columbia.

"This is wonderful news for Augusta National Golf Club and I could not be more pleased," Johnson, then eighty-one, wrote. "Darla Moore is my good friend, and I know she and Condoleezza Rice will enjoy the Club as much as I have."

To observers unfamiliar with Johnson, that might've seemed like a latter-day contradiction. In fact, the addition of Rice and Moore was, most insiders believed, another case of Augusta National—and Johnson—doing things their own way, at their own pace.

Johnson would later admit that 2002's public, belligerent response was a mistake, coming at the advice of a Washington, D.C.–based public relations consultant, Jim McCarthy, who was later dismissed. Afterward, Johnson and the club returned to previous policy of not commenting on membership. But in other areas of the club's doings, he prided himself on making needed changes—and not being shy about it.

During his eight years in charge, Augusta National expanded its TV coverage; added a "second cut" (rough) to the previously wall-to-wall fairways and also lengthened and tightened the historic golf course, both in response to players' increasing, technology-assisted distance with clubs; and constructed a state-of-the-art practice facility. The club also spent millions expanding the course's property footprint, while also donating more than $25 million to charity.

When Johnson died on July 14, 2017, at age eighty-six, his legacy at Augusta National, continued by successor Billy Payne, was that of

leading a club steeped in tradition but always making needed changes and acknowledging those changes (previously, Augusta National's tradition was of never admitting to any changes). In golf, as in his illustrious banking career, Hootie Johnson did things the way he thought they should be done: the right way.

A LIFE THAT LED TO
LEADING AUGUSTA NATIONAL

If ever a person seemed fated to become, as a headline in *The State* put it upon his elevation to chairman, "The Master of the Masters," it was Hootie Johnson. He was born in Augusta in 1931—the year Augusta National was founded—before moving with his family to Greenwood, South Carolina, where his father, Dewey, began Bank of Greenwood, the local bank that his son would grow to a behemoth. Hootie attended his first Masters Tournament—the second staged—in 1935, when he was four. He joined the private club in 1968 (invited by a letter from founder Bobby Jones), rising to vice president before being named chairman in 1998.

Johnson took up golf at age eight, playing with his father at Augusta Country Club—Augusta National's next-door neighbor—and played the National for the first time in the 1950s with his father and older brother as guests of a member from Greenwood. "It was pretty exciting for someone in his early 20s," he said in 1998, though he didn't recall his score that day.

Starting in grammar school, Johnson also played football, becoming a star running back for fabled Greenwood High coach Pinky Babb. As a player at the University of South Carolina, though, he was stuck behind two stars, Steve Wadiak and Bishop Strickland, and "couldn't see without his glasses," said former teammate Johnny Gramling. Rather than sit on the bench, Johnson switched to fullback as a junior—and wound up winning the Jacobs Blocking Trophy, given to the Southern Conference's top blocker.

Johnson would later view that move (one he wasn't happy about at the time) as a valuable life lesson. Much of his career in banking would be as a quiet, low-profile power broker, getting things done without publicity. When he and Hugh McColl (then head of NCNB) merged their two state banks into one multistate giant in the late 1980s, Johnson's role as chairman of the executive committee gave him power without much of a public image—just the way he liked it.

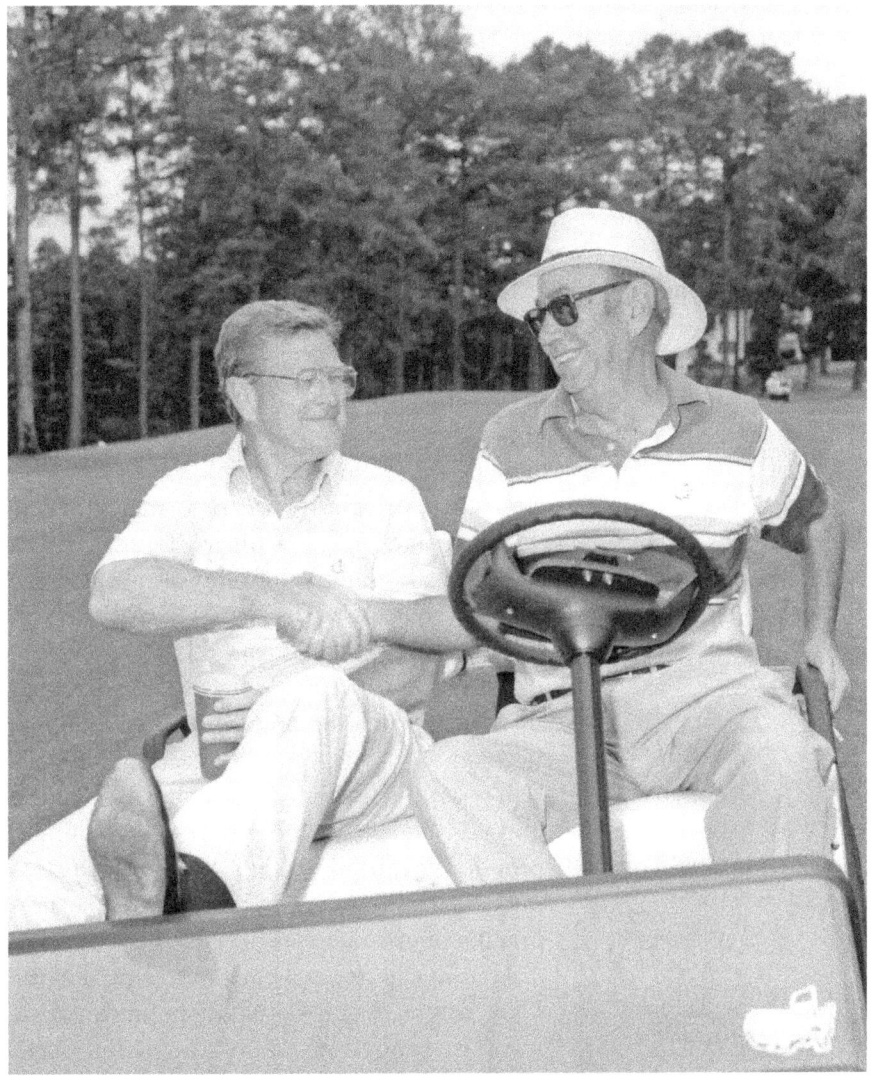

A young Hootie Johnson and Arkansas's Jackson Stephens share a golf cart at Augusta National. *Courtesy of Pierrine Johnson.*

"I just knew what I wanted to do from the time I was a teenager," Johnson said of joining his family's bank in Greenwood. "I wanted to go into banking with my father and build a statewide bank....It was a good business to be in."

It was also one he would ultimately use to influence many areas of his home state. Johnson's résumé was vast: board of directors of half a dozen elite

corporations; advisory roles with South Carolina, Clemson, Converse College and Benedict College; a list of honorary awards from a dozen organizations, including the SC Business Hall of Fame. But some of his best work helped change South Carolina's history in both education and race relations.

In 1968, after the Orangeburg Massacre where three South Carolina State College (now university) students were killed by state troopers' gunfire, Johnson worked with Governor Robert McNair to prevent other racial incidents and then positioned the state to integrate its colleges. Ever a businessman, Johnson worked on a commission that led to the state's only undergraduate business program being established at historically Black SC State. Jennifer Todd said her father was the first businessman in South Carolina to advocate for the removal of the Confederate flag from the South Carolina Statehouse, which finally occurred in July 2015.

In the 1970s, he appointed the first African American, former SC State president M. Maceo Nance Jr., to serve on the Bankers Trust board, a first in South Carolina and, indeed, the South. Johnson also joined the Columbia Urban League and served on the national Urban League's board. He would also support Black political candidates, including Columbia attorney I.S. Leevy Johnson, and hired and promoted minorities and women in his bank.

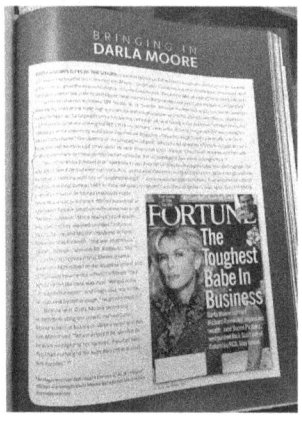

The issue of *Fortune* magazine that led Hootie Johnson to recruit financier Darla Moore to donate $25 million to the University of South Carolina business school. Moore, along with former U.S. secretary of state Condoleezza Rice, later broke the gender barrier at Augusta National Golf Club. *Photo by Bob Gillespie.*

It was also at the intersection of business and education that Johnson made one of his proudest contributions to his university. As one of the founders of a business partners foundation in the late 1960s, he later was tasked by the group with fundraising for the University of South Carolina's business school, today recognized as one of the nation's best. As his widow, Pierrine Johnson, and daughter Jennifer J. Todd, tell it, Johnson was given a list of names of potential donors to call.

"He was sitting in an office [at USC] and saw a copy of *Fortune* magazine with a cover photo of Darla Moore, with the headline, 'The Toughest Babe in Business,'" Todd said. Moore, then married to now-deceased financier Richard Rainwater, in 2012 was worth an estimated $2.3 billion, according to www.therichest.com.

"Darla was a South Carolina native [Lake City] and USC graduate," Todd said, "and Daddy said, 'This is who we need to call. Who knows her?' He called [McColl], who said he'd met her. The three of them met near Florence and she and Daddy hit it off right away; she said she'd always wanted to meet him and that her father had always talked about him. [Moore's father had played football at rival Clemson.]

"Daddy laid out what they wanted"—a gift of $25 million, with the school to be named for Moore in return—"and Darla said, 'Great!'" According to a later story about Johnson's role in securing Moore's gift, McColl reportedly said as he and Johnson left the meeting, "We didn't ask her for enough!"

No matter. Moore in years since has given some $70 million to USC—all starting with her Hootie meeting—and the two remained close for years. In 2002, when MarthaGate was raging, Moore was asked by the *Wall Street Journal* about the controversy. "I'm as progressive as they come," she said. "But some things ought not to be messed with."

Little wonder, then, that Johnson was delighted in 2012 when Moore was invited to join Augusta National. Todd and Pierrine Johnson said Moore and Hootie remained close friends and confidants until his death.

"COMFORTABLE WITH WHAT WE ARE DOING"

Other than the female membership controversy of 2002, Johnson is perhaps best known for the physical changes made to Augusta National during his time as chairman. Previously known as a wide-open course protected primarily by fast, undulating greens, the course underwent lengthening of certain holes, with more changes continuing today.

The process began almost as soon as Johnson became chairman in 1998. He recruited renowned architect Tom Fazio to institute changes, planting trees along certain fairways to narrow the target lines as well as pushing back tees, notably at the par-4 fifth and par-4 seventh, as well as lengthening a number of the "easy birdie" par-5 holes (the second, eighth, thirteenth and fifteenth).

Initially, the moves were seen as "Tiger-proofing," after twenty-one-year-old Tiger Woods's record score in winning the 1997 Masters. But, during a pre-tournament press conference, Johnson recounted how he was convinced that changes to the course were needed not because of the soon-to-be greatest player since Jack Nicklaus, but because even high school golfers were able to bomb their way around the iconic course.

Johnson told of sitting in a golf cart with Fazio during the Masters and watching as player Phil Mickelson's tee shot at the once-fearsome par-4 eleventh hole left him with a simple wedge shot to the green. But he also said he'd played with a Columbia high school player who also had proved too long for the existing hole. That player was George Bryan IV, son of Johnson's occasional instructor George Bryan III and the older brother of Wesley Bryan, a future winner of the 2017 RBC Heritage as a professional.

Golf Digest, in a 2006 story on Johnson, told how the chairman cornered a reporter who'd referred to the supposedly Tiger-inspired lengthening as a knee-jerk reaction, telling him, "Nothing we do here is knee-jerk. Every decision is well thought-out. We are comfortable with what we are doing with the golf course for the Masters Tournament."

Even when some changes were at first criticized by six-time winner Jack Nicklaus and four-time champ Arnold Palmer, Johnson was unfazed. "They are entitled to their opinion," he said, while noting that chairmen from Clifford Roberts on had reevaluated the course regularly. Johnson quoted Roberts—his mentor as a young member—as once telling a tournament patron: "Any time our studies indicate that the present policies can be improved, we will be quick to act."

There were other changes made during Johnson's chairmanship. Two of the most controversial—rescinding lifetime invitations to older past champions and eliminating automatic invitations to PGA Tour winners—were later reversed by Johnson. The former was announced to past champions by a letter, which became almost as infamous as Burk's letter. Palmer, perhaps the Masters' most beloved player, once said he would cease competing because "I don't want to get a letter," and insiders told *Golf Digest* that Johnson regretted that more even than his Burk response.

In 2006, upon Johnson's decision to hand off the job to Payne, PGA Tour players were asked to evaluate his eight-year reign. "Hootie did a great job," said Davis Love III, and "he certainly made the golf course tougher. Every time we thought he made it too hard, it played really well. I think he meant a lot to the club and to the Masters."

Three-time Masters champion Nick Faldo told *Golf Digest* in 2006: "He's had his own vision here [and] he's changed the look of the course. Anyone in that position has got to be courageous in their decision-making."

U.S. Open champion Jim Furyk went to the heart of Augusta National. "It seems to be a one-man show, and they seem to all make the decisions and stick by them through thick and thin, and do it the way they want to

do it....There's one person at the top making all the decisions and you don't have to go through a lot of red tape to make a decision. One guy is pulling the trigger."

For as long as he was chairman, Hootie Johnson was that guy.

A Life of Service to Golf and Family

In September 2002, the seventy-one-year-old Johnson underwent coronary artery bypass surgery and, while he recovered, was plagued by heart issues the rest of his life. When he died in 2017 after several months of poor health, it was due to congestive heart failure, Jennifer Todd said.

Pierrine Johnson, his high school sweetheart and wife of more than sixty years, said that only family outranked Augusta National in her husband's life—and even then, there were exceptions. "I know he went to the tournament on the day I was born," Jennifer Todd said, laughing. "I was born at 3:00 a.m. on Sunday [of Masters week in 1952], and he went that day."

The Johnsons had four daughters—a fact he would bring up when asked about his "hostility" toward female membership at Augusta National—and ultimately the family (including spouses, grandchildren and great-grandchildren) numbered forty-three. A family photo shows all the members seated together in matching blue T-shirts with "Lake Greenwood FTT" (Family Tennis Tournament) on the front.

Hootie and Pierrine began attending the Masters together while in high school, and a favorite story is about how, at the 1946 tournament, fifteen-year-old Hootie lifted his slender girlfriend above the crowd so she would see Ben Hogan three-putt the eighteenth green, handing the winner's green jacket to Herman Keiser in an upset.

As a young member, Johnson found Augusta National "mentors" in Jones, Clifford Roberts and Arkansas banker Jackson Stephens, who preceded Johnson as chairman (1991–98). "Jack Stephens was such a good friend," Pierrine Johnson said. "They won the Jamboree [a members' event] twice together."

Asked about her husband's role as chairman, Pierrine Johnson is nearly as circumspect as Hootie was. "It was [a huge responsibility] and he took it very seriously," she said. "But he loved it. He didn't talk much about it at home, though," even during MarthaGate. "[The controversy] didn't bother him much. He was happy whenever he walked in here [from Augusta], always laughing."

Hootie Johnson's widow, Pierrine Johnson (*right*), and his daughter Jennifer J. Todd at the family home in Columbia. *Photo by Bob Gillespie.*

Jennifer Todd, the Johnsons' oldest daughter, said that "he'd get letters, stacks of them, from all over the world, [saying] 'we support you.' He'd read them and then throw them away. We'd want to save those and he'd say, 'No, no.' He got more support from the public than criticism."

After stepping down as chairman, Johnson still traveled to Augusta, but he was more likely to spend time at the family vacation home on Lake Greenwood, doing family things: boating, fishing, swimming and playing golf at The Patriot, a Davis Love III–designed course across the lake.

"And mowing the grass," Todd said, laughing. "Seriously, on a tractor, and the grounds looked like Augusta National." Pierrine Johnson laughed at that, but Todd persisted: "It was perfect. Mother and Daddy would be out picking up pine cones, keeping it immaculate."

That's the Hootie Johnson his family remembers; not some "sexist" Southern male portrayed by Burk and some national media. They knew him as a loving father and grandfather, dedicated banker and someone who "always wanted to do what was right for South Carolina and the university," Pierrine Johnson said. "That was his main theme. He wanted both to improve."

In more than one interview as chairman, Johnson was known to quote Clifford Roberts, who was once told by a patron what a great tournament he ran. "[Roberts] said, 'Thank you,'" Johnson would say, "'but we never really get it right.'"

In a lifetime of golf, banking and service to community and family, Johnson got it right more often than not.

14

GROWING THE GAME

South Carolina Golf Association

Happ Lathrop had been executive director for more than thirty years when the South Carolina Golf Association earned a rare recognition. In 2008, *Golf Digest* surveyed America's top junior golf programs and concluded the SC Junior Golf Association was No. 1.

Lathrop (real name: Harrison Freeman, but known as Happ since childhood), when asked what he believed put the SCJGA on top, laughed. "Tell you the truth, I didn't ask," he said. "I didn't want to give them a reason to change their minds."

The honor wasn't totally unexpected. Since the SCJGA was created in 1990 (the SC Junior Golf Foundation followed in 1995), Lathrop and his staff had started a flood of innovative junior programs, geared toward making the game accessible to youngsters of all means.

When *Golf Digest* told Lathrop his organization was in the running for the honor, he and then-SCJGA director Tim Kreger "put together a big portfolio of information and sent it off to them," Lathrop said. "We thought we had a pretty good package; a lot of programs, and some of our stuff is a little unique."

Besides its annual SC Junior Championship, the SCJGA sponsored introductory programs for youngsters, operated a Junior Golf Land where kids could learn the basics and ran a string of top junior events. Three—the Beth Daniel Junior Azalea (Charleston), the Junior Heritage (Hilton Head) and Spartanburg's Bobby Chapman Invitational, which in 2019 had a stronger field than the U.S. Junior—are annually among the top junior events

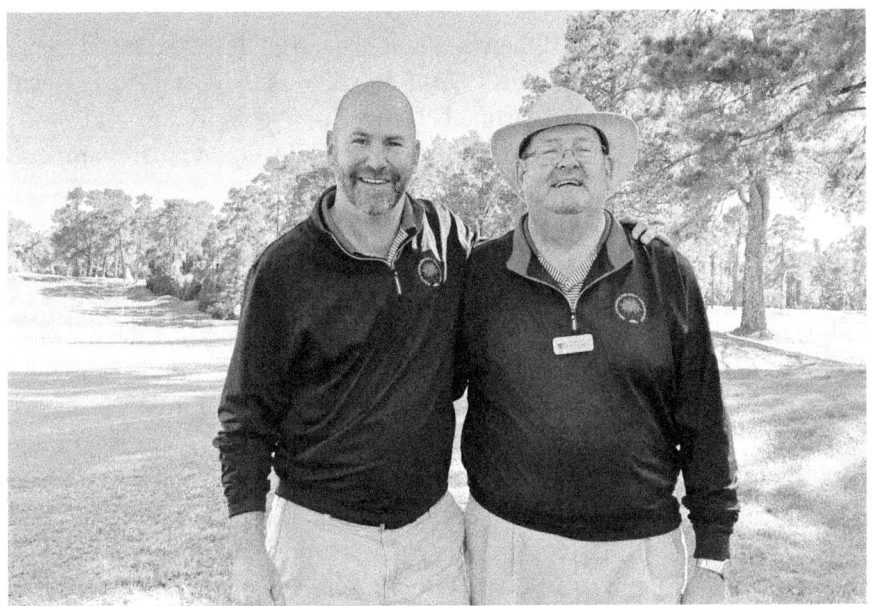

SC Golf Association executive director Biff Lathrop (*left*) inherited his job from his father, executive director emeritus Happ Lathrop. *Courtesy of the SC Golf Association.*

nationwide, and South Carolina is also home to the Sage Valley Junior Invitational in Graniteville and the Dustin Johnson World Championship in Myrtle Beach, which are not under the SCJGA umbrella.

SCJGA officials can get creative when necessary, too. The Junior Azalea in Charleston was in danger of dying until Lathrop recruited LPGA Hall of Famer and Charleston native Beth Daniel to lend her name to the tournament. "Hart Brown [head professional at the Country Club of Charleston] called Happ and said, 'This tournament won't survive unless we change something,'" Daniel said. "They decided to call it the Beth Daniel Junior Azalea—and I said yeah, I'll do it.

"To see how [SCJGA officials] do things, how they are with the kids, is very impressive. It's one of the most rewarding things I've done." Daniel's name is also on the SCJGA's annual award for the state's top girls' player, while PGA and Champions Tour veteran Jay Haas's name is on the boys' award.

Another result is a long list of former juniors who went on to great things as amateurs and professionals. Take the U.S. Walker Cup team: from 1922 to 1998, South Carolina had one player chosen (Jack Lewis of Florence, in 1965), but starting with Columbia's Jonathan Byrd in 1999, that list grew to seven.

Pro golf fans know U.S. Open champions (and SCJGA products) Lucas Glover and Dustin Johnson, plus PGA Tour winners Byrd, Bill Haas, Kevin Kisner, Scott Brown, Ben Martin, D.J. Trahan, Wesley Bryan and more. Another, Columbia's Charles Warren, the 1999 NCAA individual champion, also played the Tour.

Finally, there's that "unique stuff," such as the Hootie & the Blowfish Monday After the Masters Celebrity Pro-Am, which in twenty-five years donated more than $1.5 million for junior golf, part of more than $7.5 million raised for education and other charities via the Hootie & the Blowfish Foundation. The event brings together members of the South Carolina–based rock band, PGA Tour players and national celebrities for a day of golf at Barefoot Resort in Myrtle Beach.

The band also attaches its name to the SCJGA's summer chapter series and a men's college tournament near Charleston (the Hootie at Bulls Bay); lead singer Darius Rucker hosts a women's event (Darius Rucker Intercollegiate) at Hilton Head's Long Cove Club. Other money-raisers include the state's "First in Golf" license tag program (since copied by other states) and the Tiger Golf Gathering, a Clemson-sponsored (and SCGA-managed) event that sends the SCJGF a check each year.

Besides annual team matches versus Georgia, in 2018 the SCJGA kicked off the Watson Cup, named for PGA Tour legend Tom Watson, pitting South Carolina and Scotland junior teams in biennial Ryder Cup–style matches. Coaches for the second meeting, tentatively scheduled for summer 2021, were former University of South Carolina golf coach Puggy Blackmon and former Golf Channel host Charlie Rymer, both native sons of South Carolina.

"When I played junior golf," said Rymer, a three-time South Carolina Junior champion, U.S. Junior champion and former PGA Tour player, "it took a big investment from your family. But South Carolina is unique in that now there's enough competition in state that you can get on college radars without spending a fortune. The competition, the courses, the way events are run, are all absolutely A-plus, and it's all been driven by Happ."

The SCJGA remains high-profile, said Brian Freeman "Biff" Lathrop, who succeeded his father as executive director in January 2018, as Happ Lathrop retired after 42 years. "We go to national meetings on junior golf, and a lot come to us asking how we do things," Biff Lathrop said. "The way we get the communities involved, the way clubs and residents support [tournaments]—it's incredible to watch."

The younger Lathrop began work with the "Little Legends" program as assistant to then-director Paul Rouillard in 1997, moving up to director in

2003, and is well versed in the history. It's also his history. "I was literally born into [the SCGA]," he said. Family lore has it that he licked stamps for SCGA mail-outs at age four.

"The [SCGA] was like a brother, another piece of our family," he said. "I grew up around it, watched my parents [Happ and Joyce] do it all."

Today, the SCGA and SCJGA/SCJGF are parts of a modern, well-oiled machine; Biff Lathrop instituted online tournament registration and QuickBooks accounting. As his dad freely admits, "I couldn't keep up with the social media things, half the time I didn't know what [the staff] was talking about."

Still, Happ Lathrop almost singlehandedly built that machine starting in 1977. Until then, the SCGA, founded in 1929, had not advanced much beyond its beginnings. With Lathrop taking over, that changed.

HAPP LATHROP:
FORTY-FOUR YEARS GETTING THINGS DONE

The South Carolina Golf Association was formed on November 11, 1929, when ten state golf clubs met, naming Gordon McCabe of Charleston the first president and George T. Trescott the SCGA's secretary. The organization was created to crown an individual South Carolina amateur champion; the Carolinas Golf Association then had a champion of both Carolinas, but not one solely for South Carolina.

W.C. Hale was the inaugural champion, and until 1959, the SCGA's lone sponsored tournament was the SC Amateur. SCGA business was handled by the board until 1977, when it hired as its executive director a young man from Hampton, South Carolina.

Lathrop grew up in a town he calls the "home of the SCGA," though not because of him. His association predecessor, Bob Causey, was a hometown friend of Happ's father ("they sang together in a quartet," he said), so after eighteen-year-old Happ won the SC Amateur in 1968, Causey added him to the SCGA board as a youth liaison. Running one-day tournaments earned Lathrop fifty dollars each, "and that was big money helping with college" after his father died in 1967.

After graduating from the University of South Carolina, Lathrop took a job selling construction equipment, but after five years, he knew he wanted something else in his life. Causey's retirement from the SCGA opened a

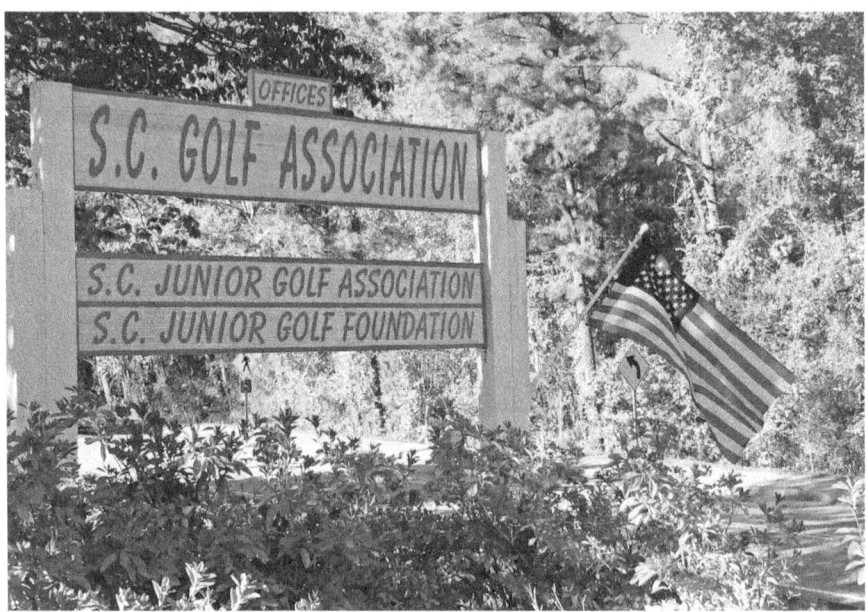

The Irmo offices of the SC Golf Association and Junior Golf Association. *Courtesy of the Golf Association.*

door, and Lathrop became the SCGA's first full-time employee, though financially, it was hardly a plum job. "A golf pro in Charleston said he'd do it for $16,000, and I said I'd do it for $12,000," he said. "It certainly wasn't a better deal" than his equipment-sales position, but "I thought I could make an impact staying in golf, and I was enjoying what I was doing."

For more than a decade, the Lathrops were a two-person show (three when Biff got old enough to help). The SCGA operates twenty-two major events and eighty-five others, including nine USGA qualifiers and not including junior events, but in 1977 it ran only the state amateur, four-ball, junior and senior championships, plus a few one-day events. "We could only run one tournament at a time," Happ said, until he added another full-time employee, Matt Harvin, in 1988.

Biff Lathrop takes credit, sort of, for the start of the Junior Golf Association. "I would finish high school golf season, and I was the only kid who had somewhere to go play," he said. "Dad said, 'We need to come up with something for other kids to do.'"

At one point, nearly 2,000 juniors were participating in SCJGA chapter events. Now, even with more sports opportunities today, roughly 1,200 still take part.

The American Junior Golf Association (AJGA) stages high-level (and often high-dollar) tournaments around the nation, but the SCJGA offers affordable instate opportunities. "Valerie Bryan [mother of Tour player Wesley Bryan and mini-tour player George Bryan IV] says, 'My boys got college scholarships [to South Carolina] and never played the AJGA,'" Happ Lathrop said.

"That was part of the point [of the SCJGA]: to control expenses and not have to travel so much, and still have good quality events that coaches will come to watch."

In 2003, Clemson's golf team, featuring all five starters from instate, won the NCAA Championship. That ranks as one of the elder Lathrop's favorite moments, along with Charles Warren's 1997 individual NCAA title and Chris Patton's 1989 U.S. Amateur victory. There also were three straight NCAA Division II titles won by USC Aiken coach Michael Carlisle, previously one of Lathrop's first SCJGA interns.

At the PGA Tour's 2011 Wells Fargo Championship at Quail Hollow Club in Charlotte, former Clemson teammates and SCJGA products Glover and Byrd battled for the title, Glover winning in sudden death. "A friend sent me a text message that day: You feel like a proud papa?" Lathrop said, chuckling.

It's a memory he can enjoy as part of a well-deserved retirement. Meanwhile, the show—with a different Lathrop in charge—rolls on.

BEST IN THE NATION FOR JUNIORS

Today, the SCGA runs tournaments for all ages and oversees rules questions, handicapping and course ratings for 280 of the state's 350-plus courses. But Biff Lathrop's roots are still in junior golf, as evidenced by this favorite story:

"Back in the day, [noted instructor] David Leadbetter told how, with all the kids in Florida, when qualifying for U.S. Junior events, they bypassed South Carolina [qualifiers] because they knew they wouldn't get a spot" ahead of the state's players, Biff said. "I think the caliber of players shows the success of the program that [Rouillard] started."

Rouillard was neither the first person to recognize the future of junior golf, nor the longest-serving or arguably most influential leader, though. Those "titles" probably should go to Charlie Rountree III (and his father) and longtime junior director Chris Miller.

Miller, SCJGA director from 2001 to 2018, had coached Dustin Johnson for a year at Dutch Fork High School, which later won state titles with the likes of Johnson and Wesley Bryan, both now on the PGA Tour, and mini-tour player George Bryan IV. But Miller said the SCJGA's emphasis was on building participation, not grooming future pros.

"It's easy to put a feather in your cap about a kid who goes on to great things," he said, "but our goal was to expose the game and get new players in the game. It's not just the kid shooting 64, but the kid who's improving from [scores of] 104 to 94. Basically, we wanted to make sure anyone who wanted to try to play, we would provide the access to courses and instruction."

Miller oversaw a slow but steady growth of junior events and led efforts to revive older events, including the Junior Azalea and the Florence Junior, the oldest junior tournament in the state. The state's newest major junior event is the Dustin Johnson World Junior Championship, staged at TPC Myrtle Beach and hosting ninety of the world's top juniors. "Dustin always wanted to do something in the state," Miller said. "[The tournament] is like a mini-tour event, and these kids don't have to travel outside the state to get that competition."

Miller stepped down from the director's role in early 2018 due to chronic migraines but remains proud of his and others' work. "The biggest thing is giving kids the opportunity to play, teaching them about the Rules of Golf, how to play the right way," he said. "We built relationships with the kids and their parents, and it's crazy how good kids are shooting now; I think [SCJGA events] toughened them up, and now they're ready to rock and roll."

As for Rountree, a past SCGA president and current statehouse lobbyist, he inherited his passion for junior golf from the late Charlie Rountree Jr., who in 1968 convinced the Country Club of Lexington and longtime professional Norman Flynn to play host to the State Junior. "There was no revenue, but the membership agreed to put on the event, with my parents overseeing the whole thing, including the scoreboard," Rountree said. Lexington since has hosted more State Juniors than all other courses combined.

The elder Rountree was also a SCGA president when Happ Lathrop became executive director, and along with longtime friend Pete Cox, they started the annual South Carolina–Georgia Junior Team Matches in 1976, the longest-running such matches in the United States. The younger Rountree "got the junior bug from his dad," Biff Lathrop said. "He's been a huge piece of the puzzle."

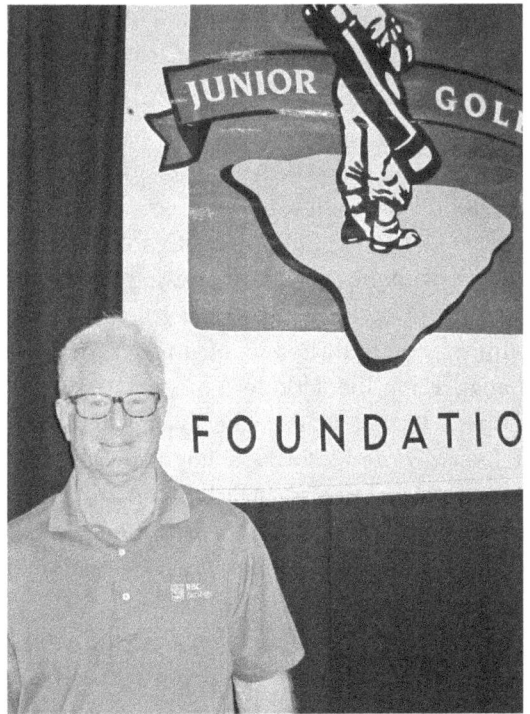

Above: Former SCJGA director Chris Miller (*right*) enjoys a moment with Columbia golf instructor George Bryan III, father of PGA Tour winner Wesley Bryan. *Photo by Bob Gillespie.*

Left: Charlie Rountree III of Lexington, at the SCGA's annual Golf Ball fundraiser, also helped launch the Hootie & the Blowfish Monday After the Masters Celebrity Pro-Am. *Photo by Bob Gillespie.*

Rountree helped the SCJGA grow to 17 major championships, 125 one-day events and some 1,400 players. As a past member of the USGA's Junior Committee, he spread the gospel of South Carolina's devotion to the game's future. And he's always loved to wheel and deal.

When South Carolina youngsters couldn't play in the Carolinas Golf Association's Father-Son, he helped recruit legendary players Henry Picard (Masters and PGA Championship titles) and Frank Ford Sr. (seven SC Amateur titles) to lend their names to a junior tournament, with Ford's 1934 silver state amateur cup as the trophy. Rountree said a conversation "in a duck blind" with former Clemson star Charles Warren led to creation of the Tiger Golf Gathering.

"We've figured out ways to work with all kinds of people to raise money for junior golf," Rountree said. The one most know best is the Hootie & the Blowfish Monday After the Masters Celebrity Pro-Am, which in 2019 celebrated its seventeenth year in Myrtle Beach and twenty-fifth overall. It, too, bears Rountree's fingerprints, among others, and is a highlight of South Carolina's golf calendar—even if it didn't start out that way.

THE BOYS IN THE BAND: HOOTIE COMES ON BOARD

The inaugural Monday After the Masters (MAM), held in Columbia, was not affiliated with the SCGA or Hootie & the Blowfish and was less than a success. Soon after, Rountree took a call from organizers asking to meet with him and Happ Lathrop, who agreed—with the proviso of choosing the event's board—to run it. The event had lost money its first year, but Rountree said, "We turned a $140,000 profit our first year, and we were off to the races."

Paul Graham, then tour manager for the Hootie band and now the MAM tournament director, said they were approached early on about getting involved. Their album *Cracked Rear View* was a huge success, and the band members—singer Darius Rucker, guitarists Mark Bryan and Dean Felber and drummer Jim "Soni" Sonefeld, who had met as students at the University of South Carolina—were enthusiastic golfers, carrying clubs in their van when on the road.

"We were getting a reputation as golf guys," said Rucker, the band's most avid player. "So when the junior golf folks asked if we'd get involved, we thought we'd do it a couple of years, but it kept growing."

The boys in the band: Hootie & the Blowfish members *(from left, back row)* Jim "Soni" Sonefeld, Mark Bryan, Dean Felber and Darius Rucker with ESPN Radio hosts Mike Greenburg and Mike Golic during the Monday After the Masters Celebrity Pro-Am. *Courtesy of Golf Tourism Solutions.*

All four members wanted to honor their home state, Graham said. "When we were approached about putting the band's name on a golf tournament, the guys, all in their twenties, said, 'Wow, this is amazing,'" he said. "Yeah, it was a chance to invite our friends to come play golf, with the celebrity part mixed in. But the opportunity to have their name on something to give back was very cool to the guys."

It didn't hurt that Rountree soon arranged to take the band members, two at a time, to play Augusta National. Rucker, whose first exposure to golf as a youngster was accompanying a friend's father to the Charleston Air Force Base course, still has vivid memories of his first Augusta visit. "I've been blessed to play there a few times [since], and every time, I get chills," he said. "That time, I couldn't believe we were there, and I'm sure I shot 90. I was in awe."

The renamed Hootie & the Blowfish Monday After the Masters scored some early successes, attracting celebrity and PGA Tour participants. Perhaps the biggest early "get" was then-rising star Tiger Woods, who drew a huge crowd in Columbia.

Following a stint at Kiawah Island, the MAM in 2003 found its current home: Myrtle Beach's Barefoot Resort's Dye Course. Besides a highly regarded course and a tourist-friendly destination, Myrtle Beach's House of Blues, a stone's throw from Barefoot, is the ideal venue for a post-golf Hootie concert each April.

"Once we established ourselves in Myrtle Beach, celebrities were asking us if they could come, instead of us having to ask them," Mark Bryan said. "I remember thinking, 'Wow, this thing has crossed the line into something special.' It's bigger than we ever dreamed, but the concept never changed: to do the right thing for education and junior golf in South Carolina, while having fun with our friends. Now that it's got [the Hootie Foundation], it's something maybe our kids can take over someday."

Rucker said the atmosphere grows more special each year. His favorite celebrity golfer is actor Samuel L. Jackson, who "isn't there to hide. He goes into the crowd, signs autographs, he's the best." Bill Murray, a part-time Charleston resident, is another favorite. But Rucker and Bryan agree on the event's biggest star ever: the late Arnold Palmer.

"I've got a picture of me with Arnie. Wow!" Rucker said. Bryan that day drew the honor of playing with Palmer. "We had the junior caddies [who earn the right to work the MAM by competing in the SCJGA's Caddie Classic], and this nice young lady accidentally left [Palmer's] 3-iron in my bag," Bryan said. "The next time I pulled the club out, I knew it wasn't mine.

"I wrote a short note, wrapped it around the club shaft and sent it to Orlando. A couple of weeks later, a package shows up; inside is the 3-iron, signed by Mr. Palmer on the grip. It's in my display collection at the house now."

The MAM has raised money for many worthy causes, but for Rucker—who in his life has known what it's like to be turned away from some courses—the real benefit is giving kids, especially minorities, a chance to discover the game he loves. "These programs are so great to take golf to kids who might never have a chance to play, because it's too expensive or whatever," he said.

"As a kid, I played military courses, so there were always other African Americans. But at other courses, there weren't a lot of people who look like me." Recalling his friend's father, Rucker said, "I'm lucky I had someone in my life, someone who cared about me enough to teach me this game. And I want to be a part of that, too."

For the SCGA and SCJGA, that's also the mission.

THOSE WHO CAN, ALSO TEACH

Picard and the Instructors

Henry Picard was, in many ways, an overlooked golf champion. His accomplishments as a player are reason enough for Henry Picard to have earned a spot in the World Golf Hall of Fame, but that didn't come about until 2006, nearly ten years after he died at the age of ninety.

During a brief but illustrious career playing what would become today's PGA Tour, Picard won twenty-six times, including the 1938 Masters and 1939 PGA Championship, and was chosen for four U.S. Ryder Cup teams. Herbert Warren Wind, the man credited with naming Augusta National Golf Club's eleventh, twelfth and thirteenth holes as "Amen Corner," said in 1947, "Henry has the finest swing in golf."

But Picard (1906–1997) was perhaps best known as one of the great teachers of his time. He worked with Jack Grout, who would become Jack Nicklaus's instructor. Sam Snead and Ben Hogan also praised Picard as an instructor.

"He helped Snead, where he put his swing on the proper plane, and said it was the most expensive lesson he ever gave. He was always very helpful," his son Larry Picard recalled prior to Picard's Hall of Fame induction.

Hogan dedicated his book, *Ben Hogan's Power Golf*, to Picard, who first encouraged him by telling him that he was good enough to win on the PGA Tour and by offering financial assistance if he was in need. Hogan played well enough to not need financial help, but in 1940, he was struggling with a hook that appeared at inopportune times.

"I can fix that in five minutes," Picard told Hogan. He adjusted Hogan's grip to a slightly weaker position, helping take the dangers of the left side out of play. Later that year, Hogan won his first tournament.

Picard got his start as the golf professional at the Country Club of Charleston in 1925 when the club hired Donald Vinton as its head professional and he brought along the talented teenager as his assistant. Later that season, Vinton got Picard into the Carolinas Open at the Country Club of Charleston, and Picard defeated Vinton in a playoff.

In 1930, when Vinton left the Country Club of Charleston, Picard was selected to succeed him. A story in Lee Pace's book on the Country Club of Charleston tells how during the Great Depression, Picard went to his bank only to find a sign that said "Closed Indefinitely," and the club told him it could no longer afford to pay his salary. But several members stepped up and offered to pay him based on his daily scores, five dollars for even par or ten dollars for 1-under.

As Picard began to make his way on the professional tour, he became recognized for his talents as both a player and teacher. Milton Hershey hired him in 1934 to serve as the head pro at Hershey (Pennsylvania) Country Club, where he remained until 1941, and when Picard left for another job, he recommended Hogan as his replacement. Picard also served at such prestigious clubs as Canterbury in Cleveland, Ohio, and Seminole in Palm Beach, Florida, before retiring in 1973 and returning to Charleston.

While Picard was naturally talented as a player, he also knew he could be better. Shortly before the 1935 Ryder Cup, Picard sought the advice of Alex Morrison, a highly respected golf instructor. Picard spent more than a week with Morrison, often hitting more than five hundred balls a day as he learned the foot roll that was a part of Morrison's method. Picard went on to win twenty-one of his twenty-six official PGA Tour victories between 1935 and 1939.

Although fellow World Golf Hall of Fame member Beth Daniel learned the basics from Country Club of Charleston professionals Al Esposito and Derek Hardy (who also taught U.S. Women's Open champion Jane Geddes), she said she benefited from tips from Picard.

When she was a youngster, Picard saw Daniel playing with Top-Flite golf balls, noted for their endurance but not their feel. The next day, Daniel came in and found her golf bag filled with Titleist golf balls.

Picard was a quiet man, Daniel said, who often taught by asking questions about the golf swing. "How do you hit the ball high?" Daniel said he might ask. "At the end of the day, he would find me and see if I knew the answer.

Henry Picard (*right*), the 1938 Masters and 1939 PGA Champion, was considered one of golf's best instructors. Here he is pictured with his friend, amateur star Frank Ford Sr. *Courtesy of the Ford family.*

I can remember hiding behind trees because I didn't know the answer....He would put a ball behind a tree and ask me how you would play from there. He was teaching course management."

When she could answer Picard's question, his response was a polite "Thank you."

Not wanting to intrude on the teaching professionals at the Country Club of Charleston, Picard did some of his teaching in retirement at Plantation Pines, a rustic par-3 course and driving range nearby.

"He was very important to the Country Club of Charleston," present-day Country Club of Charleston director of golf Hart Brown said. "The

members wanted to be around him. They would gather around and listen to what he had to say. There was no telling what was going to come out of his mouth, but it was always interesting.

"I was told that when he taught, there would be some lessons where he would never say a word. And if you got a word out of him, you'd better listen. To me, that's the sign of a good teacher."

HEMPHILL: LEFT-HANDED GOLFER AND SAXOPHONE PLAYER, TOO

Everyone who ever knew Melvin Hemphill came away with a story about the man who taught golf for forty-seven years at Columbia's Forest Lake Club. That included his granddaughter, one-time Golf Channel personality Kelly Tilghman, who was eleven years old when her "Pops" died in 1980 at age seventy-two.

"My most vivid memory," she said, "is of him with a grin on his face as he watched me hit balls" when Tilghman was three or four. "We didn't talk much about golf back then, but I knew it was a staple of his world—and it was becoming one in mine, too. I'm so lucky he got to see me hitting those balls on the practice tee."

To Tilghman, who went on to play golf at Duke and briefly as a professional, Hemphill and his sister Kathryn, Tilghman's great-aunt, were beloved family. To their contemporaries, he was the teacher who worked with PGA player Jack Fleck in the two weeks before Fleck shocked the world by beating Ben Hogan for the 1955 U.S. Open title. Kathryn—"Tatee" to Tilghman—was one of the nation's best amateur players, reaching the semifinals of the 1936 and 1937 U.S. Women's Amateur and competing on the U.S. Curtis Cup team, before turning pro in 1946, competing with such names as Patty Berg, Babe Zaharias and Louise Suggs.

Besides Fleck, Hemphill also worked with Masters' champion Tommy Aaron, U.S. Amateur champion Gary Cowan and PGA Tour standout Gardner Dickinson. A skilled left-handed player in his prime, Hemphill won the 1958 South Carolina Open (at age fifty). He also was a talented musician who led his own orchestra during World War II and was once offered the lead saxophone position in the Jimmy Dorsey Band.

Norman Flynn, longtime professional at the Country Club of Lexington, became Hemphill's assistant while playing for the University of South

Melvin Hemphill of Columbia's Forest Lake Club worked with Jack Fleck prior to his 1955 upset of Ben Hogan in the 1955 U.S. Open. *Courtesy of Forest Lake Club.*

Carolina. Along with his mentor, Flynn helped Aaron when the player was based at Columbia's Fort Jackson.

"Tommy was concerned about his golf game," Flynn said, "and a friend told him, 'Go see Melvin Hemphill, he'll find any flaws.' But Melvin thought Tommy had a perfect swing. Tommy would swing and ask, 'How about that?' and Melvin said, 'I don't see any faults.' He worked with him on his short game, and Tommy went from there."

Others impressed with Hemphill included legendary golf hustler Titanic Thompson, who tried to recruit Hemphill to go on the road, Flynn said. "A left-handed golfer who plays sax, too; we'll clean up," Thompson said.

Hemphill's primary focus starting in 1931, though, was on Forest Lake Club and its members, one of whom later became golf coach at South Carolina. Bobby Foster said Hemphill "gave me a love of the game and made it fun. He was like a second dad to me and gave me the fundamentals. The way he did it was as much about timing and rhythm, being on-plane. He was very visual and feel-oriented as opposed to a technical approach."

Flynn said Hemphill's strength was "to make [golf] simple for all. He didn't rebuild your swing but got the best part of what you were doing and built on that. Everyone in golf wanted to tell you Hogan's secret but Melvin figured it out years before: the slight lateral move from the top of the swing, right elbow on your hip, sliding the hip forward. I always taught that way, too."

Sometimes, "simple" to Hemphill could astonish others. Flynn, who grew up playing a course in Chester without bunkers, wanted to learn how to hit sand shots. "Melvin jumped into a trap at Forest Lake and showed me how to splash the ball out, curving the ball to the hole," Flynn said. "He said, 'See, it's simple.' I asked what club he used and he said, 'I don't know.' We looked—it was a 6-iron!"

Hemphill was named the Carolinas PGA's Professional of the Year in 1961 and taught until his retirement in 1978. In 1980, he and Kathryn were inducted into the South Carolina Golf Hall of Fame, the same year he died.

In 2012, Tilghman covered the U.S. Open at Olympic Club in San Francisco, and Golf Channel assigned her to interview Fleck about his 1955 victory there. "That was such a moment for me," she said. "During a commercial break I said, 'Mr. Fleck, you may not know me, but Melvin Hemphill was my grandfather.'

'[Fleck] got a grin on his face and reflected on that time. He said, 'I remember your grandfather. He was a great man.'"

GRANT BENNETT:
BASEBALL'S LOSS, GOLF'S GAIN

Grant Bennett, who died in 2005, is considered by many the father of junior golf in South Carolina. A junior tournament at Florence Country Club bearing his name is one of the most coveted titles a SC Junior Golf Association member can win.

A native of Winston-Salem, North Carolina, Bennett moved to South Carolina in 1951 and served at Florence Country Club, Country Club of South Carolina in Florence and Wildewood and Crickentree clubs in Columbia. Players he instructed went on to win amateur, PGA and LPGA titles.

As a youngster, Bennett dreamed of playing major-league baseball, but a broken arm derailed that. Looking for something else, he and a friend built a small backyard golf course. Bennett shot 43 for nine holes and began dreaming of playing golf professionally. But World War II intervened, and he spent the next five years in the navy.

When he was discharged in 1946, Bennett finally found his calling when he took a job as the head golf professional, manager and superintendent at New Bern (North Carolina) Country Club. He was a good enough player to have competed against Sam Snead and Cary Middlecoff and was a friend of Ben Hogan.

When longtime professional Ellis Maples retired in 1951, Florence Country Club wanted someone who could built a top junior program, and they found that person in Bennett. In addition to his duties at Florence Country Club, he also coached Florence's McClenaghan High School golf team, which won ten state championships between 1956 and 1969. His teams won over two hundred matches and lost only once between 1957 and 1969.

Bennett's system as a high school coach was a "ladder" system in which lower-ranked players could challenge higher-ranked players to move up the rankings. He once told *The State* newspaper, "I have an uncanny ability to see and sum up what a player's doing wrong. With some better players, I can correct 95 percent of their mistakes on the phone."

Bennett believed in starting players young. He said most of them were between eight and twelve before they were ready, but he had some as young as five. Jonathan Byrd, an All-American at Clemson who played the PGA Tour, remembered being taught by Bennett while he was in the second grade.

Florence teaching legend Grant Bennett (center) poses with 1960s championship junior players (from left) Don Greiner, John Orr, Billy Womack and Buddy Baker. *Photo courtesy David Bennett.*

"He would send us into the woods to the left of the range, and we would have to get out of the woods. And he'd sit in his cart, dodging balls and encouraging us and watching us compete," Byrd said in 2005. Byrd recalled practicing his putting on a dirt path, and a lesson in "leading with the left hip," in which Bennett pulled so hard on Byrd's pants to demonstrate that point he almost tore them.

"He taught discipline, hard work, honesty and integrity, and he instilled a competitive spirit," Byrd said.

Bennett became a member of the Carolinas Golf Hall of Fame, the South Carolina Golf Hall of Fame, the South Carolina Athletic Hall of Fame and Carolinas PGA Section Hall of Fame. He served for thirty years on the USGA's Junior Committee and hosted both the U.S. Junior Boys and Junior Girls championships.

His pupils included PGA Tour players Byrd, Charles Warren, Randy Glover, Jack Lewis and Mike Holland, former LPGA golfer Kathy Hite, 1958 U.S. Junior champion Buddy Baker, five-time U.S. Senior Women's champion Carolyn Cudone and four-time SC Amateur champion Billy Womack.

ORVILLE WHITE AND THE NEXT WAVE

South Carolina has had a legion of top-notch golf instructors, not just Picard, Hemphill and Bennett. Orville White, the head professional at four clubs in the Carolinas including Aiken Golf Club and Midland Valley in Aiken, was renowned for teaching putting, chipping and how to use a sand wedge to such players as Sam Snead and Clayton Heafner. A Chicago native, White was inducted into the South Carolina Golf Hall of Fame in 1984, the Carolinas PGA Section Hall of Fame in 1985 and the Carolinas Golf Hall of Fame in 1991. He died in 1991 at age eighty-three.

More recently, Derek Hardy taught both World Golf Hall of Fame member Beth Daniel and U.S. Women's Open champion Jane Geddes while at the Country Club of Charleston. Jimmy Koosa of Columbia was one of 2016 U.S. Open and 2020 Masters winner Dustin Johnson's first instructors. PGA Tour winners D.J. Trahan and Wesley Bryan were both taught by their fathers, Donald Trahan and George Bryan Jr. And Jackie Seawell, father of University of Alabama men's golf coach Jay Seawell, remains a sought-out teacher in Aiken.

THE VISIONARIES

South Carolina's Golf Architects

To call Mike Strantz a golf course architect was a bit of a disservice. Sure, Strantz was the designer of record of some of the country's most innovative golf courses before his untimely death from cancer in 2005. But Strantz was much more than someone who put together architectural renderings and asked the people who operated the heavy equipment to turn them into golf courses. Strantz was an artist, a visionary.

His medium was dirt and grass, and he translated those basics into some of the country's finest, most talked about golf courses. He came along in a time when minimalism was favored and built grand, majestic courses. Bulls Bay Golf Club in Awendaw, South Carolina, just a few short miles up the road from the home Strantz, his wife, Heidi, and their daughters shared in Mount Pleasant, is a living testimony to Strantz's artistry.

A group of investors had begun talking with Strantz about designing the golf club, and Strantz put his artist's pencil and sketch book to work. From the flat tomato fields where the course would be built, Strantz envisioned a clubhouse sitting atop a high dune that would offer members a view of most of the holes on the golf course and, in the distance, the Atlantic Ocean.

A few years later, Mount Pleasant attorney Joe Rice decided to take on the project, and he and Strantz flew to New York and played National Golf Links and Shinnecock Hills, then stopped on the way back to play Tobacco Road and Tot Hill Farms, both Strantz designs.

"He said, 'Joe, [Bulls Bay] will look like Shinnecock. It will be beautiful," Rice recalled. "It's amazing how much the course looks like those drawings.

Golf architect Mike Strantz, pictured with his horse Dega, often studied potential golf course sites from horseback. *Courtesy of Heidi Strantz Mortimer.*

Mike was just a genius. He had a vision for natural beauty and preservation I've never seen before."

"His drawings were picture-perfect," said Kenny Ohlinger, who became Bulls Bay's first superintendent. "If you could blow the drawings up big enough and lay it over the hole, it would match perfectly."

Strantz excavated lakes around the property and began piling the dirt into a huge dune. He would stand in the bucket of a tractor and look out, then tell the workers to keep bringing more dirt until he reached seventy-five feet, "the highest natural point in Charleston County," he once said, even though the dune was Strantz-made. Roughly two million cubic yards of earth were moved to reshape the site.

In order to give the trolley (pull-cart) paths a timeless look, Strantz would draw irregular-shaped patches and have the turf cut by hand to fill the design. "Every tee top, every fairway cut, every bunker face, Mike painted them out line-by-line. Every median you see in the cart trails, Mike Strantz painted out by hand," Ohlinger said.

"It was Mike's willingness to see things differently that led him down his own path. He was a maverick type of thinker, doer [and] creator. He detested straight lines. His golf courses reflect a lot of ruggedness and visual intimidation without actually playing as hard," said Bulls Bay's director

of golf, the late Terry Florence, who first got to know Strantz when he was working at Wild Dunes and then worked with Strantz through the construction process at Bulls Bay.

"The thing I love about his golf courses is you can't wait to get to the next hole to see what he's done next," Florence said. "Each hole is its own separate expression of Mike's artistry."

Strantz built nine golf courses, all of them award winners: Bulls Bay; Caledonia Golf and Fish Club and True Blue, both in Pawleys Island; Tobacco Road and Tot Hill Farm in North Carolina; Royal New Kent and Stonehouse in Virginia; and Silver Creek Valley and Monterey Peninsula Country Club Shore Course in California. In 1998, *Golf World* magazine named Strantz as its architect of the year; in 2000, *Golfweek* picked Strantz as one of the top ten greatest golf architects of all time.

As a teenager growing up in Toledo, Ohio, Strantz worked on golf maintenance crews during the summer. His first job after graduating from college was working at Inverness, which was being prepared for the 1979 U.S. Open by George Fazio and his nephew, Tom Fazio. Strantz, who had a talent for bunkers, was hired by the Fazios and worked on several projects, including Moss Creek near Hilton Head Island and, eventually, Wild Dunes, Tom Fazio's first solo design.

The travel was affecting his family life, so Strantz took a job working on the grounds crew at Wild Dunes and pursued his passion for art. But in 1989, Hurricane Hugo came along and scored almost a direct hit on Wild Dunes. The resort asked Strantz to rebuild the seaside seventeenth and eighteenth

Mike Strantz created his vision of a Lowcountry Shinnecock, sculpting a tall hill from flat tomato fields for the clubhouse overlooking the ninth green at Bulls Bay Golf Club. *Courtesy of Holger Obenhaus/Bulls Bay Golf Club.*

holes and help remodel the Harbor Course. Strantz also helped oversee the construction of Dunes West in Mount Pleasant.

He later was approached to do some bunker work for the Legends Group in the Grand Strand, then was hired to design Caledonia. It was the perfect fit, close enough for Strantz to commute from home. The result was stunning, and the course drew national acclaim, acclaim that would continue to grow through the years.

Strantz's last work was Monterey Peninsula Country Club's Shore Course, a low-budget, bland next-door neighbor of Cypress Point on Seventeen Mile Drive. Strantz reversed the direction of the fifth through fifteenth holes so golfers would enjoy a backdrop of the Pacific Ocean. Strantz died six months after completing the redesign, which now is ranked in America's Top 100 by *Golf Digest* and is one of the three courses used in the AT&T Pebble Beach Pro-Am.

TOM JACKSON: HALL OF FAME DESIGNER

Greenville's Tom Jackson built more than one hundred golf courses, nearly half of them in his adopted home state of South Carolina. Jackson was named to the Carolinas Golf Hall of Fame in 2007. The Cliffs of Glassy in Landrum, which sits at an elevation of three thousand feet, was named the fourth-most scenic course in the United States by *Golf Digest*.

Other top Jackson designs in South Carolina include Carolina Country Club in Spartanburg; Links O' Tryon in Campobello; Arrowhead in Myrtle Beach; the Plantation Course at Edisto Beach; Pebble Creek in Greenville; the River Club in Litchfield Beach; and Mount Vintage Plantation in North Augusta. The latter was the home of an LPGA tournament for several years.

Greenville's Tom Jackson has designed or updated numerous courses in South Carolina. *Courtesy of Tom Jackson.*

Jackson got into golf course design after earning an architecture degree in 1965. He sent out thirty-four résumés and got only one response, from the iconic golf course architect Robert Trent Jones, who hired Jackson to work on courses in Puerto Rico. Jackson later went to work with George W. Cobb before opening his own firm.

John LaFoy: Homegrown Talent

John LaFoy of Greenville got his start in golf course design with George W. Cobb, helping Cobb with a remodeling of Augusta National. A past president of the American Society of Golf Course Architects, LaFoy is most recognized for remodeling courses and worked on courses designed by architects A.W. Tillinghast, Alister Mackenzie, Seth Raynor, Charles Blair MacDonald and Donald Ross. He helped rebuild the Country Club of Charleston in 1990–91 following Hurricane Hugo.

LaFoy grew up in Greenville and graduated from Clemson University, then apprenticed with Cobb before the Vietnam War, where he served in the marines. After being discharged, he returned to work with Cobb and in 1971 became Cobb's partner.

Bobby Weed: Pete's Protégé

Bobby Weed, who was born in Irmo, South Carolina, near Columbia, began working with famed architect Pete Dye in the late 1970s. In 1983, Weed was hired by the PGA Tour and in 1987 became the Tour's in-house architect, responsible for many of today's TPC courses. Weed collaborated with such stars as Sam Snead, Gene Sarazen, Arnold Palmer, Jack Nicklaus, Raymond Floyd and Chi Chi Rodriguez.

Weed stepped out in 1994 and formed his own design firm. The list of courses he either designed or collaborated on include the Slammer & Squire Golf Course at World Golf Village in St. Augustine, Florida; TPC Las Vegas; TPC Summerlin; TPC Tampa Bay; TPC River Highlands; Mito Kourakuen Country Club in Japan; and Dye's Valley Course at TPC Sawgrass.

Others include Country Club of Landfall in Wilmington, North Carolina; Amelia Island Plantation's Ocean Links in Florida; Grove XXIII in Hobe Sound, Florida; Spanish Oaks Golf Club in Texas; Olde Farm Golf Club's Orchard Course in Virginia; StoneRidge Golf Club in Minnesota; and the Golf Course at Glen Mills in Pennsylvania.

CLYDE JOHNSTON: COLLABORATOR, RENOVATOR

Clyde Johnston of Hilton Head Island is also a past president of the American Society of Golf Course Architects and has a large body of work, including collaborations with PGA Tour legends Fuzzy Zoeller and John Daly. Johnston's father, C.B. Johnston, was a golf coach at Wake Forest College during the late 1940s and early 1950s and the man responsible for getting Arnold Palmer to the school. A PGA professional, C.B. "Johnny" Johnston also designed several courses in North Carolina, sparking his son's interest in golf course architecture.

After graduating from North Carolina State, Clyde Johnston worked for Willard Byrd on two Charleston courses, Seabrook Island's Ocean Winds and Patriots Point Links in Mount Pleasant. Johnston formed his own firm in 1987. His collaborations with Zoeller include Covered Bridge in Indiana and Jacksonville (Florida) Golf and Country Club. He worked with Daly on Wicked Stick in Myrtle Beach and in his hometown built Old South and Island West (with Zoeller).

Johnston has built or renovated numerous Myrtle Beach–area courses, including Wachesaw East, which hosted an LPGA event; Brunswick Plantation; Heather Glen; Glen Dornoch; and others.

17

THE HAASES

Upstate Golf's First Family

O n a quiet fall Sunday morning, Jay Haas and son Bill relaxed in Jay's spacious home, where the Haas family has lived since the early 1990s, overlooking the sixth green at the Thornblade Club. The conversation was about how the first family of Upstate golf in South Carolina came to be that rarest of occurrences: a father and son who both have been among the best in professional golf.

Only ten father-son tandems have played at the highest levels, dating back to Old Tom Morris and Young Tom. As of January 2020, the Haases have won thirty-three PGA Tour and PGA Tour Champions titles: nine PGA Tour wins between 1977 and 1993 for Jay, six for Bill since 2004 and eighteen Champions (seniors) victories for the elder Haas. No other family duo in the modern era has come within ten of that total.

Asked when he knew his second son might follow him onto the PGA Tour, Jay Haas nodded toward the par-3 hole below their backyard.

"When Bill was eight, nine, ten, we were playing out here, and he hit his tee shot into a grass bunker to the left," Jay said. "He was getting ready to hit his next shot, and he walked halfway up the bank, and then back to hit his shot.

"That struck me: he was formulating a shot, coming up with a plan… visualizing the shot. Most young players are just trying to hit the ball, but Bill was trying to hit a specific shot. That was the 'ah ha' moment."

Though neither Haas has won one of golf's majors—Jay finished third at the 1995 Masters and the 1999 PGA; Bill placed fifth at the 2017 U.S.

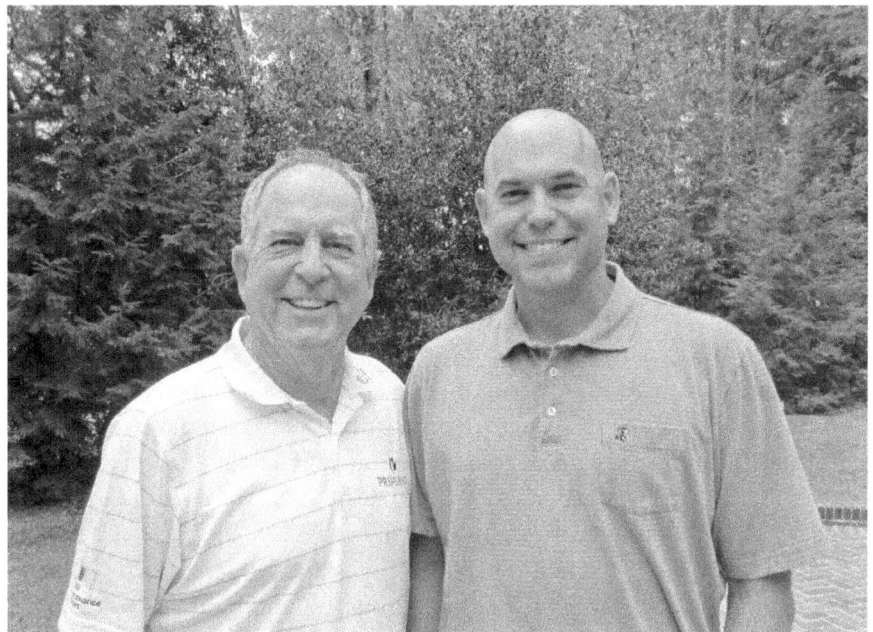

Father-son PGA Tour and Champions Tour players Jay Haas and Bill Haas at the family home in Greenville. *Photo by Bob Gillespie.*

Open—there have been other "ah ha moments." Jay won three PGA Tour Champions majors and earned spots on three Ryder Cup and three Presidents Cup teams; Bill earned a trio of Presidents Cup berths and captured the 2011 Tour Championship and FedEx Cup titles, worth a staggering $11 million.

Jay, who turned sixty-six in December 2019, finished that season among the PGA Tour Champions' top thirty-five players, and in 2004 was the oldest U.S. Ryder Cup participant ever, at fifty-one. "Those years when I did make a team, it was quite a thrill," he said. "I have great memories, still like to tell the stories."

Bill has stories, too. At the 1995 Ryder Cup at Oak Hill in Rochester, New York, he watched from inside the ropes as his dad trailed Europe's Philip Walton by three holes with three to play. Jay holed out from a bunker to win one hole and won again at the seventeenth to cut his deficit to one. Walton won the eighteenth hole and the match, but Bill never forgot the emotions of that day.

"I was thirteen and getting into [competitive] golf, and I was fired up to watch every shot," Bill said. "That was my first time with the crowd, hearing

the cheers…a very cool moment. [Jay] didn't finish like he wanted, but that didn't matter to me as much as I was inspired that he was supported like that.

"I thought, 'Man, it'd be pretty cool if I could do that.' For the rest of my middle-school years, if I watched him play, I wanted to go play, too."

Since the 1970s, Jay Haas and now Bill inspired generations of South Carolina players from the Upstate. Lucas Glover, 2009 U.S. Open winner and a Bill Haas contemporary; Greenville's Kyle Thompson, a PGA and Korn Ferry veteran; D.J. Trahan, part of the 2003 Clemson NCAA championship team and a multiple PGA Tour winner—all came up through clubs in the Upstate.

To some, golf in South Carolina begins and ends along the coast. But the Upstate region is home to some of the state's best players and top courses. In Greenville, Thornblade—a Tom Fazio design with Haas as a consultant—has hosted the Korn Ferry Tour's BMW Pro-Am for years, while Greenville Country Club's Chanticleer course annually ranks among the state's best.

Greenville Country Club is one of the state's oldest entities, dating from its founding in 1905 as San Souci, one of the original five clubs of the Carolinas Golf Association. GCC's Riverside course opened in 1923, replacing San Souci, and Chanticleer came along in 1970–71. Thornblade opened in 1990, a vision realized for investors Champ Covington, Joe Jelks, Irv Welling, Dr. Bill Hines, Johnny Harris of Charlotte…and Jay Haas.

While private courses dominate Upstate rankings, public golf has its place. Hillandale Golf Club was the area's first public course, opening in 1929, and in 1938, J.P. Traynham—a legendary player and grandfather of Clemson golfer Dillard Pruitt and Jay Haas's wife, Jan—opened Paris Mountain Golf Club. Furman University Golf Club, founded in 1956, and the Walker Course in Clemson are two of the nation's top college courses.

"The competition [in the Upstate] when I was growing up was always really good," Bill Haas said. "In high school, I wanted to play against Lucas [Glover] and Kyle [Thompson], both older than me and clearly the best players on other high schools. When Clemson won the national title my junior year at Wake Forest, every player on the team was from South Carolina."

Jay Haas says he didn't set out to be a role model, but "most young players now on the PGA Tour were helped in some way by an older person—a dad, an uncle [Jay learned from his uncle Bob Goalby, the 1968 Masters champion], a club pro—who helped them learn the game. It's a natural progression."

Still, if not for another "natural progression" at the Heritage at Hilton Head, the Haas legacy in South Carolina might never have been.

Two Generations of PGA Tour Talent

Jay Haas was just out of Wake Forest and playing in the Heritage in 1977 when, during his first round, he noticed a pretty blonde following his group. He asked a friend, Fred Reddel, to find out who she was.

Jan Pruitt was a Florida State student attending with her Greenville family (brother Dillard later became a PGA Tour player and, more recently, a PGA Tour rules official). She had picked Haas in a betting pool after she asked, "Who's a no-name?" Introduced, the two ate dinner together that Saturday, and they have been married more than forty years.

Once married, "we wanted to strike out on our own, and I didn't want to go back to [his Midwest home] and that weather," Jay Haas said. "We moved to Charlotte, but when her parents got sick, Jan said, 'Let's move to Greenville, I need to be around them.'" By the time her parents passed away, "we'd had both boys [Jay Jr. and Bill] and then the three girls, and it was home by then."

With Jay traveling the PGA Tour, Bill learned the game much as his dad had: via osmosis and phone calls. "There were always a ball and a club lying around," Jay said. "When we lived at Green Valley [Country Club], we had an artificial putting green in the backyard, with lights and a bunker.

"One time when Bill was very young, we had an eighteen-hole putting contest, and he beat me on the last hole with a long putt—I was trying as hard as I could—and he held his putter up like Jack [Nicklaus]. I'd told him he could have any trophy I had, and he picked some ugly vase thing off a shelf."

Bill laughed and said, "I still have it somewhere."

When Jay was away, he and Bill talked golf during phone calls. "I remember him telling me something like, 'Go to the right side of the range and hit it around your bag stand' to practice cut shots, nothing much more specific than that," Bill said. "A lot of it was 'This is what I'm working on, you go work on it.' That was similar to how Bob [Goalby] taught him."

In 1990, Jay became involved in the Thornblade project as an investor and also a consultant on the design with architect Tom Fazio. "I came over all the time, met with the shapers, talked about certain holes," Haas said. "It was a great thing for me, in the middle of my career, [even though] I didn't want to become an architect. It was fun to see it go from raw land to an actual golf course."

By the time he was excelling in high school, Bill—who played college golf for his uncle, Jerry Haas, at Wake Forest—was also part of the Upstate golf

Bill Haas tees off during play at the RBC Heritage Presented by Boeing, at Hilton Head's Harbour Town Golf Links. *Photo by Bob Gillespie.*

elite. "I played most of my golf, thousands of rounds, at Thornblade," he said. "In the summer, I could play [holes] 6 and 7 as many times as I could in the late afternoon, all to myself."

Following an All-American career (and a SC Amateur title), Bill joined the PGA Tour, winning the 2010 Bob Hope Classic in California—Jay flew in from a Senior Tour event in Hawaii to see the finish—and followed that with another win that year. Heading to the 2011 FedEx Cup, "my goal was to make the top 30" and earn a spot in the Tour Championship at Atlanta's East Lake Club, "but once I was there, I only had to beat 29 guys," he said.

He did, outlasting Hunter Mahan. On their second playoff hole, Bill hit an amazing "splash" shot from the bank of a water hazard to extend the playoff, then won on the next hole. "No one can say I had the best year," he said, "but I happened to win the best tournament at the end of the year."

Bill won again in 2012, 2013 and 2015, but after that, his game slumped. Some observers wondered if his FedEx payday had made him complacent. Then in February 2018, he was a passenger during an auto accident in which the driver, a family friend, was killed.

"I'm looking for why I've been struggling, so you could point to [the accident] for sure," he said. "But it's not fair to say that's why I haven't played well. The silver lining, though, I guess, is that now when I play bad golf, at least I get to play bad. I'm still here for my [three] kids and family. In that regard, I'm very lucky."

While Jay continued to play well on the PGA Tour Champions, he knew his career was winding down. Thus, in 2018, he set his sights on a Greenville driving range and practice facility then known as the Eagle Zone. There he met John Gerring, an octogenarian teaching pro and National PGA Hall of Fame member.

"[Greenville's] Green Valley [Country Club] was John's first head pro job, then he spent seventeen–eighteen years at Atlanta Country Club," Jay said. "He coached Dillard [Pruitt], and he's a fundamentals guy, not into technical things with the golf swing. I was always intrigued with the range; I took the boys there when we first moved here in 1983, and it always had a lure for me, a good spot to promote the game."

Haas asked who owned the range, and Gerring introduced him to owner Sam Phillips. "I asked, 'Can we buy it? How much is it?' and John helped me make that happen," Haas said. In 2018, the Eagle Zone became the Haas Family Golf Center.

"I'm not there much now due to my career," Haas said, "but Jay Jr. teaches there," along with Gerring, former Thornblade professional Jamie Michala and Dick Grout, son of the late Jack Grout, who taught Nicklaus. "There's a lot that can and will be done there, but we've improved the clubhouse, the pro shop, and we get good comments."

And there's Gerring: "He's definitely old school. He reminds me a lot of Uncle Bob," Haas said. "They'd get along great."

The Old Man and the Practice Tee

In an inscription in his 2016 book, *Simple Enough*, Gerring writes: "The golf swing is a lifelong chase...and will continue to be. This was my attempt to try and make the swing simpler....It seems pounding on the same thoughts—repetition—has a great value."

A golf instructor for more than half a century, Gerring returned to Greenville in 2014 after twenty years in Atlanta and Sea Island, Georgia. His ties to the Upstate date to the 1960s, when he was head professional at Green Valley. "I loved it and was determined to get back here," he said. When Phillips invited the 1957 Wake Forest grad to "retire and teach at Eagle Zone," Gerring quickly accepted.

"It's nice to have a place to work when you retire," he said.

Haas Family Golf Center has eighty hitting spaces, including a covered downstairs. "You can hit full shots," Gerring said. "We've got over three hundred yards to hit balls," plus an adjoining six acres should Haas decide to expand, perhaps to add an executive course.

The center has eight teachers, but "if you're hitting a slice, the staff gives you to me," Gerring said. "My specialty is a right-to-left shot." He's also a believer in traditional teaching methods. "My nickname is 'Dinosaur,' for the way I teach the swing," he said. "The modern swing is a blocking action, for the young and strong like Dustin Johnson. The old-school swing is a rolling action, easier for the average guy to learn and easier on you physically. If you're over forty, stay away from that blocking action."

Gerring knows Upstate golf. Greenville Country Club "has two of the very best courses in the Southeast": Chanticleer, once ranked among the nation's top one hundred, and Riverside, a favorite of seniors, women and juniors.

The Upstate's best courses are primarily private, but Gerring said public golf there is also solid. He points to Carolina Springs, Links O' Tryon, Pebble Creek and P.B. Dye design Cherokee Valley, along with Furman University's course.

"We're not as well known, but we have a variety of courses; it depends what you're looking for," Gerring said. "We've got a lot of golfers in this town, and if you talk to them, they'll help you find what you want."

For those with the means, Chanticleer remains the gold standard. To learn why, the best source is another octogenarian who had a hand in its creation.

Creating Chanticleer, an Upstate Jewel

Heyward Sullivan has been a member at Greenville Country Club since his teens. After a stint in the military, he returned home, where he's lived since. In 1966, at age twenty-nine, he was elected vice president of GCC's board of governors; a self-described "brash young man" with two (of his eventual six) club championships to his credit, he had visions of greatness for his club.

"Our Riverside course needed upgrading and they were talking about a local architect, but I said, 'If we're going to do this, let's get the best in the world,' which then was Robert Trent Jones," Sullivan said. "Everyone said, 'You're crazy, we can't get him.' But I wanted to give it a try."

Sullivan called Jones's office, but the famous architect was designing a course in Morocco for the nation's king. A week later, Jones's secretary called to say an associate would be coming to look at Riverside. "He wasn't enthusiastic, but he said, 'You'll be hearing from us soon,'" Sullivan said.

Three weeks later, Jones agreed to visit. After a tour of the course, he announced the club needed a new, larger site to build a "championship" course—and 200 to 225 more members to help pay for it. A local realtor offered 150 acres within a development called Chanticleer free with one condition: the land must always be a golf course. "And we were off and running," Sullivan said. The new course opened in 1970.

"He gave us one of the great golf courses in this part of the country," Sullivan said. Jones's designer son, Rees, oversaw a 2001–2 renovation which replaced the original bent grass greens with heat-tolerant A-1 bent, along with bunker rebuilding, new Bermuda fairways and drainage improvements. In November 2020, the club was scheduled to host the Robert Trent Jones Society's annual meeting of Jones-designed clubs from around the world.

Members of Greenville Country Club have a win-win choice of courses to play. "With Chanticleer, they know it's the championship course, and if they're fans of [Robert Trent and Rees] Jones, they want to play there," former longtime head professional Eric Pederson said. "Members who want a nice round, the clubhouse, take a steam bath and shower afterward, enjoy a nice dinner—Riverside has those amenities."

Sullivan remains active at GCC and bullish on the quality of Upstate golf. "There are an awful lot of good players here, from amateurs to Tour pros," he said. "The lower state has vacation/tourism courses; the Upstate courses are small clubs, but some outstanding courses." Among Sullivan's favorites (besides Chanticleer) are Thornblade, Musgrove Mill near Clinton,

Left: Heyward Sullivan (*left*) competed in a 1967 exhibition match with Arnold Palmer (*right*) at Furman University. *Courtesy of Heyward Sullivan.*

Below: The Chanticleer Course at Greenville Country Club, a 1970 Robert Trent Jones design, remains the gold standard of Upstate courses. *Courtesy of Greenville Country Club.*

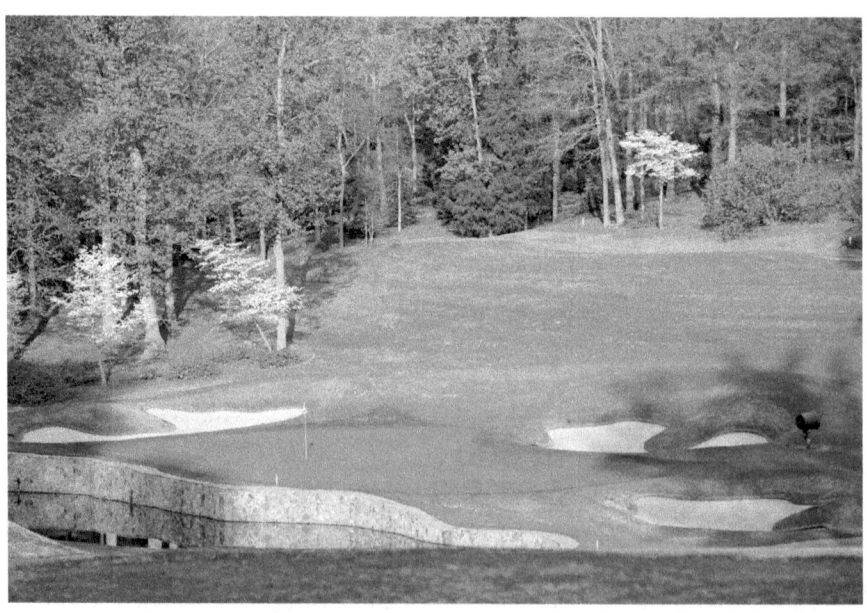

the Cliffs at Mountain Park (a Gary Player design) and Riverside, redesigned by Brian Silva in the style of 1920s architect Seth Raynor.

Chanticleer at one point ranked seventh in the United States for its number of low-handicap players. PGA Tour, Korn Ferry and other professional tour players, including Bill Haas and Ben Martin, are members or have privileges there, part of the area's support of young pros.

"We have a rotating list of ten 'aspiring' professionals," said club general manager Greg Hobbs. "They have to be full-time working to get or keep their [Tour] cards, and we help them have a place to practice and play. We do ask them to help with our junior program, and most find time to do that. Even Bill [Haas] will see kids and say, 'Want to go play?' and that makes their day."

While Chanticleer and Thornblade are Greenville's elite courses, Hobbs mentions such courses as Pebble Creek, with thirty-six holes; the Reserve at Lake Keowee, Holly Tree, Green Valley and semiprivate the Preserve at Verdae Green. For those who can't afford private club memberships, there are plenty of options—and one very good one.

EVERYMAN'S GAME: FURMAN UNIVERSITY GOLF CLUB

Matt Davidson is a fan of Chanticleer, "a wonderful layout, challenging even at [a relatively short] 6,800 yards. I'm not sure it gets its due." As a former PGA Tour and Korn Ferry Tour member, Davidson used the course to hone his game.

Now, as men's golf coach at Furman since 2018, Davidson has become reacquainted with one of the Upstate's finest public venues: Furman University Golf Club, where he played for the Paladins from 1999 to 2004. The course where Davidson won a Southern Conference title, though, isn't the current one.

In 2008, Pinehurst, North Carolina–based architect Kris Spence updated and upgraded Furman, which produced LPGA Hall of Famers Beth Daniel and Betsy King, plus current Fox Sports golf commentator Brad Faxon. Davidson estimates he played the old course "eighty to one hundred times a year when I was on the golf team," but has become familiar with the new course since returning to Greenville in 2011.

The Furman University Golf Course is a favorite of public golf players in the Upstate. This aerial view shows the practice facility. *Courtesy of Furman University.*

"Before [Spence] redid the greens, they were simple bent grass greens; I knew every inch of those," Davidson said. "They're trickier now. The greens have more challenging slopes and pin positions."

Spence lengthened the course, in particular the fifth and eleventh holes, and updated bunker positions. "Sometimes I get nostalgic, but the course now is better for my guys," Davidson said. "When it's firm and fast, and the greens get quick in the summer, it's up there with anything in the area."

Greenville remains dominated by private courses, Davidson said, but public golf is alive and well. And his course at Furman "is right up there at the top. I'm biased, but it's a solid course."

And the Upstate—from Furman to Chanticleer and everything in between—is solid golf country. Just ask the Haas family.

BUILD THEM, AND THEY WILL COME

Charleston's Golf Resorts

For many years, the thing that stood out most about Charleston in the minds of the general public was that the city was where the first shots were fired in America's Civil War. More recently, modern-day Charleston is known for its history, its world-renowned tourism attractions and its local cuisine, including its many world-class restaurants. But it's also known for its golf.

Ask a golf fan almost anywhere in the world about Charleston today, and the response very likely will have something to do with Kiawah Island and the Pete Dye–designed Ocean Course, which became internationally famous when it was built to host the 1991 Ryder Cup Matches, the War by the Shore. Kiawah Island Golf Resort has continued to build on that recognition factor with the 2012 PGA Championship and another PGA scheduled for 2021.

Nestled within a few golf shots of each other, about twenty-five miles southeast of Charleston, are Kiawah Island and Seabrook Island, neighbors that are both centered on golf. If you wanted to include a jog across the Kiawah River (technically on Johns Island), there are ten championship courses, seven open to resort guests, designed by the cream of American golf course architecture.

Kiawah Island Golf Resort has five courses designed by Dye, Jack Nicklaus, Tom Fazio, Gary Player and Clyde Johnston. The private Kiawah Island Club has two courses, one designed by Fazio and the other by five-

Looking across the putting green and clubhouse toward the eighteenth hole at Kiawah Island Golf Resort's Ocean Course. *Courtesy of Kiawah Island Golf Resort.*

time British Open winner Tom Watson. Seabrook Island, meanwhile, features two courses designed by Willard Byrd and Robert Trent Jones. The tenth course in the area, across the Kiawah River from the island of the same name, is the ultra-exclusive Golf Club at Briar's Creek, which was designed by Rees Jones.

And just north of Charleston, located in the Isle of Palms community, is another highly recognized golf resort: Wild Dunes, which features the Links Course—which has been ranked in America's Top 100 courses—and the Harbor Course. Both were designed by Fazio.

It didn't take long for the nation's golf resort industry, which was spawned in 1956 when Charles Fraser began developing Sea Pines Resort on Hilton Head Island, to make its way up the South Carolina coastline to Charleston. Like Hilton Head, these sea islands began as fishing and hunting retreats, until visionaries realized the fortunes that could be made through golf.

From Seabrook Island to the Ocean Course

The first of the Charleston resorts was Seabrook Island. In 1970, the Seabrook Development Co. negotiated with the Episcopal Diocese of Charleston and paid just under $2 million for 1,071 acres, with plans for a residential and recreational development. A five-year plan for the development included two eighteen-hole golf courses.

Willard Byrd, a well-known architect in the Southeast, was selected to design the course, now known as Ocean Winds, which opened in July 1973. It was considered a strong, challenging layout with players having to contend with strong breezes from the nearby Atlantic Ocean, which could be seen from the course's tenth hole.

The second course, designed by Robert Trent Jones, was more of an inland layout, playing through the oaks and along lagoons. It was designed by Robert Trent Jones and opened in October 1981.

The development of Kiawah Island followed closely on the heels of Seabrook Island and had ties with the original Sea Pines Resort on Hilton Head. The island had been purchased in 1950 by C.C. Royal for logging and timber, and Royal allowed a few friends to build getaways on the island. Royal's heirs sold the property to Kuwait Investment Corp. in 1974, and Sea Pines helped the new owners produce a master plan.

Kiawah Island Golf Club opened in 1976, designed by Gary Player, who just two years earlier had won both the Masters and British Open. The course was renamed Marsh Point when a second golf course was announced and now is known as Cougar Point, a salute to the wild cat that inhabits the island. It was located just as one comes onto the island and has been remodeled and lengthened several times, the most recent occurring in 2017.

Five years later, in 1981, Kiawah added another course and another major champion with the opening of the Jack Nicklaus–designed Turtle Point, which featured three holes that play along the Atlantic Ocean. The resort's Kuwaiti owners soon after announced another golf course, member-friendly Osprey Point, designed by Fazio, but it didn't open until 1988. It was built in a private residential portion of the island, behind a second security gate.

The property for the Ocean Course, which opened in 1991, was a piece golf architects would kill for, designer/builder Pete Dye said. And he took advantage of that reality, building up fairways to give golfers views of the ocean on all eighteen holes. The Ocean Course seemed to have completed the Kiawah Island Golf Resort family.

The par-4 tenth hole at Seabrook Island Club's Ocean Winds course plays out to the Atlantic Ocean. *Courtesy of Seabrook Island Club.*

But then in 1997, the resort's owners purchased an eighteen-hole golf course that had opened in 1989, located just a couple of miles off the island and designed by Clyde Johnston, and christened it Oak Point.

Kiawah Island Golf Resort president Roger Warren, who came to the resort in 2003 as the director of golf, gives all the credit to owner Bill Goodwin. "I'm biased, but when you take everything into consideration, it is the premier golf resort," Warren said. "And it is a direct reflection, no doubt about it, on Bill Goodwin and his family and the standards they have for the businesses they own and operate. They want it to be of the highest caliber.

"He bought the Ocean Course and we've built a new clubhouse. He built a new clubhouse at Osprey Point, built a new clubhouse at Turtle Point, now we've built a new clubhouse at Cougar Point and built a new clubhouse at Oak Point. He has renovated all five golf courses in the time he's been here, built the Sanctuary Hotel and has built a new conference center.

"The point I'm trying to make is there's an attitude that it's going to be the best and we're going to upgrade it to that or we're going to replace something that's here to make sure it's best."

Golfers look out at the Atlantic Ocean while hitting their tee shots on the fourteenth hole of Kiawah Island Golf Resort's Ocean Course. *Courtesy of Kiawah Island Golf Resort.*

Warren also noted that the resort's Sanctuary Hotel is the only 5-Star, 5-Diamond hotel in South Carolina.

The private Kiawah Island Club added the Fazio-designed River Course in 1995 and brought in Tom Watson to build Cassique, which is named after the Kiawah Indians' chief, giving the club its second course just outside the entrance to the island in 2000.

FAZIO'S DEBUT: WILD DUNES LINKS COURSE

Twelve miles north of Charleston sits another barrier island, the Isle of Palms. Unlike Kiawah and Seabrook, much of that island already was built with beach homes, but there was a wild, untamed portion on the northern part of the island that developers began to eye in the 1970s.

Construction of the Isle of Palms Beach and Racquet Club began in January 1977 with Sea Pines, which owned half of the development, guiding it through the planning stages before selling off their share to Wilbur Smith

The par-3 sixteenth hole at Wild Dunes Resort's Links Course plays out to Dewees Inlet, which feeds into the Atlantic Ocean. *Courtesy of Wild Dunes Resort.*

and Associates. Finch Properties, owned by brothers Henry and Raymon Finch, was the other owner.

In announcing plans for the resort, Henry Finch in 1977 said they planned to develop the property over twelve to fifteen years but had not promised potential property owners a golf course—even though noted architect George Fazio had visited the place several times and was working on a course design.

"George Fazio tells us with the natural terrain we have, the course could be the best on the East Coast," Henry Finch said.

But when it came time to build the course, it was George's nephew Tom who ended up getting the job. The developers gave the younger Fazio some prime property for his routing, and he finished the course with a par-3 sixteenth hole that played out to Dewees Inlet, the par-4 seventeenth that played alongside Dewees Inlet and the par-5 eighteenth that started along Dewees Inlet and finished along the Atlantic.

"God laid this one out," Tom Fazio said.

The course, given the name Wild Dunes because of its seaside location, opened in 1980 and almost immediately began to make waves in the national rankings. The resort soon changed its name to take advantage of the course's notoriety. In 1985, it served as the site of the U.S. Senior Amateur.

The developers still had enough property to add nine more holes but wanted a full eighteen-hole layout. They arranged to purchase adjoining property that had once been a small airstrip on the island. And knowing they had a good thing going with Tom Fazio, they hired him to build the Harbor Course, a linksy layout that played alongside the Intracoastal Waterway.

Kiawah, Seabrook and Wild Dunes have had their ups and downs during their early days—particularly Wild Dunes, which took a direct hit from Hurricane Hugo in 1989, forcing major reconstruction and putting the course out of commission for months. But with maturity, they all have since flourished and become quality golf destinations.

FROM FAIRWAYS TO AIRWAVES

TV Golf's Stars

Ask Charlie Rymer for a funny story from his PGA Tour days, and a wide grin spreads across his dimpled face. In a career long on laughs but short on winning, the Fort Mill native has no problem coming up with a tale that he's pretty sure will never see print.

Suffice to say his story from the 1997 International at Castle Pines, Colorado, is both cringe-inducing and hilarious. Key elements include a fruit-heavy lunch, a "wardrobe malfunction" and a round completed wearing rain pants that, he said, resulted in some serious chafing.

"[Longtime CBS golf reporter and friend] Gary McCord was working for USA Network," Rymer said, "and he said on-air, 'Look at Charlie Rymer, walking funny in rain pants with not a cloud in the sky. Hmm, I wonder what happened to him out there?'

"He knew what had happened. I haven't eaten fruit since then."

Rymer has always been able to laugh at himself. But his efforts as a professional golfer were more frustrating than funny; in 1998, he missed retaining PGA Tour playing privileges by a shot at qualifying school and, facing a year on the then-Nike Tour, was contemplating what to do next.

"My heart wasn't in golf, I had two kids, I wasn't playing well," Rymer said. "It wasn't a happy time."

Enter McCord, again. During that year's Hootie & the Blowfish Monday After the Masters annual fundraiser, Rymer told McCord he wanted to find something else to do, and McCord suggested covering golf on TV.

"I'd love to, but I'm not qualified to do TV full-time," Rymer said.

Charlie Rymer (*right*) chatting with golfer Henrik Stenson on the Golf Channel. *Courtesy of the Golf Channel.*

"Well," McCord replied, "you're an idiot, and that qualifies you to do TV."

McCord "made some calls, got me some auditions, got my foot in the door," Rymer said. That was the start of a twenty-two-year career in broadcasting, the last eleven at Golf Channel, ending in 2019 when he became celebrity spokesperson for Myrtle Beach Golf Tourism Solutions.

"I do like TV, it's a lot of fun," said Rymer, who will still do occasional gigs with Golf Channel. "I worked for every network that broadcasts golf, in every role: on-course, lead analyst, host, studio shows."

Rymer's would be a unique story—kid from South Carolina makes it big in golf TV—except he's one of a handful who've become more known for reporting on golf than for playing it. Golf Channel was home to three South Carolina talents: Jennifer Mills of Greenville, the network's first woman reporter (1994–2005); North Myrtle Beach's Kelly Tilghman, whose twenty-two-year GC career ended in 2018; and Rymer.

Then Brad Faxon, a Rhode Island native, two-time All-American at Furman University and PGA Tour veteran, became in 2015—after occasional TV spots starting in 2010—part of Fox Sports' planned annual coverage of the U.S. Open, U.S. Women's Open and other USGA events. But in June 2020, citing scheduling issues and Covid-19, Fox relinquished its golf deal, scheduled to run through 2026, to NBC.

All four—plus Florida native Steve Burkowski, who worked in radio in Columbia before joining Golf Channel in 2000, and former University of South Carolina player Brett Quigley, an on-course reporter for Fox Sports— were part of golf's TV presence. Another former Gamecocks player, Carl Paulson, worked for ESPN and DirecTV before SiriusXM's PGA Tour Radio.

None set out to star on the small screen instead of the golf course. Each eventually found his or her niche in golf broadcasting.

Golf Channel's First Lady: Jennifer Mills

Jennifer Mills, unlike the others, never played golf professionally. But she has fond memories of spins around Fox Run Country Club in Simpsonville with her dad. ("I was five or six years old, and I got to drive the cart those last three holes," she said. "I fell in love with the sport.") She played other sports at J.L. Mann High, where TV station WLOS discovered her and she discovered broadcasting.

"My junior year, they did a 'Player of the Month' story about me and sent a camera crew to my school for a day," Mills said. "I watched and I thought, 'Gee, they get paid to do this?' A month later, I got an internship over the summer."

When Mills went to Wake Forest University on a basketball scholarship, she also landed a weekend TV job in Winston-Salem, North Carolina. In 1984, as Wake Forest's homecoming queen, she shot football video before and after her halftime coronation. After college and a year at WXII-TV, she was hired by NBC affiliate WYFF in Greenville.

Then Mills got a call from Arnold Palmer's office, informing her Palmer, another Wake Forest alum, had recommended her to the fledgling Golf Channel, which he founded along with Joe Gibbs. Mills signed on in November 1994, becoming GC's first female reporter.

One early incident showed she could hold her own with the press corps and Tour players. "I asked a question, and this player—who was No. 1 in the world at one point—looked at me and glanced at the rest of the reporters for the next question," she said. "I was livid."

Mills followed the player (whom she declined to identify) to his car and asked, "Have I done something to offend you?" Embarrassed, the player apologized, and "from that moment on, he was respectful. I knew then I was here to stay."

Jennifer Mills of Greenville was the first on-camera female personality at Golf Channel. *Courtesy of the Golf Channel.*

She stayed eleven years, doing her research to understand professional golf, refusing to be "another pretty face," she said. "I'm very thorough, and they joked that I was always digging for the last-minute nugget or fact. I wanted as much information as possible."

Affirmation came one day when Mills approached golfer Davis Love III, and a local reporter yelled at her. "Davis said, 'Hey buddy, she's Jennifer with Golf Channel, and I'll talk to her if I want to talk to her.'"

But in 2005, the divorced mother of two said it was time to move on. "My son was ten, my daughter eight, and one day he put on my running shoes by accident—and they fit," she said ruefully. "I knew then I had to go home and be a mom, because they were growing up too fast."

USA Network signed her for its weekly *PGA Tour Sunday* program, a less time-demanding schedule. She had worked for *PM Magazine*, the Travel Channel and ESPN as a college basketball analyst, so Mills was a known quantity, and she also worked for NBC Sports as host of its USGA and Ryder Cup package and Masters TV's in-house operation.

"It's all part-time, so I can fit the schedule I want," she said. She and her husband live quietly in the western portion of the Carolinas, and she's taken up painting. In 2019, she was selected for a North Carolina Arts Foundation

grant, and she has created artwork of Love, Greg Norman and Annika Sörenstam. "I'm pinching myself," Mills said.

She said she has no regrets about leaving it behind. "I thought, 'I can always get another interview with Tiger Woods, but I can't go back and watch my kids grow up,'" she said. When you're Jennifer Mills, you can have it all.

GOLF IN HER BLOODLINES: KELLY TILGHMAN

If ever anyone seemed destined for a golf career, it was Kelly Tilghman. Her grandfather Melvin Hemphill, a renowned golf teacher for forty-seven years, worked with Jack Fleck before he famously denied Ben Hogan a fifth U.S. Open title; her great-aunt Kathryn Hemphill played on the U.S. Curtis Cup team and won an LPGA event as an amateur. Her father's family built Gator Hole, a now-defunct golf course in North Myrtle Beach, where Tilghman spent much of her youth.

"I was lucky with my bloodlines," she said. "The Tilghman name carried weight in Myrtle Beach, and the Hemphill name let me go as far as I did in South Carolina."

Tilghman played at Duke and always figured she'd make it to the LPGA. But after playing mini-tours and in Europe, "I realized I'd reached my ceiling; Annika [Sörenstam] and others were a lot better than me. So I walked away."

One day after reaching that decision, Tilghman was at a driving range in Florida when she noticed a man watching her. "He said, 'You have a great swing, are you a professional?' I said, 'I was.' Then he said, 'I noticed your voice, it's authoritative,' and gave me a business card, said he had a friend in broadcasting and I should try getting on-air."

That led Tilghman to a TV station internship in Palm Beach, Florida, where she "fetched coffee, transported scripts" and put together "a really bad résumé tape." She was playing in a charity golf tournament in 1996 when she met Scott Van Pelt, now an ESPN regular, on the driving range.

"He said, 'I just got on at the Golf Channel,' and I said, 'The *what?*' So I gave him my bad résumé tape." That led to a job in GC's video tape library, paying $21,000 a year. Her star began to rise, and in 2007, she became the channel's first female play-by-play announcer, working GC's lineup of PGA Tour tournaments with six-time major champion Sir Nick Faldo.

"When they told me, I was excited; you get caught up in the dream and it fell into my lap," she said. She was prepared, though. "The nights leading up to [her debut in Hawaii], I'd visualize my performance on-air, my chemistry with Nick, so it felt like I'd done it before." Afterward, "I came off the set and the vice president of production said, 'How'd you do that? You didn't look nervous at all.'"

Tilghman made it look natural for twenty-two years, anchoring Golf Channel news programs and its PGA Tour schedule. She reported the game's biggest stories, including revelations in 2009 of Tiger Woods' cheating with multiple women—a story that tore at Tilghman, who had established a strong working relationship with Woods.

Her landmark moment came when Golf Channel was credentialed to work the Masters. She remembers walking onto the grounds of Augusta National with her colleagues: "It was Monday, and there was a sea of people there already," she said. "Golf Channel was still young, but there, they all treated us like rock stars."

Early in her Golf Channel tenure, Tilghman connected with GC founder Arnold Palmer in the network's newsroom. "He came over, said, 'Hey, what's your name?' and then he whispered in my ear, 'I hope you believe in this

Kelly Tilghman (*left*) became a close friend of the legendary Arnold Palmer, Golf Channel co-founder and co-owner. *Courtesy of the Golf Channel.*

place as much as I do.' If Arnold Palmer knew it was going to be okay, why wouldn't I believe that?"

At the Masters, Tilghman was chosen to caddie for Palmer in the tournament's Wednesday Par-3 Contest, walking alongside legends Jack Nicklaus and Gary Player. That, she figured, was a one-time thrill. But a year later, "We're at Bay Hill [for Palmer's tournament]," Tilghman said, "and he came by the broadcast like he always did, and then he said, 'Well, you know we've got business coming up next month; you're going to caddie for me again, right?' And I was over the moon."

"I've asked myself why he took such good care of me. Why did he feel safe with me? Maybe because he had two daughters or because he respected that I'd played professionally…not a day goes by that I'm not thankful."

In early 2018, Tilghman decided to leave Golf Channel. In 2012, her daughter was born, and Tilghman also was picked by NBC to work the London Olympic Games. Six years later, she knew it was time.

"I met my boss for coffee, and I said, 'I'm ready to go,'" she said. "We created a mutually respectful exit, Golf Channel threw a hell of a going-away party, I had an emotional sendoff at Bay Hill [without Palmer, who died in 2016], and they allowed me to say goodbye on the air."

Now in "Kelly 4.0," Tilghman said her focus is family and philanthropy. In October 2019, she headed up a charity initiative, Gene's Dream, honoring former golf mentor Gene Weldon in North Myrtle Beach. "Whatever I do from here on will transcend what I've done so far," she said. "This is me starting over, with advantages of great relationships built over the years. But it'll always relate to golf."

It's in her blood, after all.

SERIOUSLY FUNNY GOLF: CHARLIE RYMER

Charlie Rymer seemed unlikely to end up a golf jokester on TV. While winning three straight SC Junior Championships, the imposing (six-foot, four-inch) youngster was soft-spoken, almost reticent. But four years at Georgia Tech, "where I discovered beer," brought out his unique, fun-loving personality.

That persona was what sold executives at ESPN and later USA Network, CBS and Golf Channel. Rymer said he was helped to find the reporting and interviewing chops to compliment his natural sense of humor.

"There's no book on how to be a golf TV announcer; you learn from those [already] there," he said. "It was more challenging than I thought it would be." Rymer credits veteran golf announcer Bill McAtee for getting him over the hump. "One day he put his arm around my shoulder and said, 'No one ever told you how to do an interview, did they?'" Rymer said. "He was the guy giving me feedback, which was helpful coming from a veteran broadcaster."

It took time to find his balance. "I do look on the lighter side, but there are a lot of places that's not appropriate, such as the Masters," he said. "Covering live golf, the action dictates where you need to go. Later, when I was doing more studio shows, you're creating content, and it's a different way you prepare."

A testament to Rymer's ability to do both: for more than a decade, he's been Westwood One Radio's lead analyst at the Masters.

Tilghman recalled she found out Rymer was preparing to join her at Golf Channel while sharing a flight. "I asked him, 'Are you happy with ESPN?' and he said, 'I've been thinking about a change' to join Golf Channel.

"I told him, 'Charlie, we've got to make a deal: You've got to let me stay as the most famous South Carolina person there.' And he said, 'I can't promise that Kelly; you know how attractive I am. I'm a magnet.' And then he got the job."

The funny Rymer is never far away, but he was serious when need be, as after the 2016 death of Golf Channel founder Arnold Palmer. "That was a tough couple of days," Rymer said. "I did an interview with him two weeks before he passed, and the network really shined covering the funeral, reactions, what he meant to the world of golf. We handled it all with the respect he commanded. I was honored to be part of that."

When Rymer decided it was time to move on to his current role with Myrtle Beach Golf Tourism Solutions, "I was doing more than two hundred live shows a year," he said. "I enjoyed it, but it was taking a toll on my personal life. It's a good job, but a tough job.

"[Golf Tourism Solutions CEO] Bill Golden and I had done a show for Golf Channel, *Road Trip: Myrtle Beach*, a few years back, and I'd host the World Amateur (Championship) every year. Bill said, 'We'd love to have you here full-time,' so we're now here full-time," moving from Orlando in 2019.

Ahead are plans to produce a documentary on South Carolina's history in the game, tentatively titled "First Golf," contingent on raising funds. He likes the project's chances. For the immediate future, he said, "my job is to tell the world what's going on in Myrtle Beach." He grinned. "That's a pretty good gig, too."

FROM PUTTER TO MICROPHONE: BRAD FAXON

Brad Faxon spent thirty-four years on the PGA Tour, with wins at the 1993 Australian Open and the 2005 Buick Championship, plus Ryder Cup selections in 1995 and 1997. In 2012, Faxon, a Rhode Island native, was awarded the Jim Murray Award by the Golf Writers Association of America (GWAA) for his cooperation, "quote-ability" and accommodation with media.

That was a help when he began his own work as a broadcaster, first in 2010 with NBC and, starting in 2015, as analyst for Fox Sports' USGA lineup, until the network gave up its USGA deal. "No doubt," Faxon said. "I'd watched golf on TV since I was a kid, and I had opinions about who I liked among broadcasters.

"I'd imagine what I'd say if I was doing the interviewing. During my career, I was invited to talk on camera a few times, and I got comfortable with it."

Faxon said he never thought about a career in TV until his forties, after a torn ACL. That year, he was invited to the NBC booth at the Deutsche Bank event to talk about renovations he and architect Gil Hanse had done to the TPC Boston course. "I thought I'd spend ten to twelve minutes with [NBC announcers Dan] Hicks and [Johnny] Miller; it ended up being two hours," he said.

In 2010, NBC's Tommy Roy invited Faxon to work more events, starting with the Shell Houston Open. In all, he worked seven of NBC's ten big events, "a nice transition to get into TV before I turned fifty," he said.

The lure to join the fledgling Fox golf broadcasts was the network's contract with the USGA. In 2014, as NBC and Golf Channel were wrapping up their USGA tenure, Faxon was invited to join Fox host Joe Buck and fellow analyst Greg Norman at Pinehurst, North Carolina, for that year's U.S. Open.

"They asked me to come meet them, and Joe said, 'You'll be able to work more weeks at Golf Channel, but at the Open [for Fox], 25 million people will be listening,'" Faxon said. "Golf Channel was getting at most 200,000. It was a no-brainer."

In 2019, Fox covered its fifth (and final) U.S. Open, to mostly good reviews, but in 2015 it was all new, and it showed at times. "We started [at a course, Chambers Bay] where no one had ever been," Faxon said. "We wanted to make a big first impression, but we had all kinds of people there who'd never done golf before.

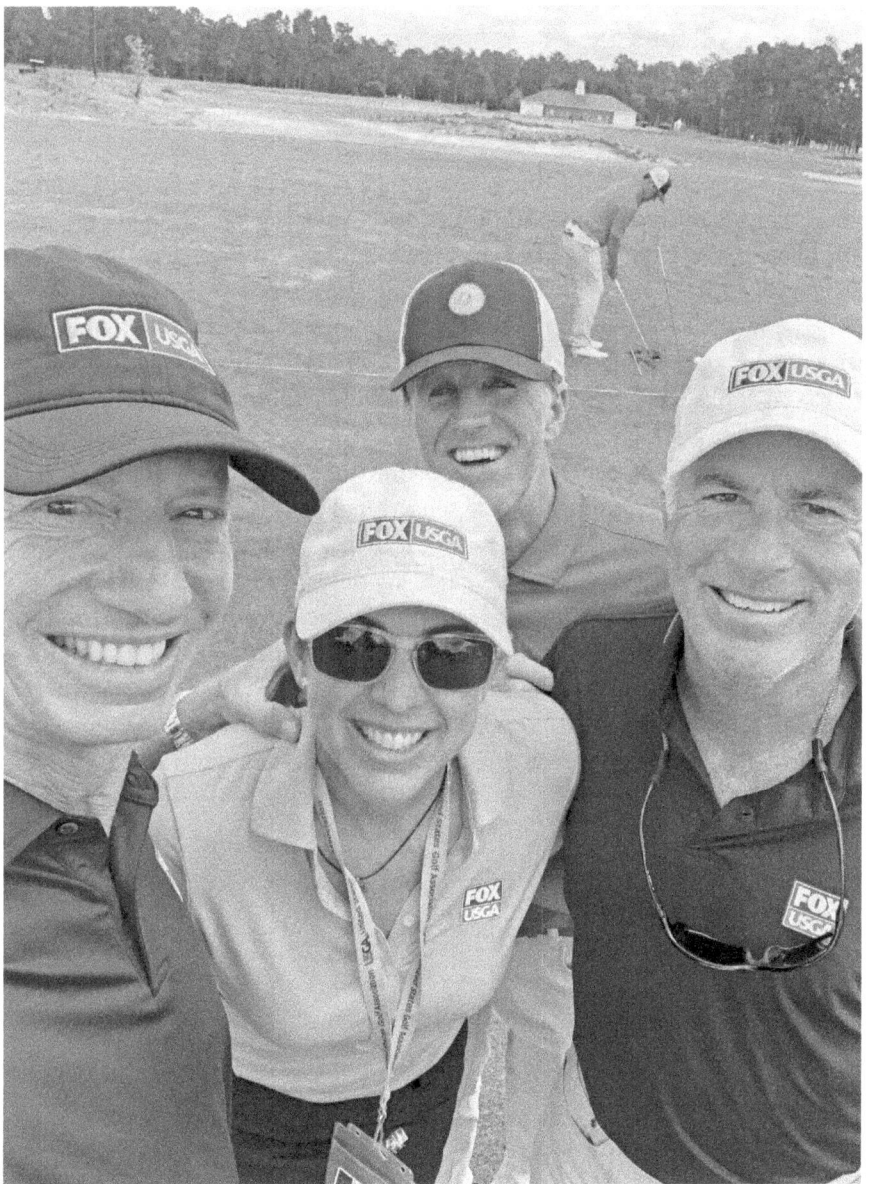

Brad Faxon (*left*) and the Fox Sports crew relax between sessions at the U.S. Open Championship. *Courtesy of Fox Sports.*

"We got off to a slow start. Now, fast-forward five years; how we've covered the last couple of Opens, especially Pebble Beach—the technical part, the experience—I think we figured out how to do a really good job as a team."

Even when Fox's early Open telecasts drew criticism, Faxon received good reviews for his on-air composure and expertise. "I've had experiences as a player, and I had a relationship with the players, so they weren't going to run away from me," he said. Faxon also has worked with a number of players on their putting, notably 2019 Open winner Gary Woodland. "So they're not rolling their eyes, like 'who's this guy?'"

Faxon looks back at 2015 and sees "some snafus there" but views the 2016 Open at Oakmont, won by South Carolina's Dustin Johnson, as a triumph. Johnson, who played not knowing if he'd be penalized for a moving ball, was "nothing short of sensational" in his finish. Fox's coverage of the complicated situation was solid, too.

Faxon's future in TV seemed likely to only get better. But with NBC taking over the USGA contract, his future in the booth was unknown as of fall 2020. Still, Faxon said he had no regrets about his time covering USGA events, especially some amateur events.

"I'm a golf nut," he said. "The USGA picked the courses…and then we got to play them." For five years, at least, it wasn't a bad way to wrap up a career.

BIBLIOGRAPHY

Board, Prudy Taylor. *The History of the Dunes Golf and Beach Club.* Virginia Beach, VA: Donning Company, 2005.

Bunton, Terry. *The History of the Heritage, 1969–1989.* Savannah, GA: Savannah Print Company, 1989.

Finley, Thomas Alton. *Golf in the Upstate Since 1895.* Greenville, SC: Olde Sport Publishing, 1999.

———. *Greenville Country Club, From Century to Century: A History 1895 to 2017.* MOA Press, 2017.

Fowler, Vance. *MCI Classic: The Heritage of Golf, a Tournament Retrospective.* Hilton Head Island, SC: Heritage Classic Foundation, 1995.

Pace, Lee. *Country Club of Charleston.* Charleston, SC: 2018.

Palmetto Golfer magazine

Post and Courier newspaper archives

Price, Charles, and George C. Rogers Jr. *The Carolina Lowcountry, Birthplace of American Golf, 1786.* Hilton Head Island, SC: Sea Pines Company, 1980.

South Carolina Golf Hall of Fame

The State Media Company archives

INDEX

ABOUT THE AUTHORS

BOB GILLESPIE was a senior sportswriter, columnist and golf writer for *The State* newspaper in Columbia, South Carolina, from 1979 to 2010. He won *The State*'s Ambrose E. Gonzales Award for distinguished journalism in 1988, was Associated Press Sports Editors national runner-up in features (2001) and explanatory stories (2009) and was named the Herman Helms Excellence in Media award winner by the South Carolina Athletic Hall of Fame in 2019. He and his wife, Jane, live in Columbia.

TOMMY BRASWELL has written about golf in North and South Carolina since the mid-1970s, covering everything from local golf events and personalities to Ryder Cups, PGA Championships, the Masters, the Heritage and numerous LPGA events held in the Palmetto State. In addition to covering golf for Charleston's *Post and Courier* since 1982, he also has written for national golf publications, including *Golfweek* and *Golf World*. He and his wife, Ann, live in Charleston.

www.ingramcontent.com/pod-product-compliance
Lightning Source LLC
Chambersburg PA
CBHW052120210526
45161CB00011B/81